MUG SHOTS

MUG

AN ARCHIVE OF

BY

SHOTS

THE FAMOUS, INFAMOUS, AND MOST WANTED

RAYNAL PELLICER

ABRAMS, NEW YORK

Design: Maurice Croat

Translated from the French by Liz Nash

English-Language Edition:
Magali Veillon, Editor
Shawn Dahl, Designer
Michelle Ishay and Gregg Kulick, Jacket Design
Jules Thomson, Production Manager

Library of Congress Cataloging-in-Publication Data

Pellicer, Raynal.
 [Présumés coupables. English]
 Mug shots : an archive of the famous, infamous, and most wanted /
by Raynal Pellicer.
 p. cm.
 ISBN 978-0-8109-2109-2 (hardcover)
 ISBN 978-0-8109-9612-0 (paperback)
 1. Celebrities—Portraits. 2. Criminals—Portraits. 3. Identification photographs.
 I. Title.

 TR681.F3P43 2009
 779'.2—dc22

 2008045414

Printed and bound in China
10 9 8 7 6 5 4 3 2 1

Abrams books are available at special discounts when purchased in quantity for
premiums and promotions as well as fundraising or educational use. Special
editions can also be created to specification. For details, contact specialmarkets@
abramsbooks.com or the address below.

THE ART OF BOOKS SINCE 1949

115 West 18th Street
New York, NY 10011
www.abramsbooks.com

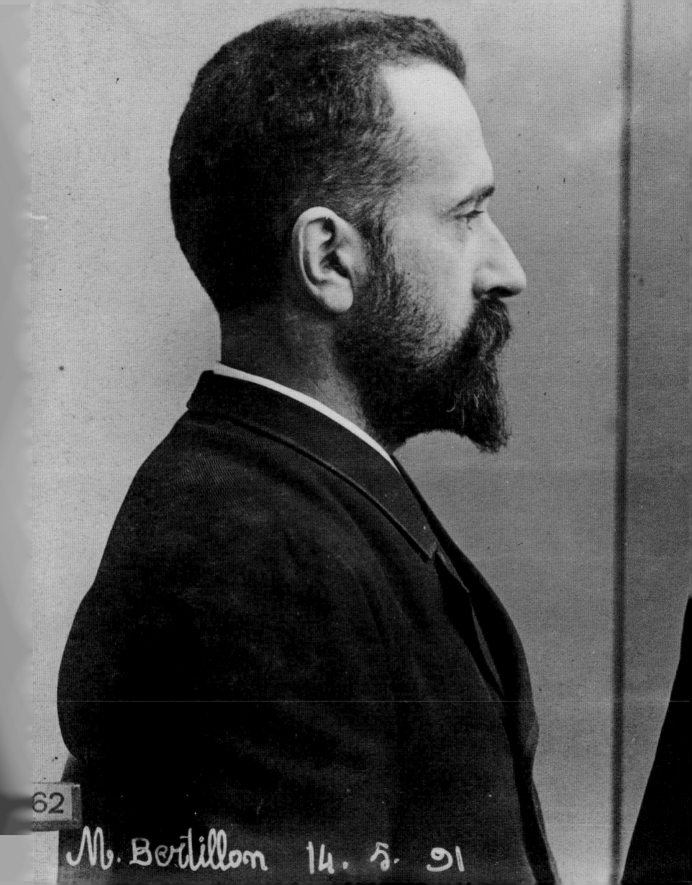

62

M. Bertillon 14. 5. 91

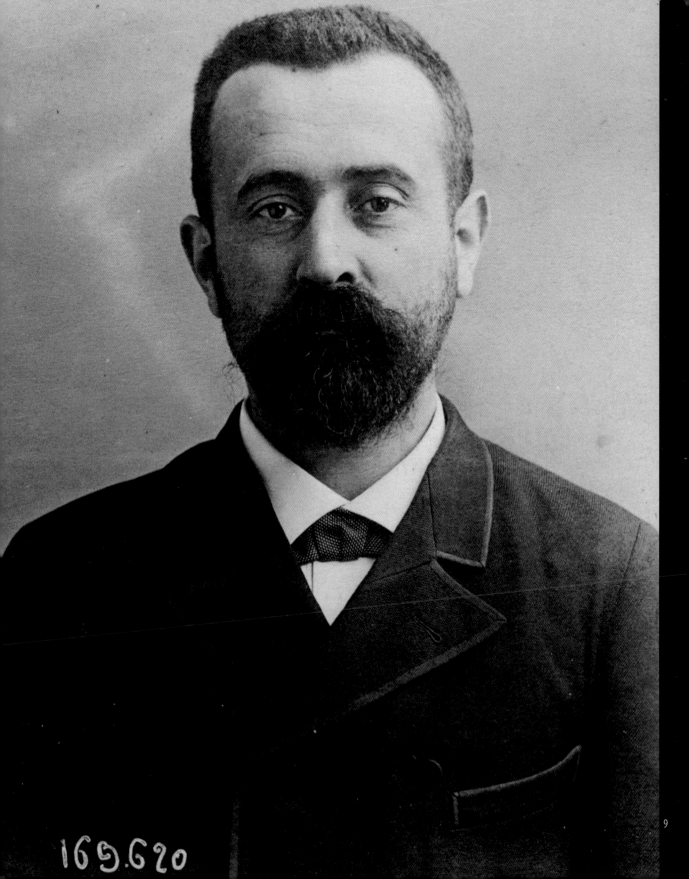

169.620

In 2006, while researching for a documentary project at the Police Headquarters Museum (Le Musée de la Préfecture de Police) in Paris, I found myself looking at the anthropometric photo of Amélie Hélie, known as "the Golden Helmet." What I saw, front and profile, was a face and some facts, revealing a real story. In my memory, however, there was a different image, taken from the cinema: the face of Simone Signoret, who played the role of Hélie in Jacques Becker's film.

This was when the idea for *Mug Shots* started, as I became interested in legal photography and began my research on Alphonse Bertillon, who set up the first scientific police laboratory in late nineteenth-century France and invented anthropometry. Putting together a collection of this very particular type of photography meant first of all making a subjective selection of about 240 faces. The task was not easy because these documents are rarely listed or classified, tend to move or get lost between departments, or become buried in the depths of an archive. Inevitably, some photos have disappeared. Others belong to private collectors.

Another fascinating discovery is that for more than a century, millions of anthropometric photos, now known as mug shots, have been piling up in the archives of the police headquarters in Paris, and in the National Archives of France and the United States. Millions of lives have been recorded on glass plates, negatives, or paper photos, mostly in black and white. Either printed on a slate or engraved, we find on these shots an identification number, a date, and a name. Most of the individuals who have been arrested and photographed have remained unknown, but a small number have become legendary.

Mug Shots rediscovers the stories of these exceptional arrests, piecing them together in chronological order—from the beginnings of legal photography during the Paris Commune in 1871 to the last silver prints at the end of the twenty-first century right before the arrival of digital photography—compiling an enormous portrait of violence and dysfunction over the years and of the people who were regarded as outlaws in different eras. Unlike in American legal cases, most of the anthropometric photos in French cases are kept in files that are closed for one hundred years. Many of them can only be viewed by special dispensation and cannot be published. Exceptions are made for cases (normally before 1945) that received exceptional media coverage or involved highly notorious individuals. For more recent cases it is almost impossible

to gain access to the photos, apart from those published as Wanted notices—when a prisoner has escaped, for example. In the United States, alterations made by Congress to the Freedom of Information and Privacy Acts led to the FBI making thousands of files public globally and available online. For the researcher wanting to find all the details of a case, it requires a real treasure hunt through official archives and press agencies.

The profiles of these men and women suspects are many and various: criminals, public enemies, Mafiosi, members of the French Resistance, Civil Rights protesters. . . . They include infamous people such as "the Black Dahlia," "Pierrot le Fou (Mad Pierrot)," and "the Birdman of Alcatraz," who nowadays are thought of more as movie characters than real people. Does anyone still remember them by their real names: Elizabeth Short, Pierre Loutrel, and Robert Stroud?

In returning to these lives just long enough to look at a photo, I aim not to rehabilitate them or judge them, but rather to move backward from fiction and the collective cinematographic memory that we all share in order to return to reality. Here we can look at the real face of "the Birdman of Alcatraz" and compare it with the picture of Burt Lancaster that we have in our subconscious. We can assess our fascination with the cinema and see how much the reality of these mug shots can still arouse our imaginations.

For this reason, you will not find any comments here on a smile, a look, or an expression shown on the photographed faces. These would mean nothing in any case, since according to the police officers I met in the course of my research, the moment when each of these photographs was taken was intensely stressful for the person being photographed; it was the moment of arrest, captured at $\frac{1}{125}$ second.

There is, therefore, no point in attempting to give a definitive interpretation of these pictures. Even so, look at them carefully. You will find that since 1880 there has been little variation in postures, expressions, and frames. Only occasionally is the face-on and profile mug shot routine interrupted by a full-length photo or a police line-up, mainly for American Mafia.

Similarly, the written details that accompany the photos are intended to report reality and give the facts without ever interpreting them. They are mostly taken from legal files, and they stick as closely as possible to the recorded facts. This is first and foremost a book of stories, not a history book.

—*Raynal Pellicer*

Insurrection 1871

Luitriller condamné à mort

Bénaud condamné à mort

Insurrection de 1871

Herpin Lacroix condamné à mort pour le meurtre des Généraux

Vité

incendiaire des Tuileries

E. APPERT, Phot. Expert. Depose. Reproduction interdite

In 1871, at the end of the reign of the Paris Commune, the Préfecture de Police de Paris (police headquarters in Paris) engaged a photographer to take portraits of the Communards in the prisons of Versailles. For the first time, posed photographs, sometimes full-length and all signed "Eugène Appert, painter and photographer, expert to the court of the Seine region" were added to the legal files of sentenced persons. On some photographs, specific details were given of names and sentences.

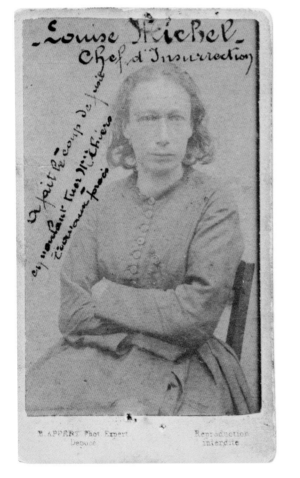

Opposite and above: Communards Lutrillier, Bénaud, Lacroix, Vité, and Michel, photographed by Eugène Appert

Alphonse Bertillon He joined the police headquarters in Paris as an assistant office clerk in 1879. In 1881 he devised a means of identifying habitual offenders by legal anthropometry, taking precise, codified measurements of all defendants. He also recorded eye and hair color and any distinguishing marks.

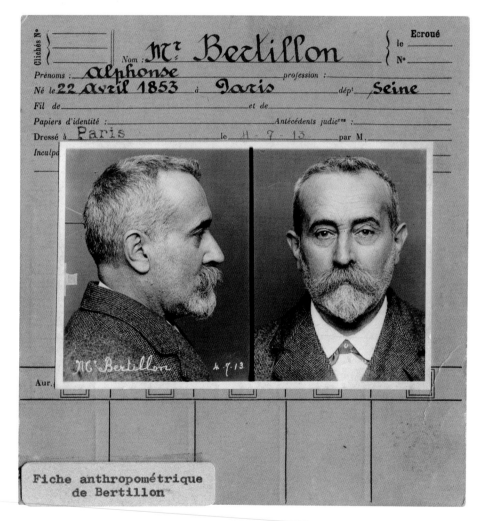

Fiche anthropométrique de Bertillon

In 1888, he completed his research system by inventing the full face and profile mug shot, standardizing lighting, scale, and angles. The Bertillon system, known in French as *bertillonnage,* was a triumphant success at the Paris Universal Exhibition in 1889 and was adopted in Europe, Russia, and the United States as the "Bertillon card." In 1893, Bertillon added details of anthropometric fingerprints.

Numéro 800

Nom **Lépine**

Prénoms *Louis* Surnoms

Né le _____ à _____ dép.

Fils de _____ *Préfet de Police*

Papiers d'identité _____ Profession _____

Antécédents judiciaires _____ Motif de la détention _____

Empreintes de _____ Empreintes de
L'INDEX GAUCHE ARRESTATIONS CONSTATÉES & RENSEIGNEMENTS DIVERS **L'INDEX GAUCHE**

Dressé au DÉPÔT à Paris

le _____

Auric

M^r Lépine Préfet de Police
11.11.09

*Louis Lépine, police
commissioner for the Seine
region, as he tried out the
bertillonnage system for
himself on November 11, 1909*

The work of **Cesare Lombroso** (1835–1909) was rooted in his many years of practice in the field of institutional psychiatry, from his time as the director of the insane asylum of Pesaro beginning in 1871 to his work at the office of the general inspector of all asylums in Italy's Piedmont region in 1906.

Following in the tradition of physiognomy, Lombroso studied the protuberances and asymmetries of the skull of a thief and arsonist—a certain Giuseppe Vitella—and went on to develop his famous theory on recognizable "atavistic stigmata." Linked to inherited biological abnormalities, the stigmata indicate predispositions, tendencies, and habits that were likely to lead to crimes and immoral behaviors. Lombroso was the first to lead the way to a transition from psychiatry to criminology, merging the two disciplines into a new science of which he was unquestionably the father: criminal anthropology.

Tirelessly measuring criminal indicators and traits, Lombroso founded the Museo Lombroso in Turin, published extensively, and did a great deal of scientific research. He succeeded in extending the criminalization of the "insane" to all sectors of society in which the "other" was identified: in intellectual pursuits (*Genius and Madness,* 1864); in the lives of lawbreakers (*Criminal Man,* 1876–97 and *Criminal Woman,* 1894); and in politics (*Political Murder,* 1894).

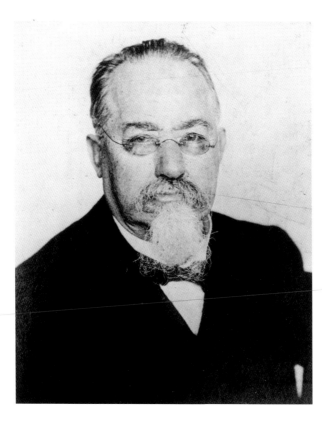

The Dreyfus Affair In October 1894, French Captain Alfred Dreyfus was accused of handing over secret documents to the Germans. The accusation was based on nothing more than handwriting analysis. Against the advice of other experts, Bertillon developed a theory whereby the accused had attempted to disguise his handwriting, and he concluded that Dreyfus was guilty.

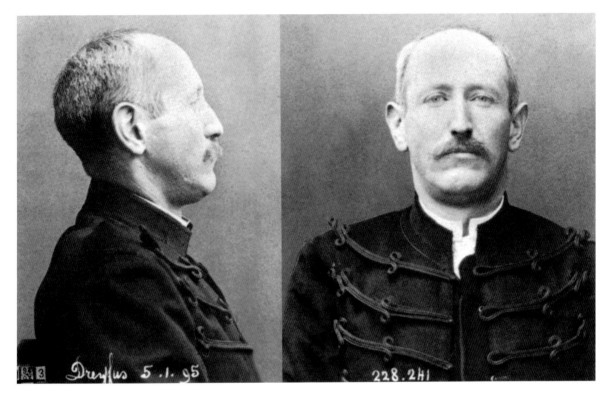

Above: Captain Alfred Dreyfus, photographed on January 5, 1895
Following spread: The French anarchist Ravachol

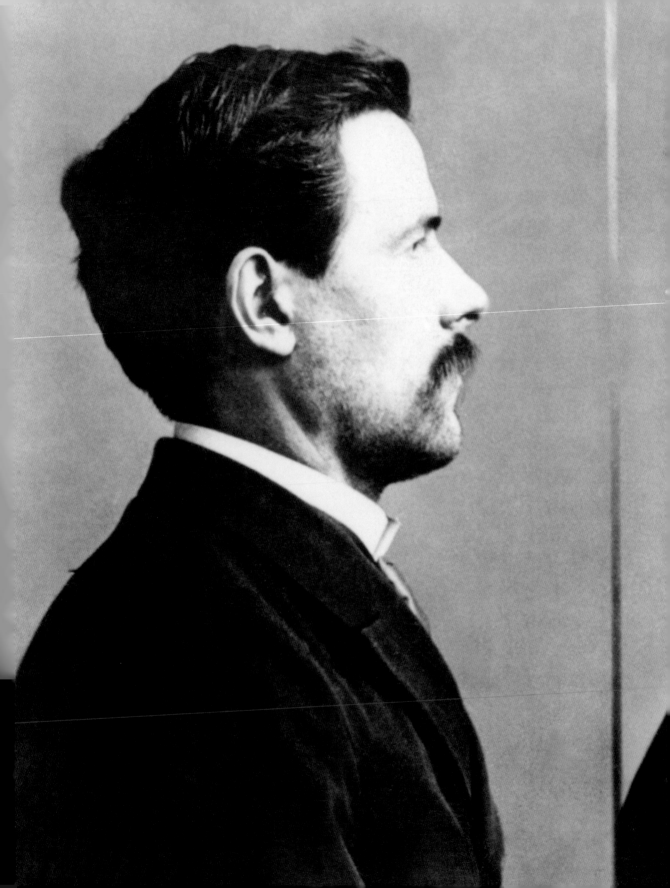

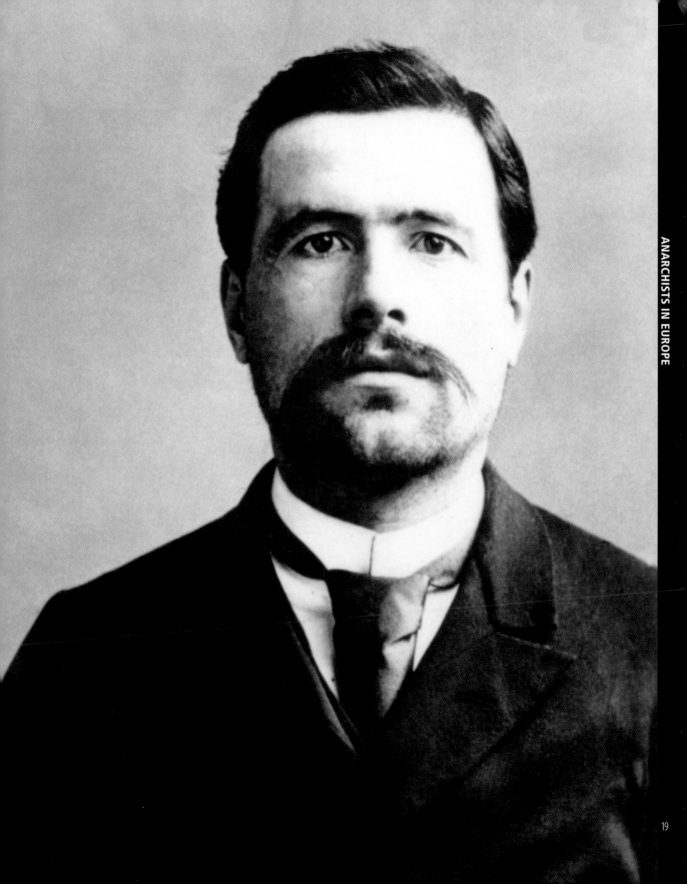

The anarchist movements of the late nineteenth century proclaimed the **"propaganda of the deed,"** a strategy that consists of spreading a doctrine not by words but by violence and acts of terrorism. Waves of attacks broke out in Europe, the United States, and Russia.

Anarchists in Europe

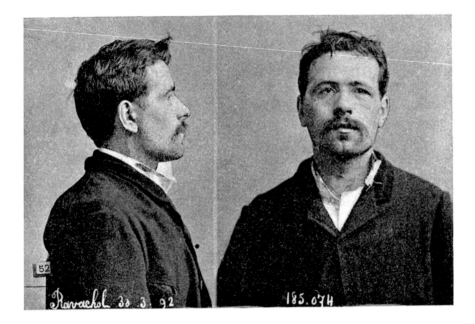

The French anarchist **Ravachol** was arrested on March 29, 1892. Accused of being responsible for a series of bomb attacks on Paris magistrates, he was sentenced to hard labor for life. Later, Alphonse Bertillon discovered that Ravachol's anthropometric details matched those of François Claudius Koenigstein (born 1859), who had been put on file two years earlier by the Saint-Étienne police and was wanted for five foul murders committed between 1886 and 1891. Retried under his real identity by the district court for the Loire region, he was sentenced to death and guillotined on July 11, 1892.

Émile Henry, alias Breton On February 12, 1894, the French anarchist Émile Henry carried out a bomb attack on the Café Terminus in Paris that killed one person and injured about 20. When he was arrested he also claimed responsibility for the attack on a police station that caused six deaths on November 8, 1892. He was sentenced to death and executed on May 21, 1894, at the age of 21.

Santo Caserio On June 24, 1894, in Lyon, France, the 20-year-old Italian anarchist Santo Caserio fatally stabbed the president of France, Marie François Sadi Carnot. He was sentenced on August 3 and guillotined 13 days later. With the assassination of Sadi Carnot, the wave of anarchist attacks in France had reached its peak.

On September 10, 1898, in Switzerland, the French-Italian anarchist **Luigi (Louis) Lucheni** assassinated Empress Elisabeth of Austria, who was known as Sissi. He believed that he had struck at a "symbol of the nobility which insults and persecutes the working class." Sentenced to life imprisonment at the age of 25, Lucheni committed suicide by hanging himself in his cell on October 19, 1910.

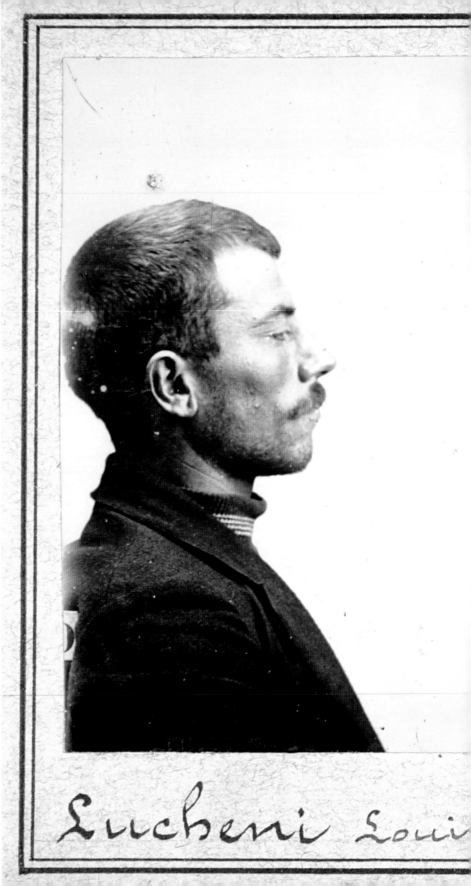

Lucheni Loui

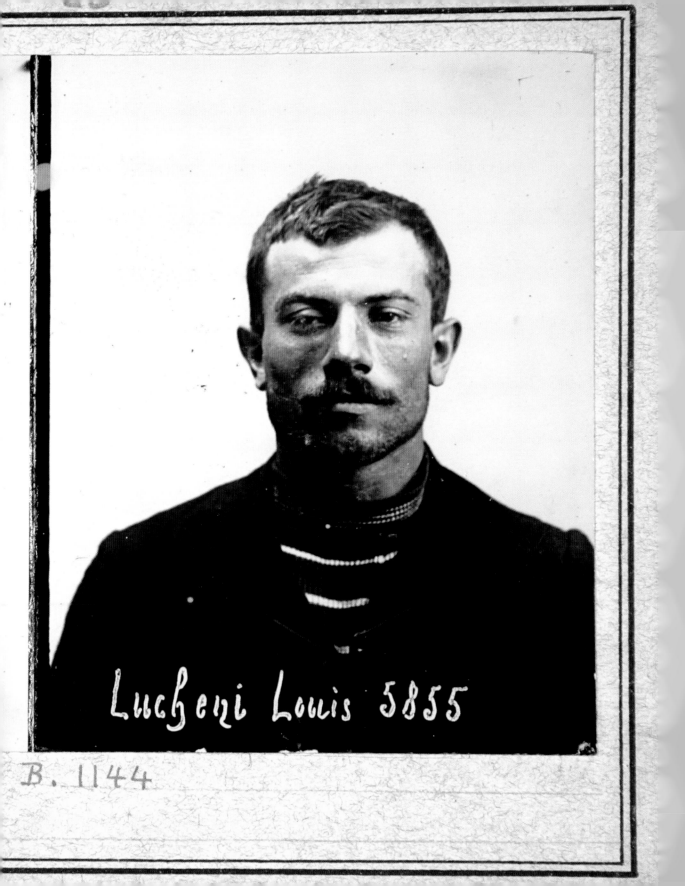

Lucheni Louis 5855

B. 1144

Benito Mussolini On June 19, 1903, a 20-year-old immigrant Italian worker called Benito Mussolini was arrested in Bern for vagrancy. The future Il Duce was also suspected of inciting Italian workers to go on strike and revolt. The Swiss Public Ministry put him on file as an "anarchist" and on June 30, 1903, deported him from Switzerland.

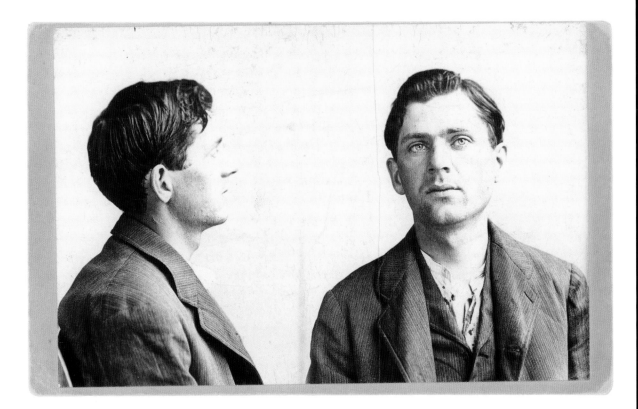

Anarchists in America

Leon Czolgosz, the American anarchist of Polish origin (born 1873), shot twice at William McKinley, the twenty-fifth president of the United States, on September 6, 1901. Czolgosz described himself as an "individual anarchist" and declared that he had shot "an enemy of the working class." McKinley died of his wounds on September 14. Czolgosz was sentenced to death on September 26 and executed by electric chair on October 29, 1901, in Auburn Prison, New York.

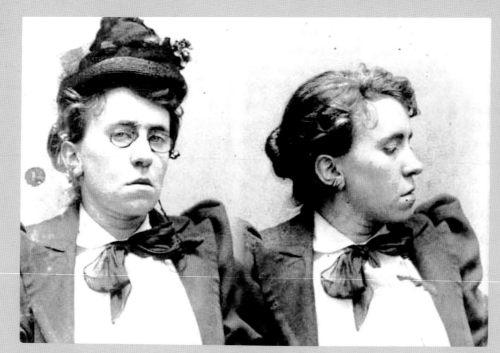

August 1893

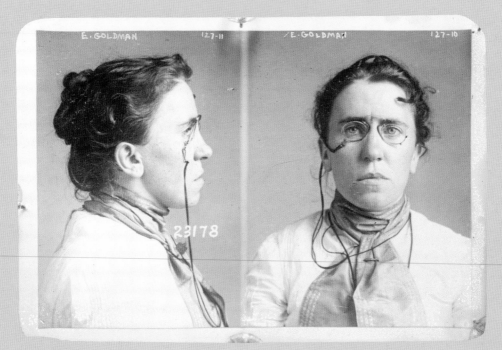

September 1901

Emma Goldman An emblematic figure in American anarchism, Goldman was arrested on August 31, 1893, in New York for incitement to revolt.

Ask for work. If they do not give you work, ask for bread. If they do not give you bread, take bread.

On September 10, 1901, following the assassination of McKinley, Emma Goldman was arrested and accused of being part of the conspiracy. On the subject of Czolgosz she declared: "Am I responsible for a madman who misinterpreted my words?"

In 1917, the year in which the United States entered the war on Germany, Emma Goldman called on Americans to refuse the draft. On July 9, 1917, she was arrested and tried in accordance with the Espionage Act by the New York Tribunal. She was sentenced to two years of imprisonment, and then deported to Russia in 1919.

Emma Goldman, photographed on Ellis Island during her deportation to Russia in 1919

Sacco and Vanzetti In 1919, following an unprecedented series of anarchist attacks, the United States took a dive into the "Red Scare" syndrome. Under the authority of the Minister of Justice, Attorney General Alexander Mitchell Palmer, who himself had been the target of an attack, hundreds of political extremists of foreign origin were deported. It was in this political context that the Sacco and Vanzetti affair broke out.

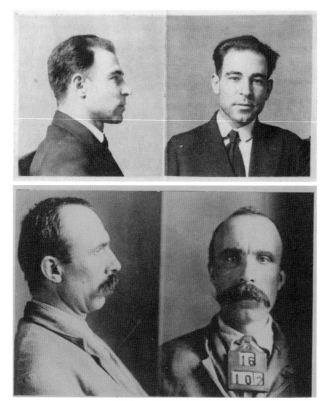

On April 15, 1920, in South Braintree, Massachusetts, the cashier of a shoe factory and his guard were killed during the course of a hold-up in which the workers' wages were stolen. On May 5, two anarchists of Italian origin were arrested in a tram in Brockton, Massachusetts, for possession of prohibited weapons. Accused of having committed the hold-up, they were sentenced to death on July 14, 1921, despite the absence of material evidence. Following a long appeal procedure, on August 23, 1927, six years after their sentence, **Nicola Sacco** (top) and **Bartolomeo Vanzetti** (bottom) were executed by electric chair in the prison at Charlestown, Massachusetts. The death sentence passed on Sacco and Vanzetti led to mass demonstrations across the world. Fifty years later, on August 23, 1977, the governor of Massachusetts, Michael S. Dukakis, absolved the two men, declaring that "any stigma and disgrace should be forever removed from the names of Nicola Sacco and Bartolomeo Vanzetti."

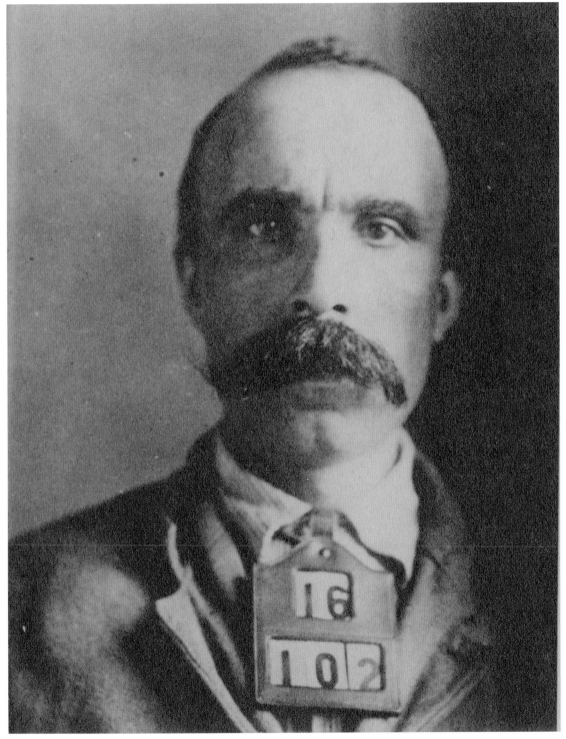

Bartolomeo Vanzetti (born 1888, in Villafalletto, Italy)

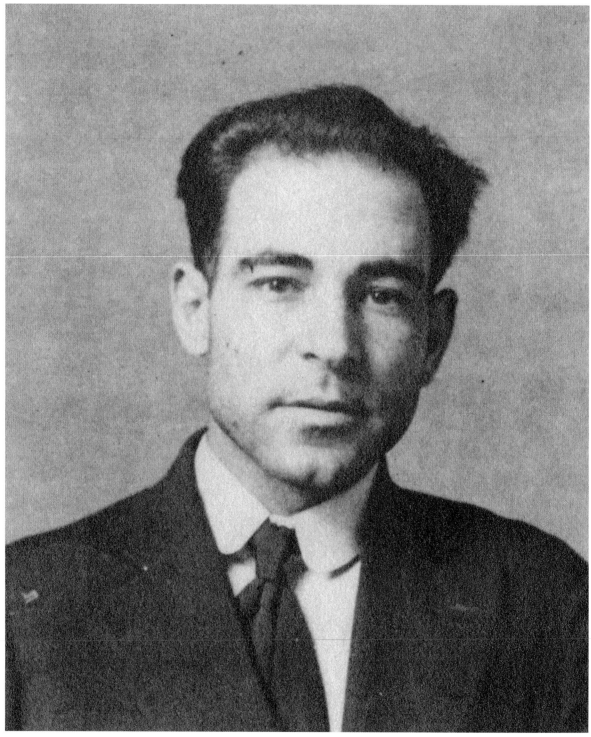

Nicola Sacco (born 1891, in Torre Maggiore, Italy)

Luigi Galleani In 1913, Nicola Sacco helped to organize many anarchist meetings, and during this time he met Luigi Galleani, a major figure in Italian-American anarchism. As the founder and editor in chief of the newspaper *Cronaca Sovversiva* (Subversive Chronicle), Galleani campaigned for the "propaganda of the deed" and direct action. He was extradited to Italy in 1919, and in 1922 he was sentenced by the district court for Turin to 14 months of imprisonment for "violation of the press laws." In November 1926 he was arrested again and sentenced to nine months in prison for an "insult to Il Duce."

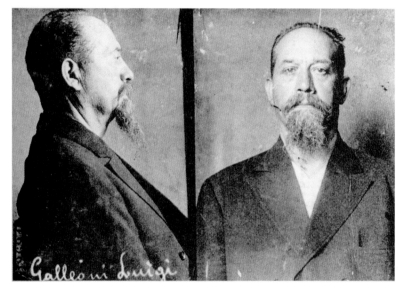

Lenin Born Vladimir Ilitch Oulianov in 1870, Lenin is regarded as the real father of the Russian Revolution. He was arrested by the Czar's police on December 7, 1895, in St. Petersburg and incarcerated by the authorities for 14 months before being sent into Siberian exile for three years.

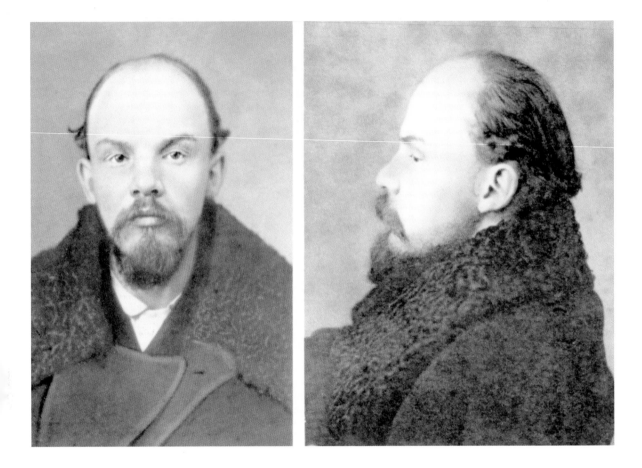

Released in January 1900, he left Russia and took refuge in Switzerland. He adopted the pseudonym Lenin for the first time in December 1901. The failure of the 1905 Russian Revolution forced him once more into a long period of exile. He returned to Petrograd in 1917 after the abdication of Czar Nicholas II. He was in power until 1922, and he died on January 21, 1924.

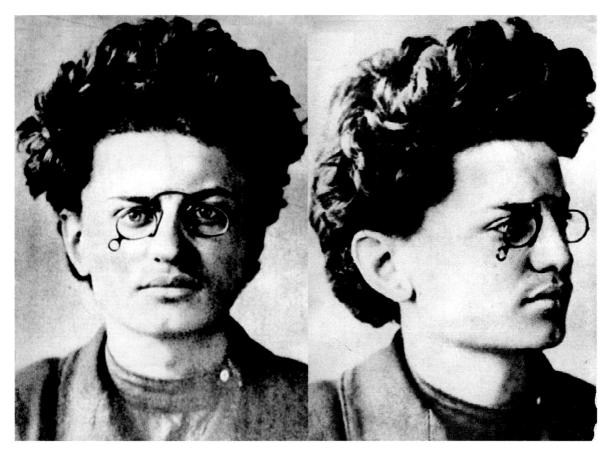

Leon Trotsky Born Lev Davidovich Bronstein in 1879 in the Ukraine, Trotsky was a Russian Jewish intellectual; he became a member of the Social Democrat Workers' Party in 1896.

He was arrested by the Czar's police in 1898, then deported to Siberia in 1900. After escaping in 1902, he adopted the name Trotsky and took refuge in England. He returned to Russia and took part in the 1905 uprisings. Once again he was arrested and sentenced to exile for life in Siberia. He escaped in 1907 and went back to England, then returned to Russia in 1917 at the time of the Revolution, as Lenin's chief collaborator. He became Commissioner for Foreign Affairs and served as Commissioner of War during the civil war, when he created the Red Army. Upon Lenin's death he was expelled from the party because of his opposition to Stalin, and then in 1929, he was deported from the USSR. In 1940, Trotsky was assassinated in Mexico by one of Stalin's agents.

Stalin The Soviet leader was born Josef Vissarionovich Dzhugashvili in 1879.

In 1902 Stalin was a member of the Social Democrat Workers' Party, and on April 5 of that year he was arrested during a political meeting. After being incarcerated until April 19, 1903, in the prison at Batum on the shores of the Black Sea, he was exiled to eastern Siberia, from where he escaped on January 5, 1904. On March 25, 1908, he was arrested in Baku under the name of Gaioz Nizharadze. Sentenced to three years of exile in Solvychegodsk (Vologda), he escaped on June 24, 1909, and returned to Saint Petersburg. On March 23, 1910, he was arrested, this time under the name Zakhar Grigoryan Melikyants, and imprisoned in Baku, then once again exiled. In June 1911 he was freed at the end of his sentence, then barred from residence in the Caucasus and arrested again on September 9, 1911, in Saint Petersburg. He was exiled to Vologda for three years under police surveillance, but managed to escape on February 29, 1912. In April he was arrested in Saint Petersburg and sentenced to three years' exile in Narym, under police surveillance. Once again he escaped, in September the same year. On February 23, 1913, he was questioned during a concert organized by the Bolshevik group in Saint Petersburg. This time he was exiled to the north of the Arctic Circle and placed under closer police surveillance. Released in March 1917, Stalin returned to the Northern Capital of Russia, then called Petrograd. He succeeded Lenin in 1922, and he remained leader of the Soviet Union until his death in 1953.

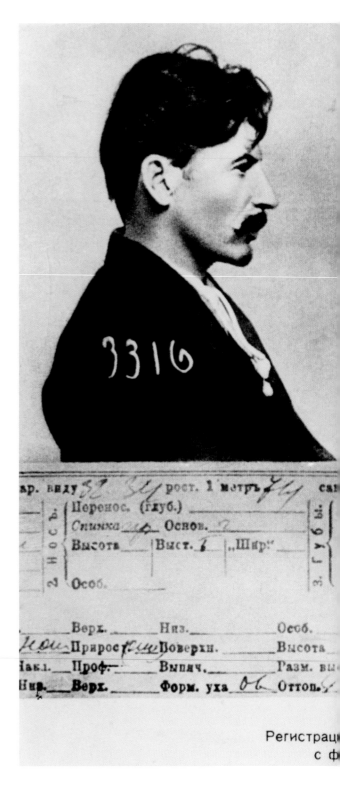

Saint Petersburg Police Department registration card for J. V. Stalin

ная карточка петербургского охранного отделения
графическим снимком И. В. Сталина. (Фото)

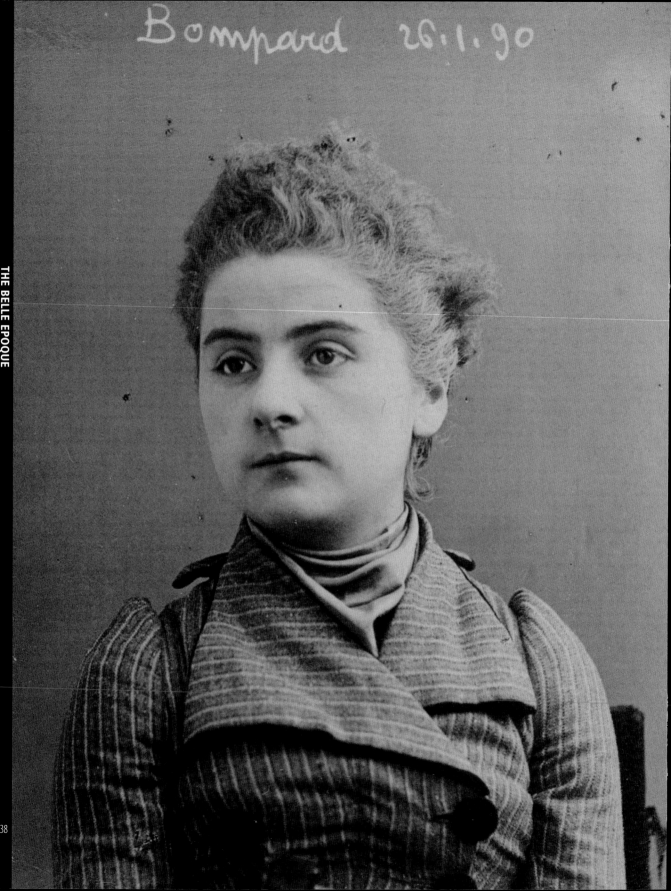

Bompard 26.1.90

"The Bloody Trunk" On July 26, 1889, a Parisian bailiff, Maître Toussaint-Auguste Gouffé, was murdered. His body was shut in a trunk and abandoned at Millery near Lyon, France.

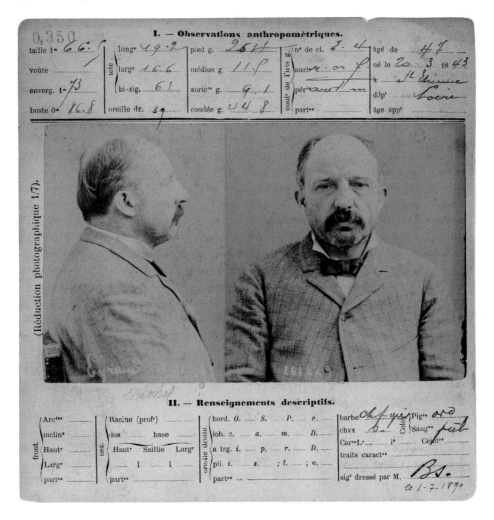

At the beginning of 1890, the guilty parties were arrested: **Michel Eyraud** (above), a 46-year-old ruined industrialist, and his mistress, **Gabrielle Bompard** (opposite), a 20-year-old prostitute. They admitted to having murdered the bailiff in order to gain possession of his fortune. This criminal case, known as "Gouffé's trunk" or "the bloody trunk," was one of the leading news stories of the late nineteenth century. Eyraud was sentenced to death and executed on January 3, 1891. Gabrielle Bompard was sentenced to 20 years of hard labor and released in 1903.

"Casque d'or" French Amélie Hélie was known as "Casque d'or" (the Golden Helmet) or "Hélène de Troie du pavé" (Helen of Troy of the Streets). In 1898, at the age of 19, she was a prostitute in the Charonne district of Paris. She lived with Joseph Pleigneur, known as "Manda de La Courtille" or "l'Homme" (The Man), a 22-year-old pimp and leader of the "Orteaux" gang. Three years later, in December 1901, she left him for Leca, a Corsican pimp and leader of the "Popinc" gang, proclaimed "the king of the Belleville Apaches."

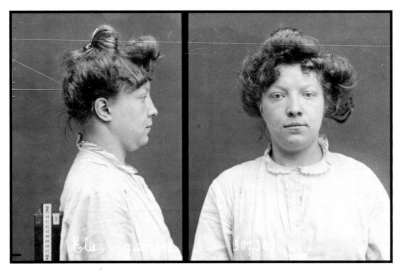

The jilted lover **Joseph "Manda" Pleigneur** (following spread) wanted to take bloody revenge on his successor, **Félix Leca** (following spread). There followed a succession of violent confrontations between the two gangs, armed with clubs, knives, axes, and pistols. The tabloid press seized on the story and compared the two clans to Apaches fighting in the middle of Paris over "a blonde with her hair in a high bun, done like a dog's!" The legend of "the Golden Helmet" was born. She sang in several cabarets, and her photo was on the front page of the newspapers. She was "the famous gigolette." In March 1902, after further violent clashes, the two gang leaders were arrested and given heavy sentences: for Manda, hard labor for life, and for Leca, eight years of the same punishment and exile from France. Both men were sent to the penal colony in French Guiana, from where they never returned. Amélie Hélie died in oblivion in 1933. In 1952 her character was immortalized in Jacques Becker's film *The Golden Helmet*, starring Simone Signoret.

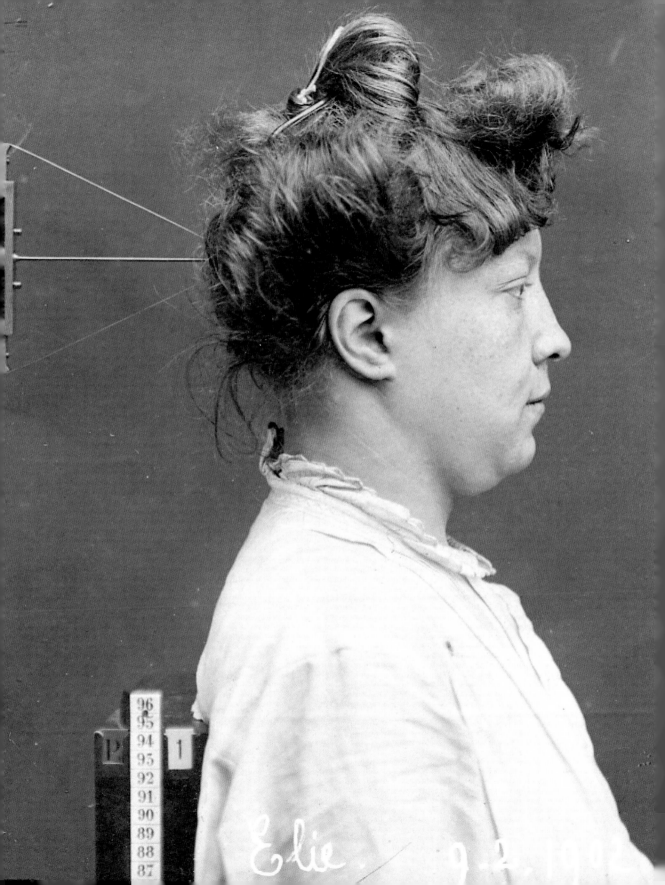

Elie

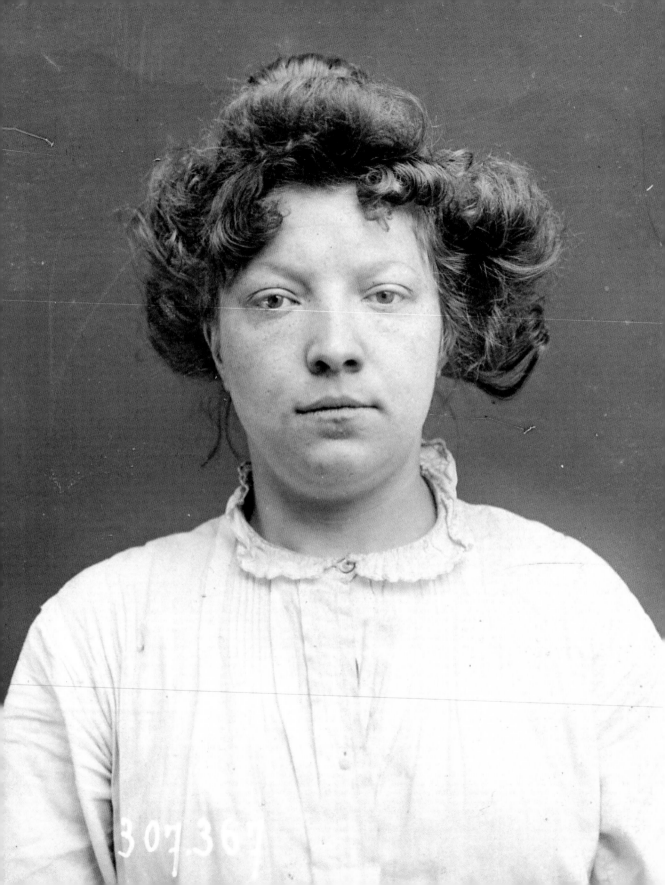
307367

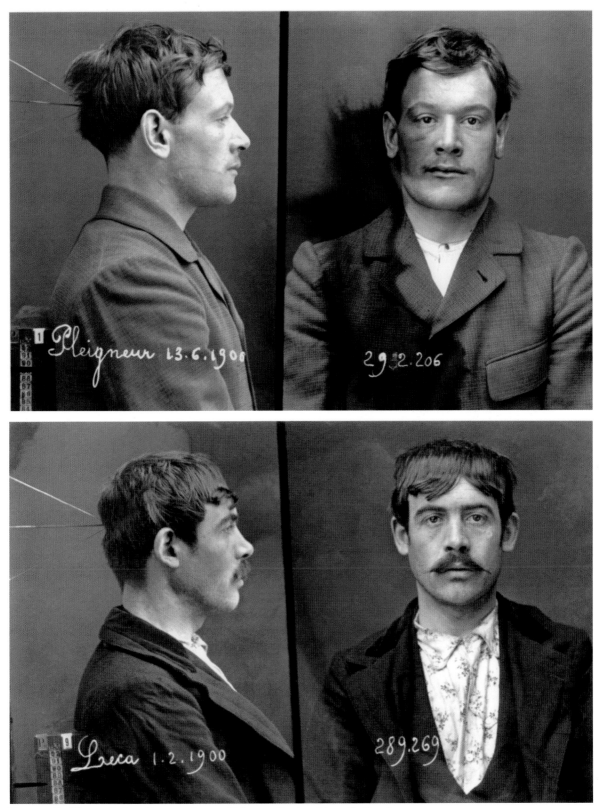

"Casque d'or" (opposite) and her two lovers, Pleigneur (top) and Leca (bottom)

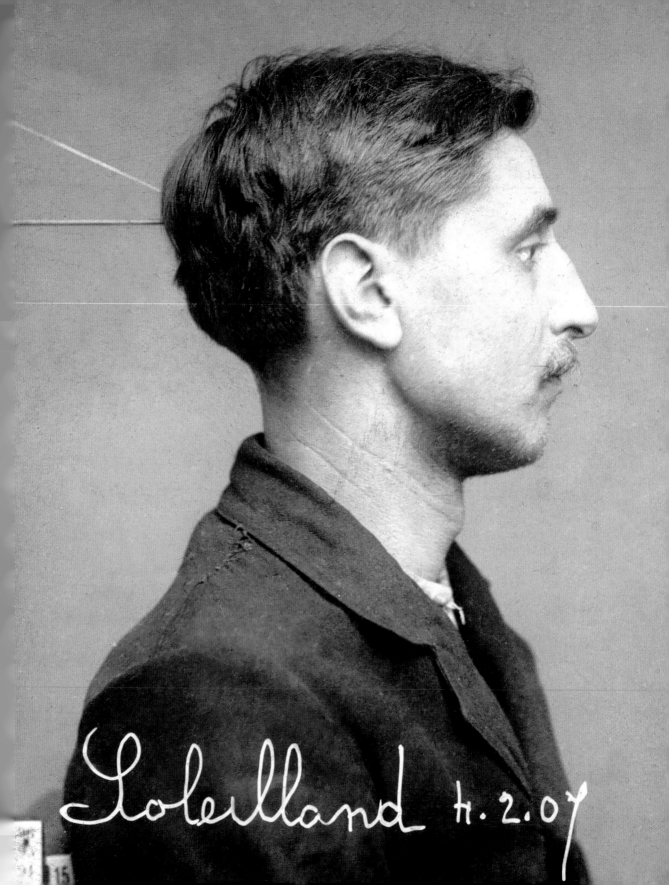

Soleilland 4. 2. 07

The Soleilland Case On January 27, 1907, in Paris, Albert Soleilland raped and murdered his neighbors' 11-year-old daughter, Marthe Eberling. The victim's dismembered body was found in a checkroom at the Gare de l'Est. Soleilland was sentenced to death by the district court, but the presiding judge, the abolitionist Armand Fallières, commuted the sentence to hard labor for life. The press denounced the laxness of French institutions. *Petit Parisien,* the most popular newspaper of the time, organized a readers poll; there were 1,400,000 responses, 75 percent of which were in favor of the death penalty. On December 8, 1908, the bill to abolish the death penalty was debated in the Assemblée Nationale and rejected by 330 votes to 201. Albert Soleilland died in the French Guiana penal colony in 1920, at the age of 39.

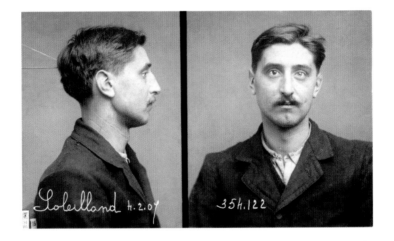

Maria Nikolaevna O'Rourke (spelled phonetically, in Russian: Orurk) was born into a noble family in Poltava, Ukraine, on June 9, 1877. She was married to Count Vasily Tarnovsky while still in her teens. The couple divorced after just a few years. Her lust for money and power drove her to seduce Count Pavel Kamarovsky. She persuaded the count to take out a life insurance policy naming her as beneficiary. The value of the policy was half a million rubles, a staggering sum at the time. Then she managed to make a young man named Nikolai Naumov fall in love with her, and convinced him that she was being persecuted by Count Kamarovsky.

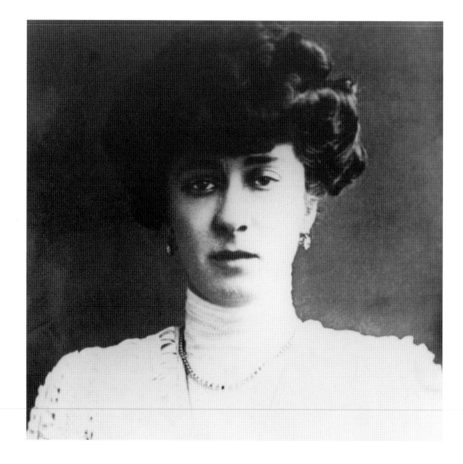

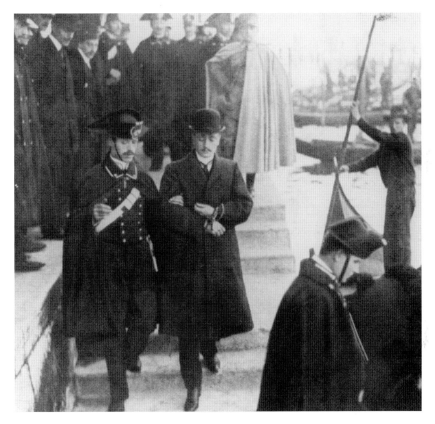

Nicholas Naumov being taken to jail by the Carabinieri in Venice, 1910

On September 4, 1907, Naumov killed Kamarovsky. Before dying, however, the count managed to explain to his killer the trap into which he had fallen. Horrified at the realization of what he had done, Naumov found the courage to go to the police and confess his crime.

During a trial held before the Criminal Court of Venice, beginning on March 4, 1910, Maria Tarnovskaya and Nikolai Naumov were found to be mentally ill. Maria Tarnovskaya was sentenced to prison for eight years and four months; the killer himself got off with a sentence of just three years and one month. Maria Nikolaevna Tarnovskaya née O'Rourke died on January 23, 1949, in Santa Fe, Argentina, forgotten and alone.

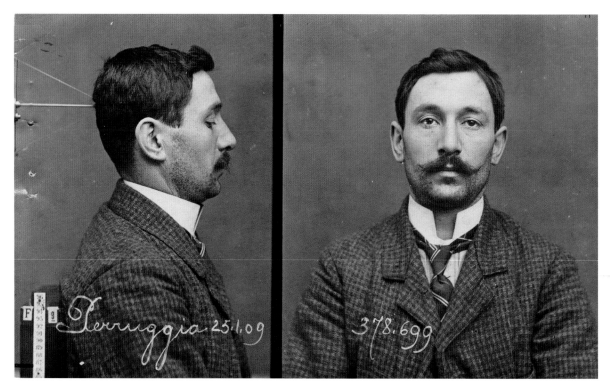

The Theft of the *Mona Lisa* On August 21, 1911, the *Mona Lisa* was stolen from the Louvre by **Vincenzo Perruggia**, an Italian painter. Arrested in Florence in December 1913 as he was trying to sell the painting to an antique dealer, Perruggia claimed that he had acted for patriotic reasons, with the intention of restoring Leonardo da Vinci's painting to Italy. He was sentenced to one year in prison.

The Bonnot Gang

In 1911, a group of French anarchists and "illegalists" took crime to new levels and used automobiles to carry out numerous hold-ups.

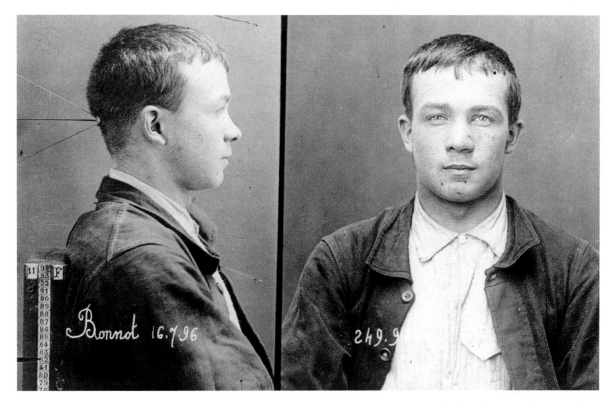

On December 21, on rue Ordener in Paris, **Jules Bonnot** attacked two security guards from the Société Générale bank with three accomplices: Octave Garnier, Eugène Dieudonné, and Raymond Callemin. Garnier shot down one guard in cold blood. The Bonnot gang arranged their getaway in a stolen Delaunay-Belleville limousine with nothing to show for the robbery except some bearer bonds and 5,000 francs in cash. For the first time, a car had been used in a hold-up. It became headline news. The "auto-gang" went on to commit a string of fatal shootings: seven deaths in less than five months. On April 28, Bonnot was cornered in a garage at Choisy-le-Roi, south of Paris. On the orders of Police Commissioner Louis Lépine, the police set siege. Two brigades of the Garde Républicaine were called in as reinforcements. Thousands of people turned out to watch the "show." After several attempts to storm the garage, the order was given to blow it up with dynamite. When the policemen finally entered the building, the gang members René Vallet and Octave Garnier were dead, but Bonnot was rolled up in a mattress, shooting at the police with his revolver. He was fatally wounded. An autopsy revealed that there were 11 bullets in his body. That was the end of the Bonnot gang.

Following spread: **Jules Bonnot, photographed on March 4, 1912—anthropometric card on file for Jules Joseph Bonnot:** Age 35, born October 14, 1876, at Pont-de-Roide (Doubs [France]), son of Joseph and Hermance Monotot; metal worker and mechanic, no fixed address. Height 5'3" (1.59 m), eyes pale yellow on mauve background, hair dark blond, beard light auburn. Eyes only half open, scar in right ear, jaw prominent, especially the lower one [sic]. Hair possibly dyed. Responsible for the murder in 1911 of one of his accomplices, Giuseppe Platano.

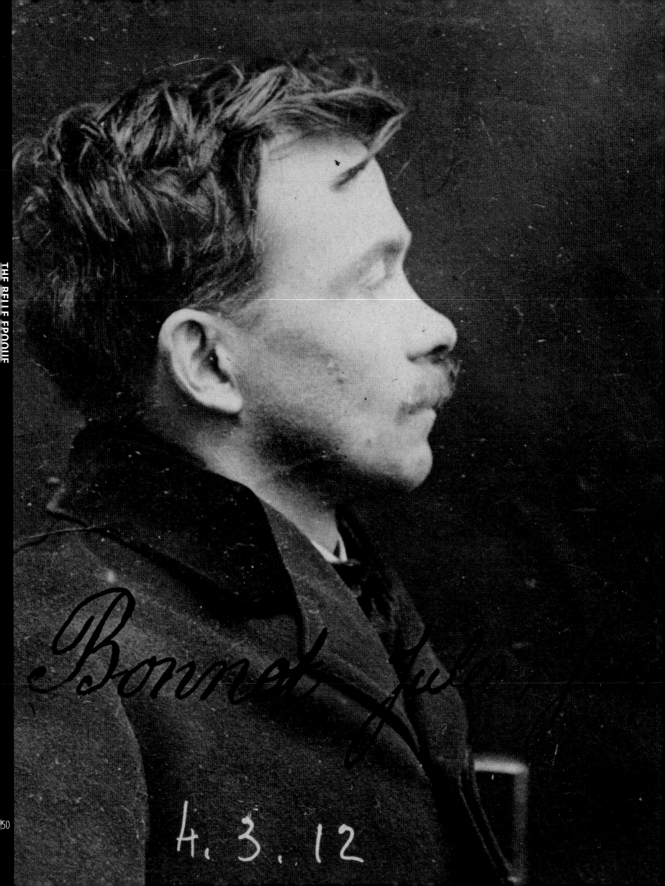

50

Bonnot Jules

A. 3. 12

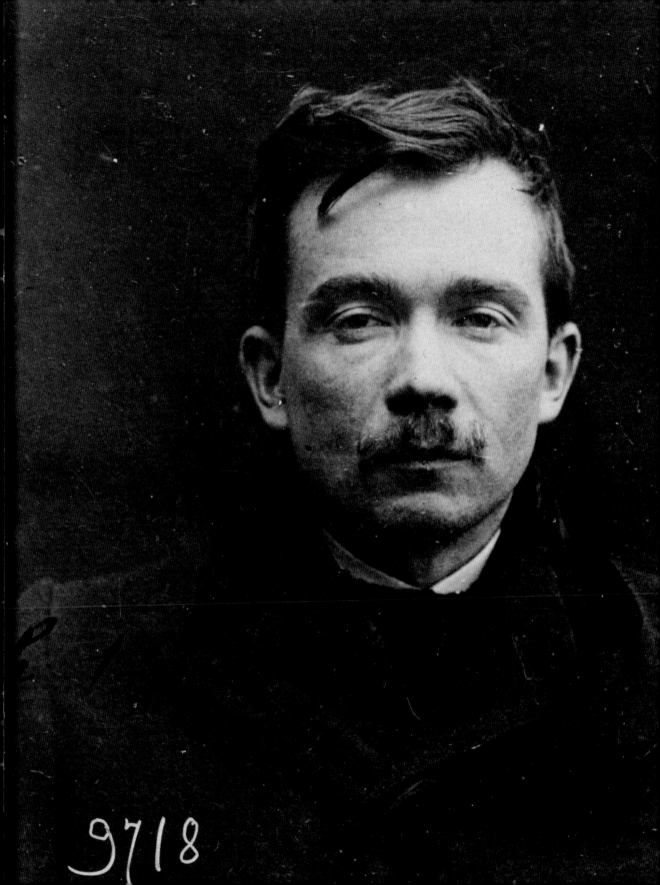

9718

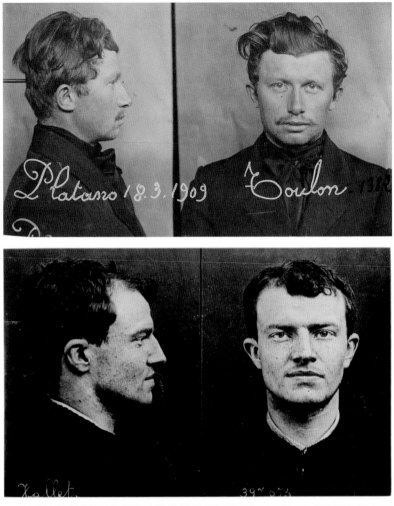

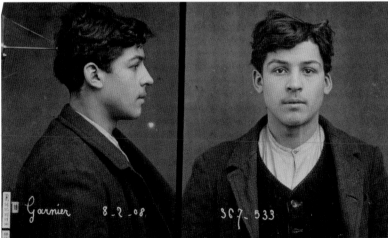

René Vallet (center) and Octave Garnier (bottom), known as "le Terrassier" (The Digger), both killed on May 15, 1912, when the police and army raided their safe house

February 27, 1913, saw the end of the trial of the surviving members of the Bonnot gang: Raymond Callemin (age 23), known as "Raymond la Science," André Soudy (age 21), known as "Pas de chance" (No Luck), and **Antoine Monier** (age 24), known as "Simentoff." They were sentenced to death and guillotined on April 21, 1913.

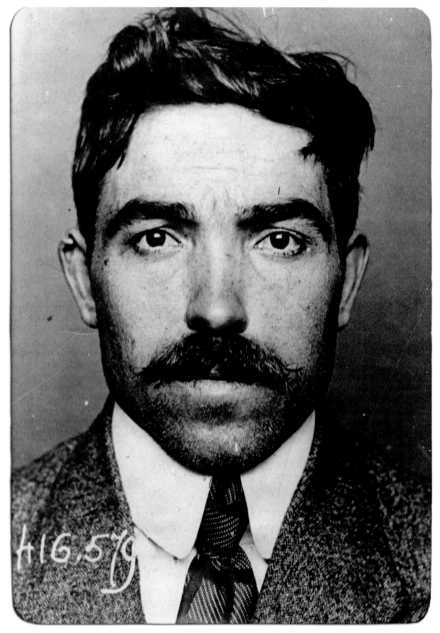

Wanted card on file for Antoine Monier, aliases "Simentoff" and "Étienne:"
Height 5'7" (1.72 m), hair dark brown, very arched dark brown eyebrows, small dark mustache turned up at the ends, gray eyes, matte complexion, medium build. Often dressed in a gray suit with black stripes, or a navy blue suit, with long gray overcoat. All his clothes are very well cut, wears a bowler hat or car driver's cap. Very well-groomed. Wears perfume.

Following two spreads:
Mug shot of Raymond Callemin,
followed by his fingerprints

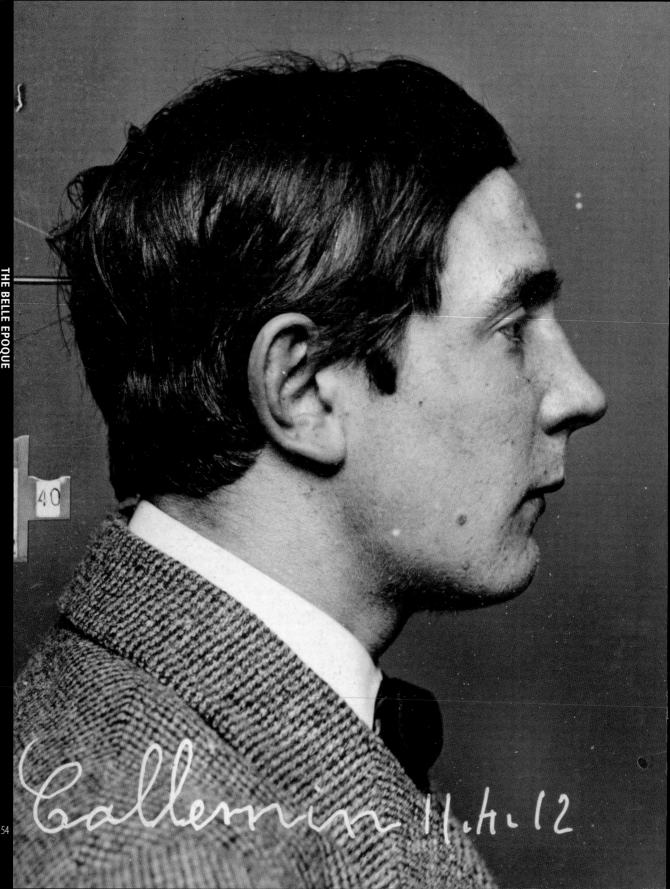

40

Callemin 11.4.12

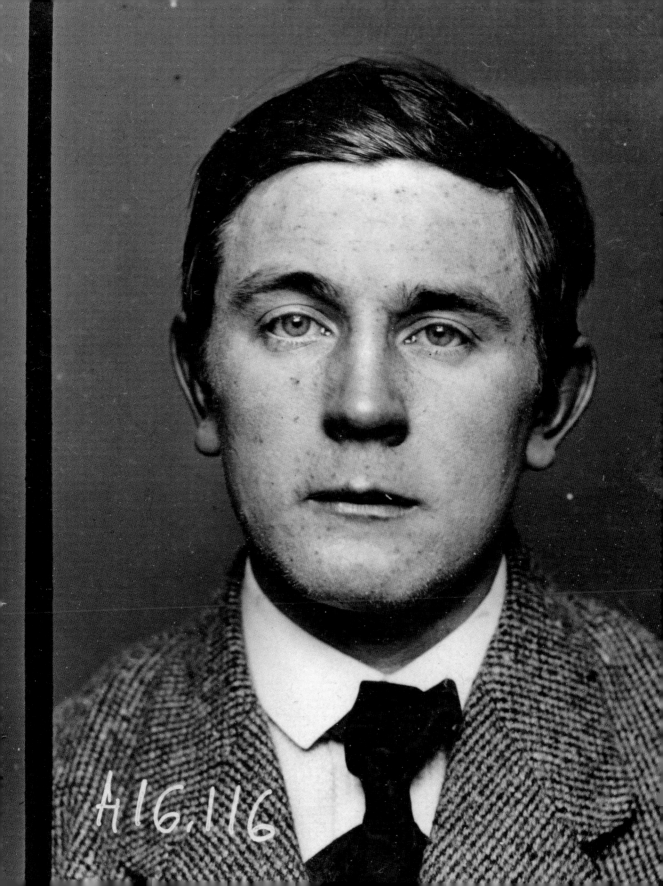

A16.116

main d

main J

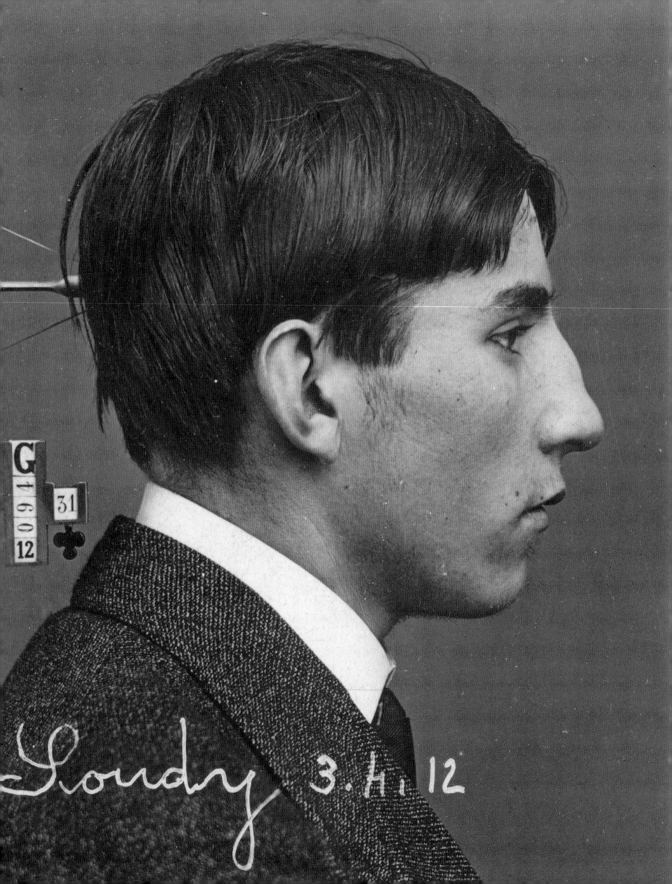

Soudry 3.4.12

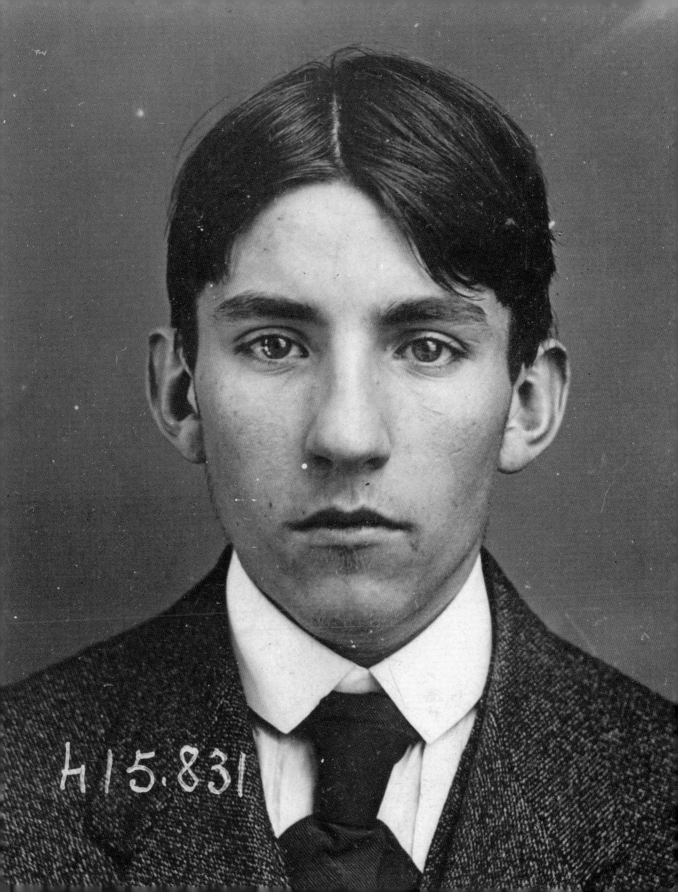
H15.831

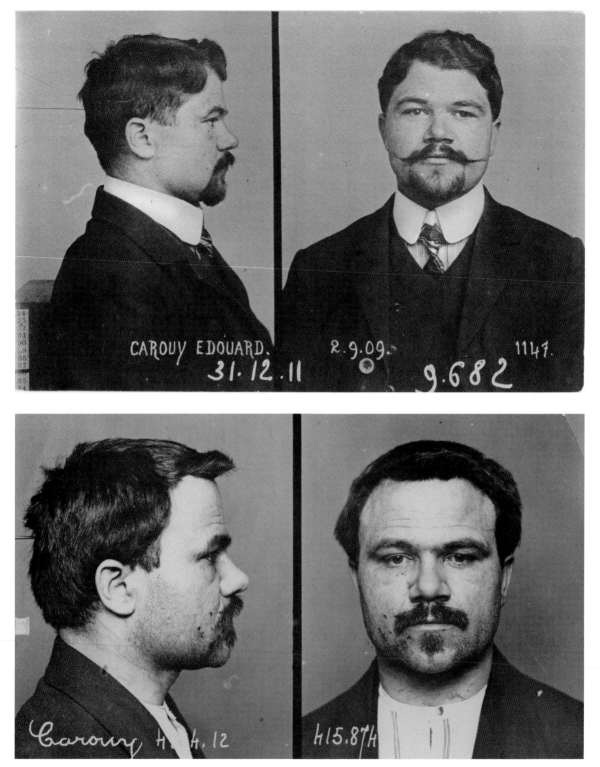

CAROUY EDOUARD. 2.9.09. 1141.
31.12.11 9.682

Carouy H.H. 12 415.874

Above: Photographed when he was arrested both in 1909 and 1912, Édouard Carouy, aliases "Leblanc" and "Raoul Édouard," was born in 1883. He was sentenced to hard labor for life, but the following day committed suicide in prison.

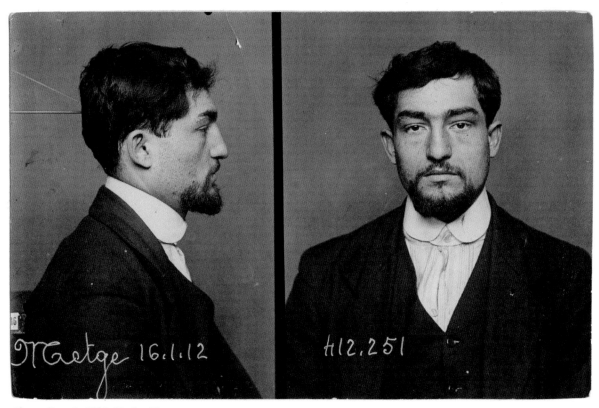

*Above: Born in 1890, Marius Metge was
sentenced to hard labor for life. Released
from the penal colony in 1931, he died of a
fever in Cayenne, French Guiana, in 1933.*

*Following spread: Eugène Dieudonné, photographed on December 2,
1929, was sentenced to death but, exonerated by his accomplices,
his sentence was commuted to hard labor for life. Sent to the penal
colony in Cayenne, he made several attempts to escape and finally
succeeded on December 6, 1926. He was pardoned in 1927 following
a campaign by Albert Londres, a French journalist and fierce
critic of forced labor. In 1930 Dieudonné wrote La Vie des Forçats
(The Life of Convicts). He died in Paris in 1944 at the age of 60.*

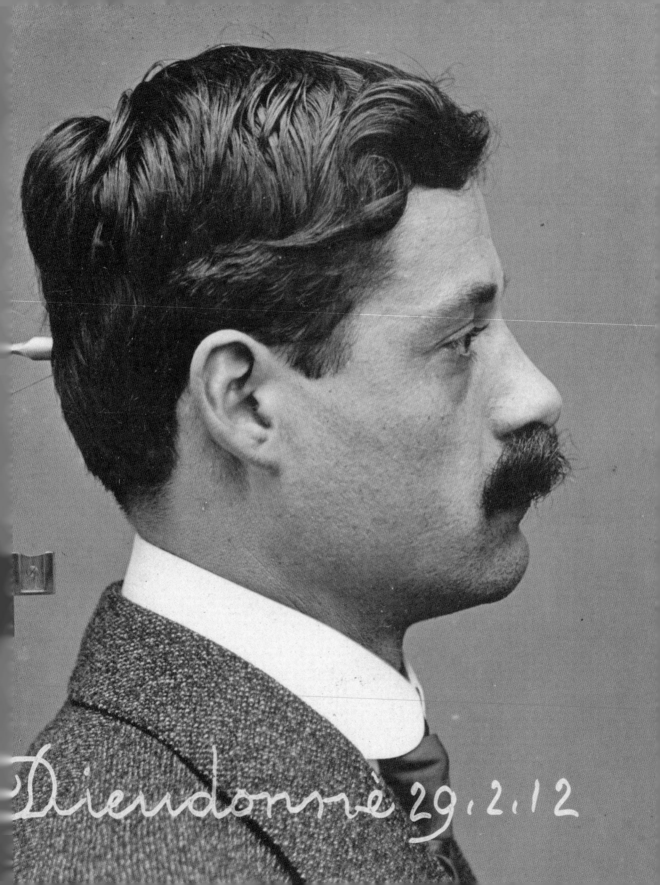

Dieudonné 29.2.12

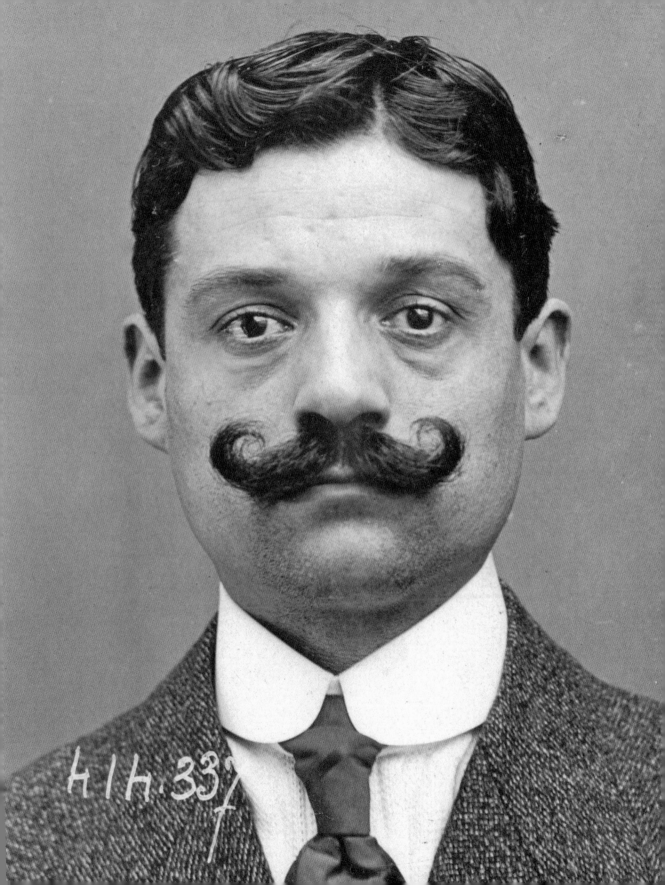

On July 31, 1914, in the Café du Croissant, 146 rue Montmartre in Paris, **Raoul Villain** assassinated Jean Jaurès, the socialist representative and founder-editor of the newspaper *L'Humanité,* with two shots from his revolver.

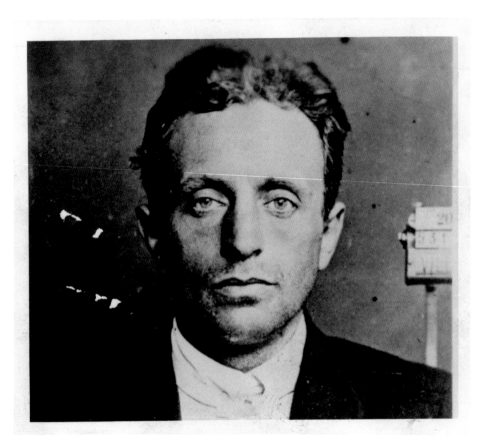

Extract from the interrogation of Raoul Villain on July 31, 1914, at the police station in the precinct of Mail in Paris:

Q: "Your civil status?"

A: "I refuse to answer any of your questions concerning my identity or place of residence. All I will tell you is that I admit that on that evening, in the Café du Croissant at 146 rue Montmartre, I saw, from the rue Montmartre where I was, Monsieur Jaurès sitting at a table with six or eight people. With my left hand, I lifted the half-curtain and fired two revolver shots at Monsieur Jaurès, who had his back turned to me. I committed this act because Monsieur Jaurès has betrayed his country by conducting his campaign against the three-year law. I believe that traitors should be punished and that one can give one's life for such a cause [sic]. I have a deep sense of duty accomplished [sic]. I have nothing to add to the preceding."

He then refused to sign after his statement had been read out to him.

The Police Commissary
Signed Gaubert

Numéro { 448.037 / 551358 }

Nom *Villain*

Prénoms Raoul Marie Alexandre Surnoms

Né le 19 Septembre 1885 à Reims dép. Marne

Fils de Louis Marie Gustave et de Marie Adèle Collery

Papiers d'identité Sf. Profession élève à l'École du Louvre

Antécédents judiciaires ge. Motif de la détention assassinat de Mr Jaurès dans un café de la rue du "Croissant"

Empreintes de
L'INDEX GAUCHE

ARRESTATIONS CONSTATÉES & RENSEIGNEMENTS DIVERS

Empreintes de
L'INDEX GAUCHE

Dressé au DÉPOT à Paris

le **1-8-14**

par M. Ruby

VRP CE JOUR Bonavita

20.7.20 IDF audien
trafic de monnaies mat.ᵉˢ
cor: z puis Alexandre Marie
(arrêté à Montreuil)
PHOTO CE JOUR

Auriculaire g.	Annulaire g.	Médius g.	Index g.	Pouce g.

C. Bourgoin

While waiting for his trial, Villain was incarcerated throughout the First World War and finally acquitted on March 29, 1919. Madame Louise Jaurès, who was associated with the case as a private party, was made to pay costs. Raoul Villain left France for the Balearic Islands, Spain, where he was executed by the Republicans during the Spanish Civil War on September 15, 1936.

The day after Jean Jaurès was assassinated (see page 64), a decree went out in France announcing general mobilization. On August 3, 1914, Germany declared war. The First World War marked the end of the Belle Epoque.

Mata Hari Margaretha Geertruida Zelle, known as "Mata Hari," was a dancer of great charm, born in the Netherlands on August 7, 1876. In 1905, she performed in Paris disguised as a Javanese princess. From 1906 on, her fame spread beyond France; she danced in Madrid, Monte Carlo, Berlin, Vienna, Rome. . . . In 1916, she agreed to work for Captain Georges Ledoux, head of the French espionage and counter-espionage service. She was arrested on February 1, 1917, accused of being a double agent in the service of Germany, identified under the code name H21. Incarcerated in the Saint-Lazare women's prison in Paris, she admitted to having been contacted by the German secret service but denied having provided them with secret information. She was found guilty of secret dealings with the enemy, sentenced to death, and executed by firing squad at the Caserne de Vincennes in Parisian suburbia on October 15, 1917. In the 1950s, archive documents were published that showed that Mata Hari had indeed worked for the German secret service. It was made clear, however, that she had never handed over any important information.

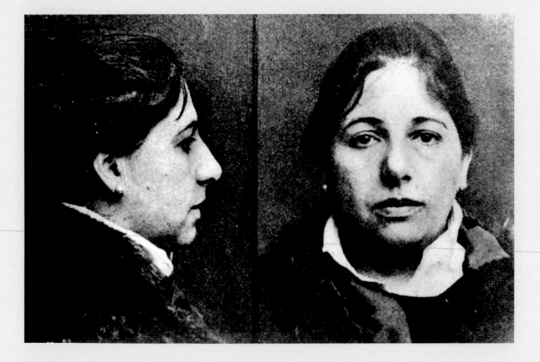

Despite the parliamentary debates in 1908 about the abolition of the death penalty, and in breach of social justice, other women were tried and sentenced to death for espionage and secret dealings with the enemy.

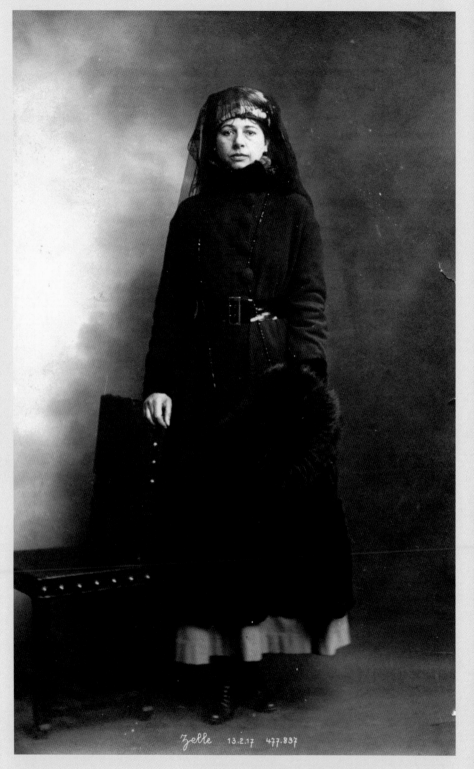

Right: Margaretha Geertruida Zelle, known as "Mata Hari," photographed on February 13, 1917

Following spread: Ottilie Voss, a German spy executed by firing squad on May 16, 1915, at Bourges, France

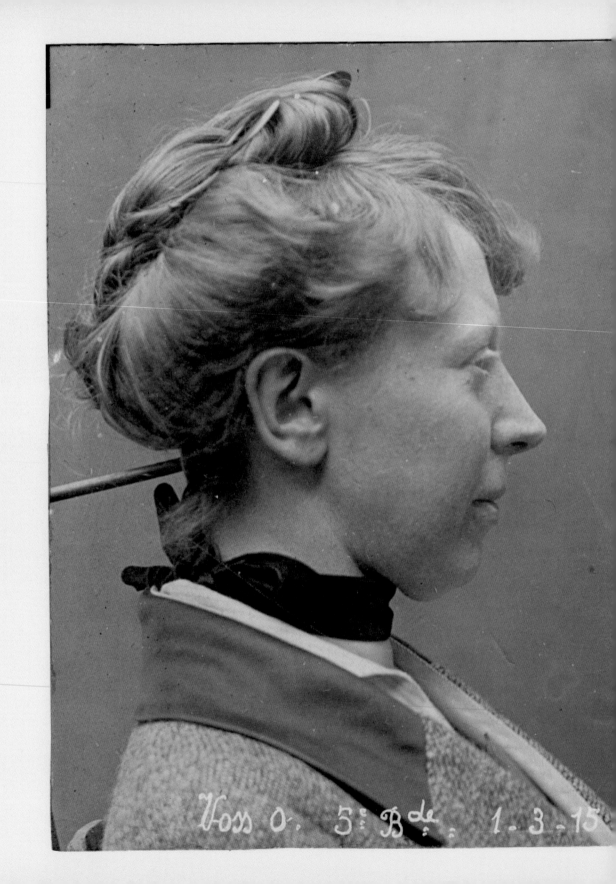

Voss O. 5: B<u>de</u>. 1 - 3 - 15

3913 - C.E.

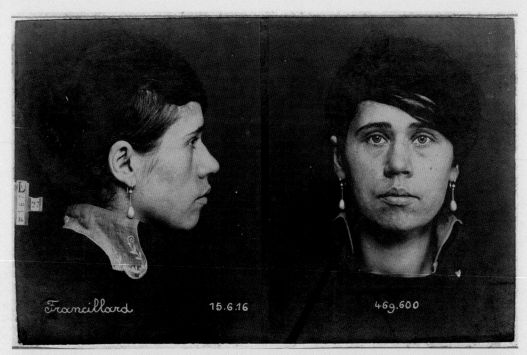

Camille Francillard, executed by firing squad at Vincennes, in the Paris region, on December 17, 1917

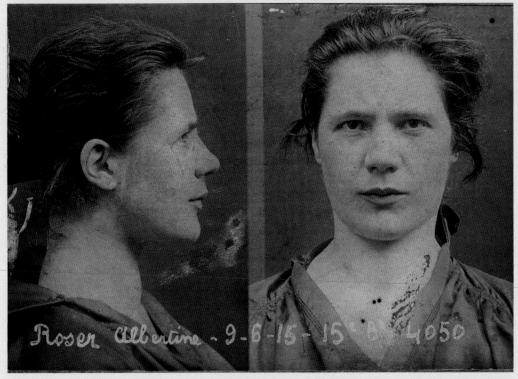

Albertine Roser, executed by firing squad at Lunéville, in eastern France

Henri Désiré Landru Nicknamed "le Barbe-Bleue de Gamais" (The Bluebeard of Gambais), the French serial killer Landru received numerous sentences for theft, fraud, and confidence trickery between 1904 and 1910. In 1914, he was wanted for embezzlement and was sentenced in absentia to four years in prison. Throughout the First World War he lived under a false identity. Passing himself off as a widower, he committed fraud on a large scale by making promises of marriage. Landru selected only widows and isolated women. Ten of them disappeared. Human bones were found in his oven, and the furniture of some of his victims was discovered in a shed belonging to him at Clichy, France.

Police interrogation notes:

Following an enquiry carried out by the first brigade of the mobile police at the request of the public prosecutor, Mr. Landru was found guilty of murders by the examining judge, arrested in accordance with a warrant for arrest on April 11, 1919, and locked away in Mantes prison on April 12, 1919.

At his trial, Landru denied his crimes. All he admitted was that he had stolen from and swindled his "supposed victims." After an investigation lasting two years, he was sentenced to death and executed on February 25, 1922.

Following two spreads: Landru, known as "the Bluebeard of Gamais," photographed close-up and standing on April 17, 1919

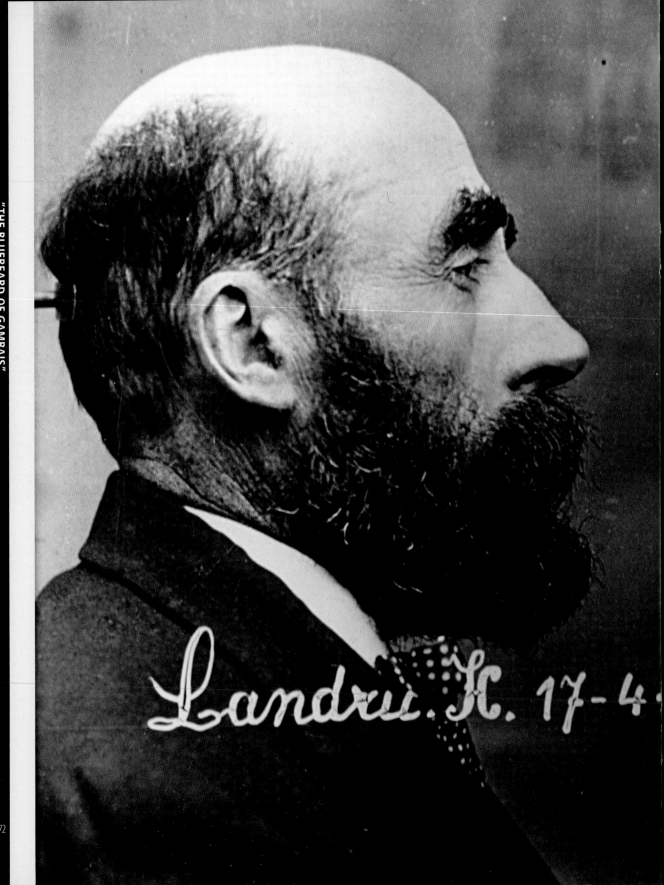

Landru. H. 17-4.

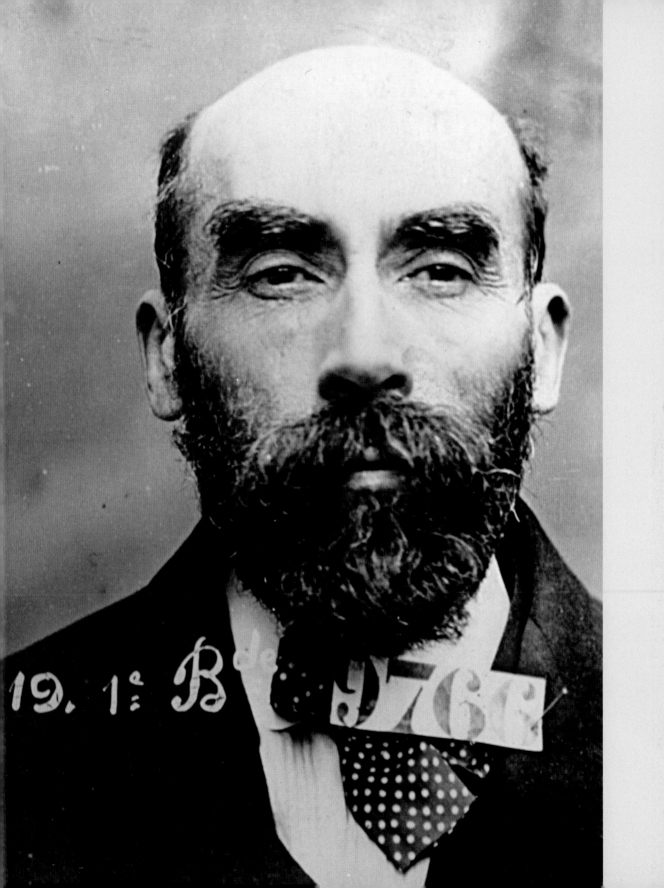

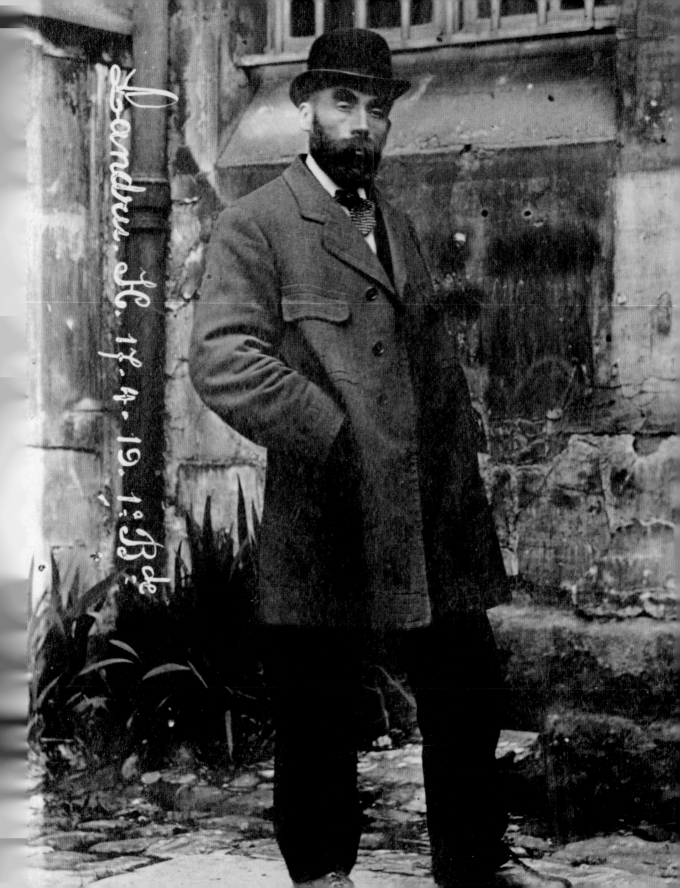

Landru. H. 18.-4.-19.1.B de

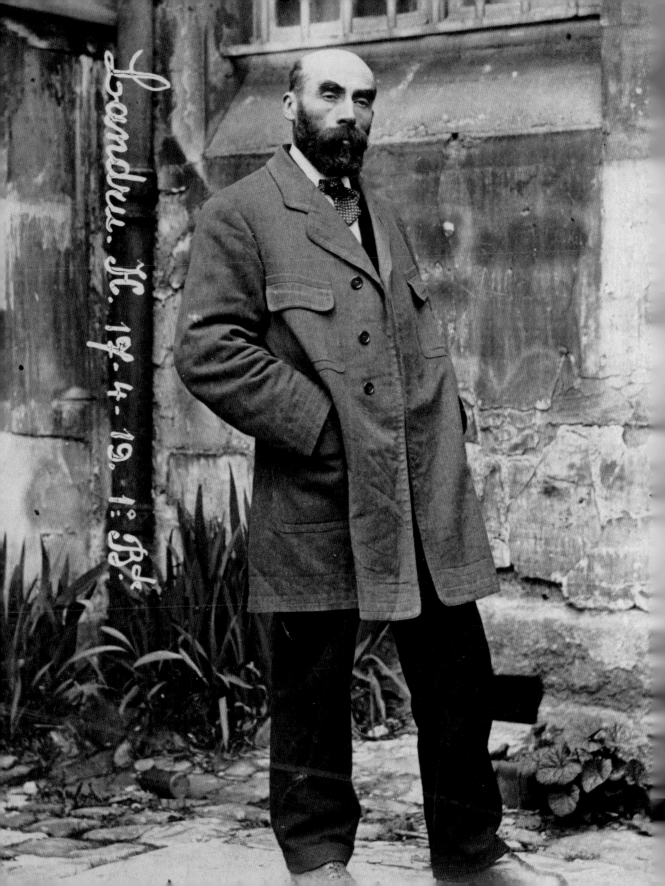
Landru K. 17. 4. 19. 1° Bd

Germaine Berton A militant 21-year-old anarchist, Berton fatally shot Marius Plateau, the secretary-general of the militant royalist group "Les Camelots du Roi" (The King's Pedlars) on January 22, 1923, at the headquarters of the right-wing Action Française in Paris.

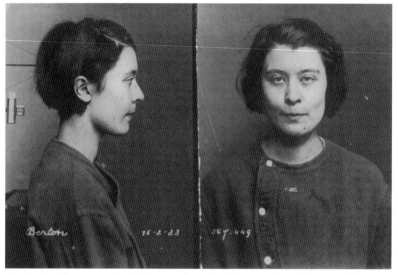

Berton's anthropometric full face and profile photo, collected by surrealist André Breton

The French Surrealists, and in particular Louis Aragon and André Breton, fought hard in defense of Germaine Breton—as they would do later for Violette Nozière (see page 120) and the Papin sisters (see pages 121–23). On December 24, 1923, she was acquitted. On December 1, 1924, her photo (full face), surrounded by figures, including Aragon, Pablo Picasso, Giorgio De Chirico, Robert Desnos, Paul Éluard, Max Ernst, Man Ray, and even Freud, was published in the first issue of the *Révolution Surréaliste* magazine.

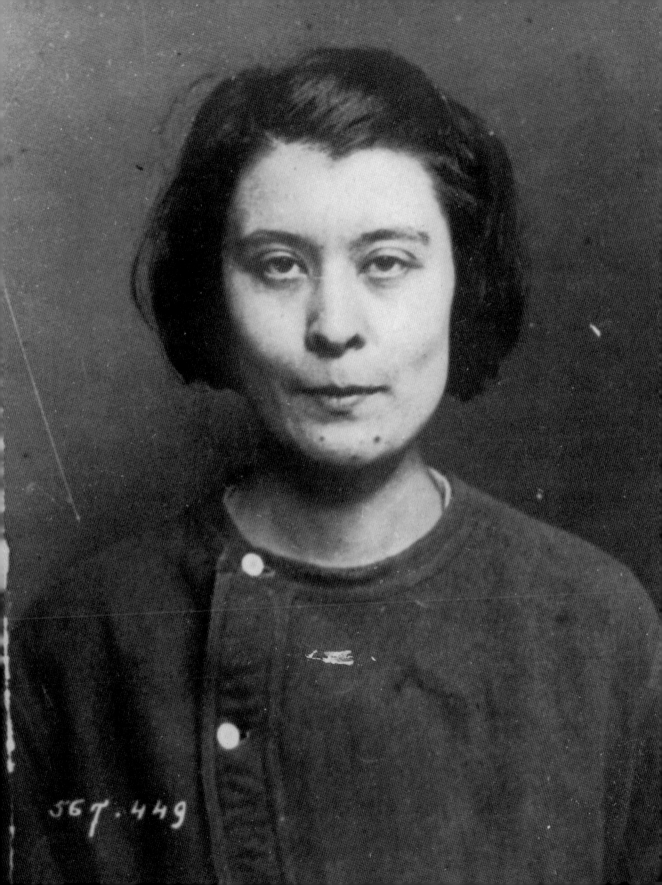

567.449

The Seznec Case On July 1, 1932, Guillaume Seznec, a timber merchant in Morlaix, France, was arrested on suspicion of killing Pierre Quemeneur, a regional councillor for Finistère in Brittany, France.

November 4, 1924: Seznec was sentenced to hard labor for life. After more than 20 years' detention in the penal colony in French Guiana, General Charles de Gaulle issued a decree for his pardon on February 2, 1946.

November 14, 1953: Seznec was knocked over by a van that then sped off. He died in 1954 as a result of his injuries.

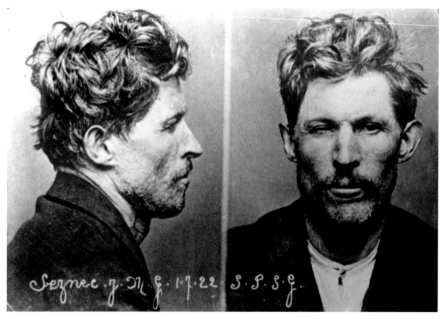

The anthropometric photograph is mistakenly dated 1922; some believe that this was a printing error, others that it was a deliberate attempt to manipulate the case.

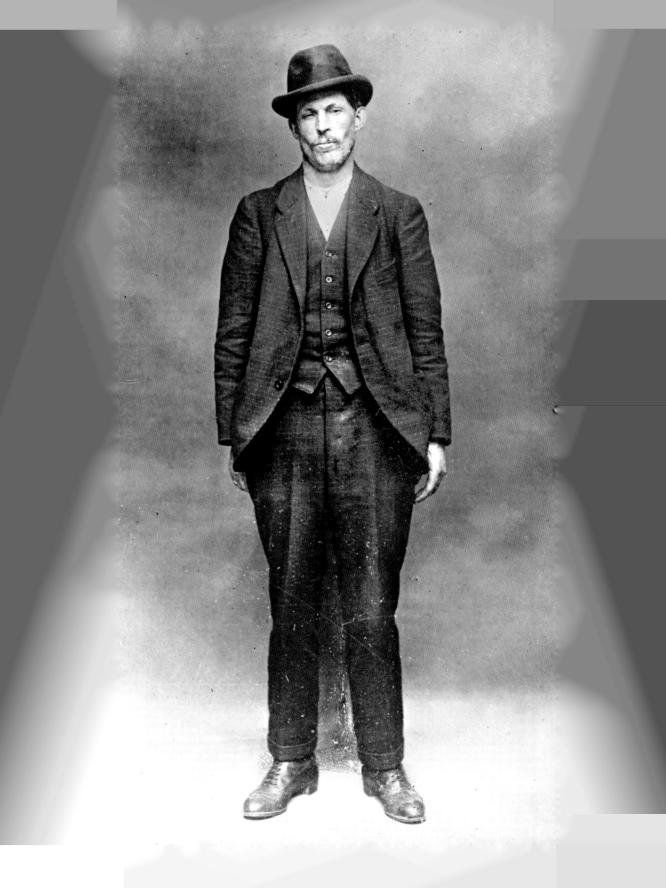

POLICE d'ETAT DE MARSEILLE MARSEILLE, le 28 Février 1941
COMMISSARIAT CENTRAL
Service de la Sûreté

N°678 C.B.

LE COMMISSAIRE DE POLICE CHEF DE LA SURE

à Monsieur le COMMISSAIRE CENTRAL

 Comme suite à une communication téléphonique de Monsieur MATHIEU,
Commissaire Divisionnaire, chef de la I8°Brigade de Police Mobile, à NICE
j'ai l'honneur de vous communiquer ci-dessous les renseignements recueil
lis à nos archives, concernant les nommés CARBONE Paul Bonnaventure, et
CARBONE François Alexandre.

 CARBONE Paul, Bonnaventure, alias: CARBONE Paul Venture, s'étant d
PICHETTTI Paul Abraham, né le I3 Février I894 à PROPRIANO(Corse)fils de
Paul et de Marie RUISUTI, célibataire, demeurant: 2, rue Audimar, a été
condamné à MARSEILLE?,le 29.4.1935 à 50 Fr d'amende pour port d'arme proh
bée.
 De la classe I9I4, du recrutement de MARSEILLE, le susnommé est ti
tulaire de la carte du combattant délivrée à MARSEILLE le 22 Février I93
sous le n°8I2II5.
 Le I2 AOUT I924, il a fait l'objet d'une lettre de la part du sieu
TREPICCIONE, demeurant 5, rue de la Croix, signalant CARBONE Paul, comme
le meurtrier de son frère, le nommé TREPICCIONE Luiz, dit "Le Brésilien"
trouvé noyé dans le Nil au CAIRE et enterré sous le nom de PREDALI Joseph
 Une information a été ouverte, mais on ignore la suite donnée.
été CARBONE Paul a été expulsé d'Egypte le 25/I2/I924 et

gato ARBONE Paul est cité dans l'interro

Juge d'une Commission Rogatoire de M. RABU
cité culpation d'assassinat, vol et compl

de d'une plainte pour coups et blessure
 On ignore la suite donnée.

tiq l a été entendu dans une affaire pol
sur de feu sur la voie publique"exercées
Com ph, Secrétaire de Section du Parti

le objet d'une Commission Rogatoire de M
qu NCE, l'inculpant de tentative d'escro
 uite donnée.

MA rère du précédent, né le 25/5/I905 à
LI de Marie RUISUTI, marié à Mathilde PAO
le nt, demeurant 2,rue Audimar, a encouru
le

Carbone and Spirito Carbone, aliases "Venture" and "le Tatoué" (Tattoo Man), born February 13, 1894, in Popriano, Corsica; and Spirito, alias "Lydro," born January 23, 1900, in Itri, Italy, are truly mythological figures in the history of the underworld of Marseille, France. They were precursors of the organized crime that developed on the French Riviera in the interwar years.

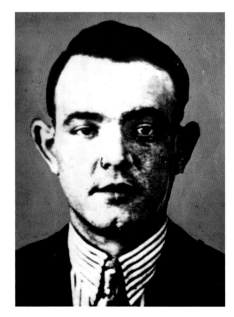

The two partners met in Egypt, and from the 1920s on were engaged in numerous illegal activities: large-scale racketeering, rigged boxing matches, smuggling, cheese trafficking, prostitution, white slave trading between North Africa and the Riviera, importing opium into France to turn it into heroin. . . . They basically established the basis for the future French Connection between Marseille and the United States. In the early 1930s, **Paul Bonaventure Carbone** (opposite) and **François Spirito** (above) made connections in political circles, in particular with the deputy mayor of Marseille, Simon

Sabiani. They gave "assistance" during fist-fight attacks on striking dockers. On March 29, 1934, they were implicated in the Prince affair—one month earlier, the body of Albert Prince, a magistrate of the Paris appeal court who was involved in the Stavisky case (see page 129), was found along a railway line a few miles from Dijon, France. Carbone and Spirito were arrested by Inspector Pierre Bonny (see page 168), and charged with murder, theft, and complicity. Very quickly, however, the charges were dropped and they were released. During the Second World War, from 1942 on, they collaborated

with the occupying forces. On December 16, 1943, Paul Carbone died in a car crash (possibly an assassination) involving a collision with a train. When France was liberated, François Spirito fled to the United States. In 1952 in New York, he was sentenced to two years in prison for drug trafficking offenses in connection with the Mafia. He returned to France in the 1960s and died in 1967. Carbone and Spirito were the inspiration for the 1970 film *Borsalino,* directed by Jacques Deray and starring Alain Delon and Jean-Paul Belmondo.

Charles Ponzi Born in Italy in 1882, Ponzi emigrated to the United States in 1903 and became one of the biggest fraudsters in American history.

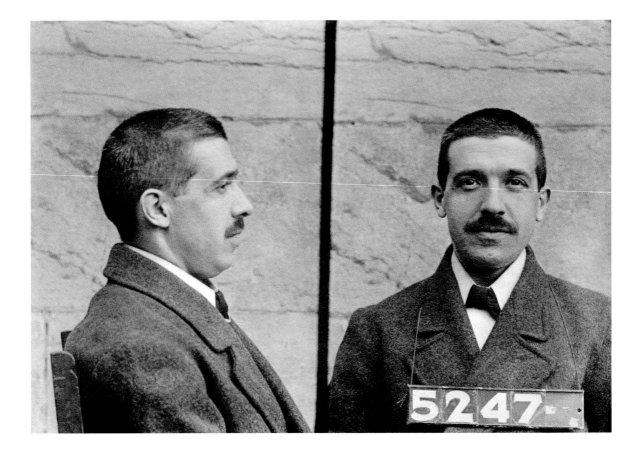

In December 1919, he founded an investment company in Boston, offering investments based on the purchase of international money orders and guaranteeing a return of 50 percent in 45 days! Six months later, in July 1920, by which time he had accumulated several million dollars, the Boston Post exposed the Ponzi system—the first buyers were in fact paid with the money deposited by later buyers—and revealed his previous dealings with the law, including three years in prison for fraud in Montreal in 1908. On August 13, 1920, Ponzi was arrested for fraud and swindling. Sentenced to five, then nine years in prison, he took advantage of his release on bail to run off to Florida, where he attempted another fraud, this time in real estate. Once again he fled to Texas. He was arrested in 1926, released in 1934, and deported to Italy. Ponzi died ruined in Rio de Janeiro on January 18, 1949. Nowadays, the fraudulent principle of pyramid selling is still known as the Ponzi scheme.

The Mafia 1920: The production, sale, transport, import, export, and consumption of alcohol were forbidden throughout the United States. The introduction of the Prohibition encouraged the growth of the Mafia and resulted in bloody conflicts between gangs vying for control of alcohol trafficking and the emergence of New York Italian-American and Jewish criminals such as Al Capone, Dutch Schultz, Lucky Luciano, and Meyer Lansky.

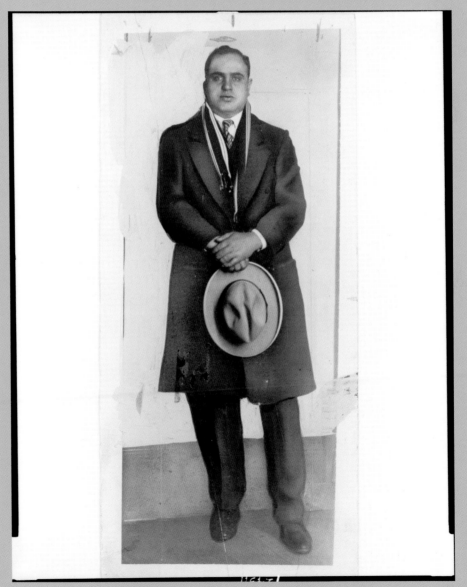

Above and following spread: Al Capone

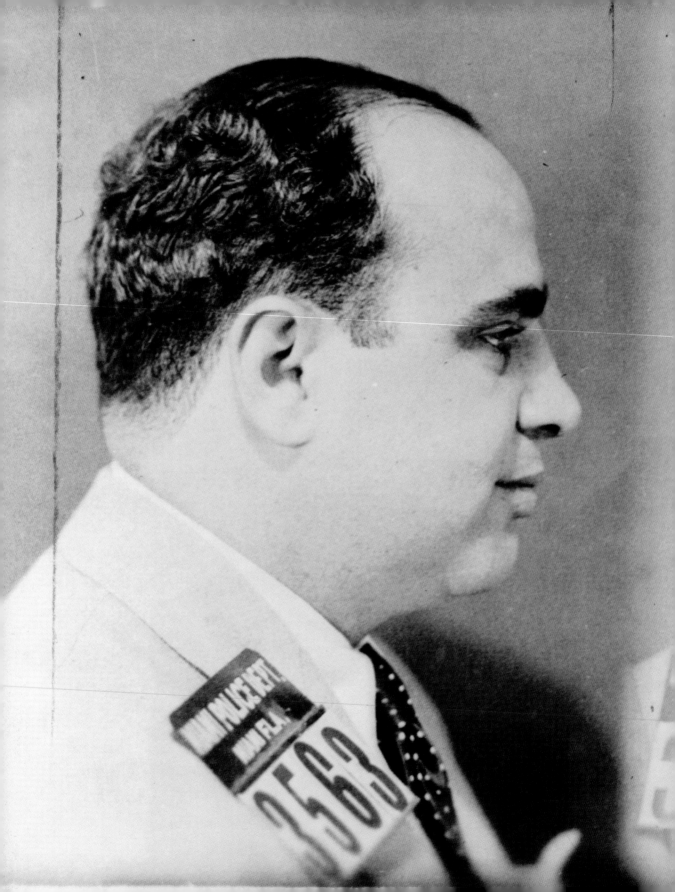

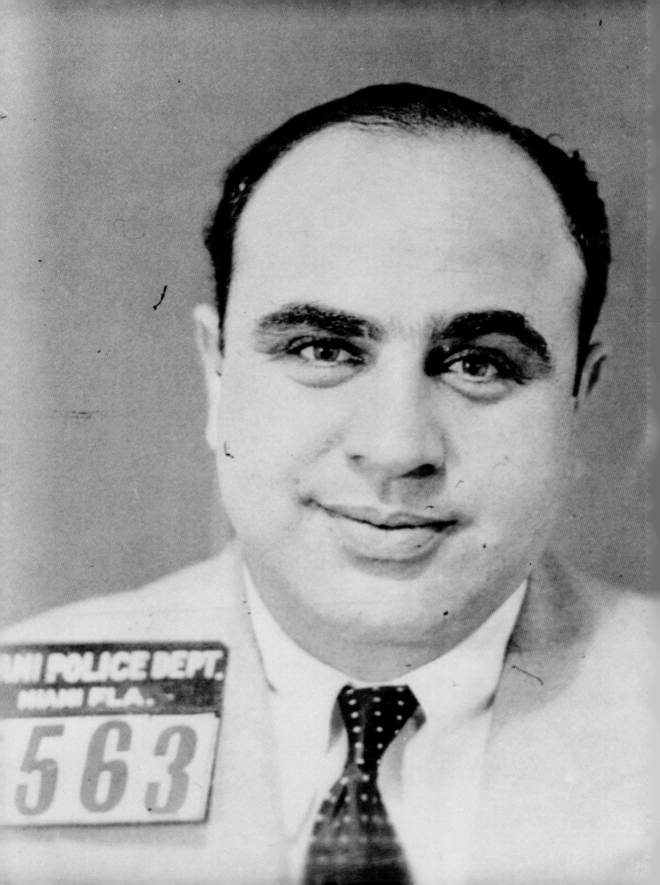

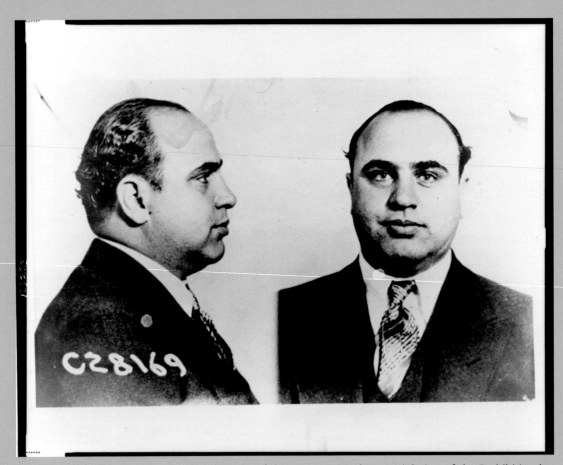

Alphonse Capone, known as **Al Capone, alias "Scarface,"** was born January 17, 1899, in Brooklyn, New York to Italian immigrants. In 1925, in the middle of the Prohibition era, he emerged as one of the most powerful bosses in the Chicago underworld.

The Chicago gang war reached its peak with the St. Valentine's Day Massacre on February 14, 1929. Seven members of a rival gang were murdered, and Al Capone was suspected of having ordered their execution. When summoned to appear before a jury, he produced a medical certificate stating that he had been in Florida at the time of the massacre and had been physically incapable of traveling. Despite this, the FBI discovered evidence of several journeys he had taken, apparently in good health. On March 27, 1929, Capone was fined $5,000 for contempt of court. He was arrested on May 17, 1929, for carrying illegal weapons and was sentenced to one year in prison, then released on March 17, 1930, for good conduct. Capone possessed genuine wealth, but was nevertheless given away by a lifestyle that exceeded his official income, and in June 1931, he was charged with fiscal fraud and violation of the Prohibition law. In November he was sentenced to 11 years of imprisonment and required to pay a fine of $50,000 and $215,000 in tax arrears. He was incarcerated in the Atlanta penitentiary and then, in 1934, in Alcatraz, the infamous federal penitentiary built on an island off the shore of San Francisco. On November 16, he was released after seven years; he was suffering from syphilis and his health had deteriorated considerably during his imprisonment. Al Capone died at home in Florida on January 25, 1947, a few days after turning 48 years old.

DIVISION OF INVESTIGATION, U. S. DEPARTMENT OF JUSTICE
WASHINGTON, D. C.

Record from: _U. S. Penitentiary_ (Address) _Alcatraz Cal_

On the above line please state whether Police Department, Sheriff's Office, or County Jail

Date of arrest _Aug 22, 1934_

Charge _Vio Income Tax_

Disposition of case _10 yrs_

Residence _Chicago, Ill_

Place of birth _Brooklyn, NY_

Nationality _Ital-American_

Criminal specialty _Hoodlum_

Age _35_ Build _Stocky_

Height _5-9_ Comp. _OK_ Hair _Blk_ _slight Bald_

Weight _214_ Eyes _Brown_

Scars and marks _Lge ragged cut scar on left side of neck._

CRIMINAL HISTORY

NAME	NUMBER	CITY OR INSTITUTION	DATE	CHARGE	DISPOSITION OR SENTENCE
Alphonse Capone	40886	U.P. Atlanta, Ga	(Transf to U.P. Alcatraz Cal 8/22/34)		

(Please furnish all additional criminal history and police record on separate sheet)

Charles "Lucky" Luciano His real name was Salvatore Lucania. Born in 1897 in Sicily, Luciano entered the United States illegally in 1907, and in the early 1920s he teamed up with Frank Costello, Meyer Lansky, and Benjamin Siegelbaum, known as Bugsy Siegel, as a racketeer and bootlegger.

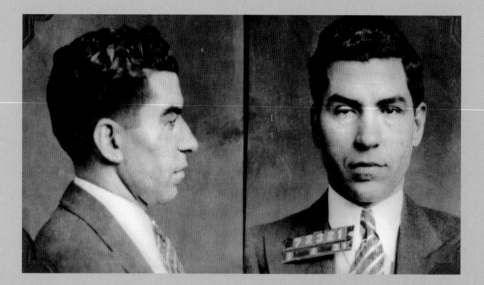

In 1931, Lucky Luciano orchestrated the murders of Giuseppe "Joe the Boss" Masseria and Salvatore Maranzano, two of the most powerful family heads in New York who were competing for control of alcohol trafficking. With these two murders he became the *capo di tutti capi* (boss of all bosses). Along with Meyer Lansky, he restructured organized crime and created the **National Crime Syndicate**, also known as "the Commission." From then on, any action against magistrates, policemen, or politicians was prohibited.

No Mafia boss could dominate the whole of organized crime. Sectors of activity and territories were shared. An organization called Murder Inc. was set up, with the job of executing organized crime members who broke the rules or were considered unreliable. In 1936, Lucky Luciano was sentenced to 50 years of imprisonment for procuring. During the Second World War, in exchange for a remission of his sentence, he collaborated with the CIA to protect port installations against possible Nazi attacks. In 1943, he facilitated

contacts between the Allies and the chief Sicilian families in preparation for the landing in Sicily. Released on parole in January 1946, Lucky Luciano was deported to Italy. He settled in Naples, where he organized traffic in heroin on an international scale. He died of a heart attack in January 1962, at the age of 64. In 1998, *Time* magazine ranked Lucky Luciano among the major empire builders of the twentieth century.

Meyer Lansky Born to a Polish-Jewish family in 1902, Lansky was nicknamed "Mastermind of the Mob" and regarded as the treasurer of the National Crime Syndicate. In 1920, when he was head of a New York gang along with Bugsy Siegel, he was the target of an attempted racket organized by Lucky Luciano. What should have degenerated into gang war turned into an unbreakable partnership. When Lucky Luciano founded the Crime Syndicate, Lansky set up a communal fund from which bribes were paid to the authorities.

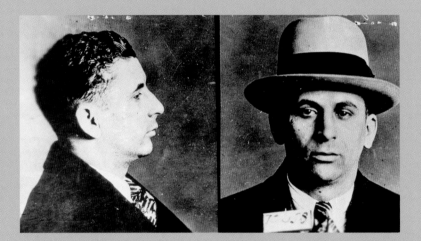

At the end of the 1930s, Lansky invested in the gambling and casino sector, notably in Florida and Cuba, in association with the Cuban dictator Batista. In 1946 he supported Bugsy Siegel in building the famous Flamingo Hotel and Casino in Las Vegas. The project swallowed up huge amounts of money, however, and the following year the Syndicate decided that Siegel should be disposed of. Lansky was neither willing nor able to prevent it. In 1970, he was being hunted by the FBI, and hoping to benefit from Israel's Law of Return, he decided to move there. Under pressure from the United States, the Israeli authorities declared him undesirable and rejected his application to immigrate. Three years later he was back in Florida, where he was arrested for tax evasion but acquitted due to procedural irregularities. Lansky died of lung cancer on January 15, 1983, at the age of 80. All his life he had managed to slip through the net of justice.

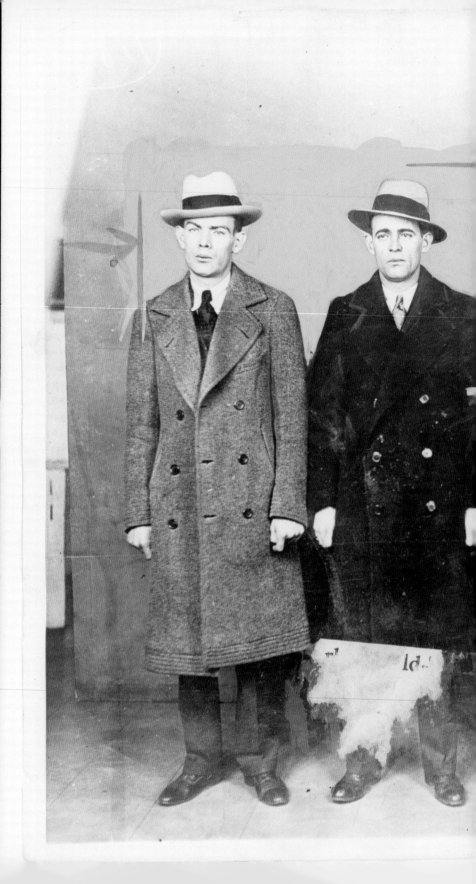

From left to right: Ed Diamond, Jack "Legs" Diamond, Fatty Walsh, and Lucky Luciano

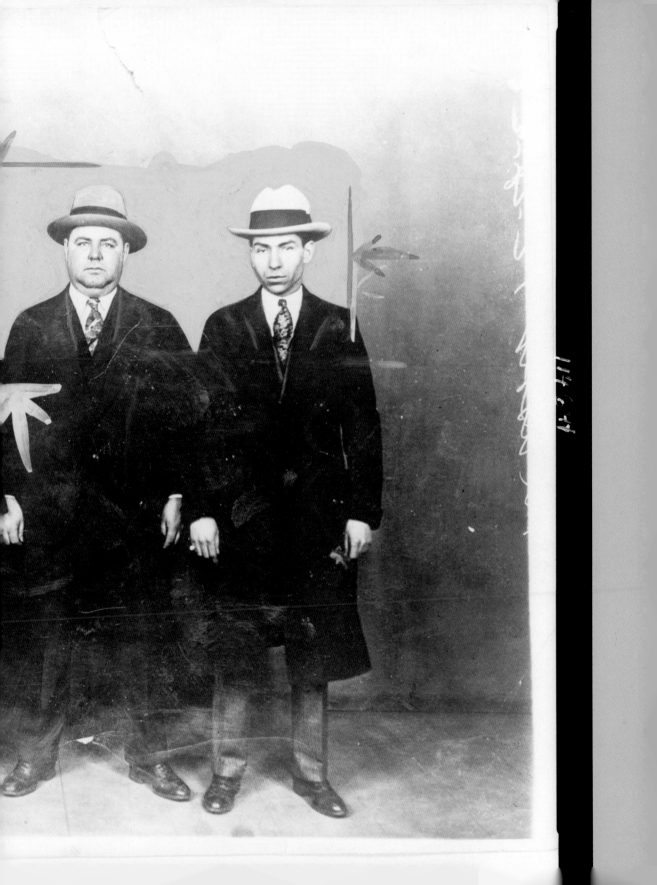

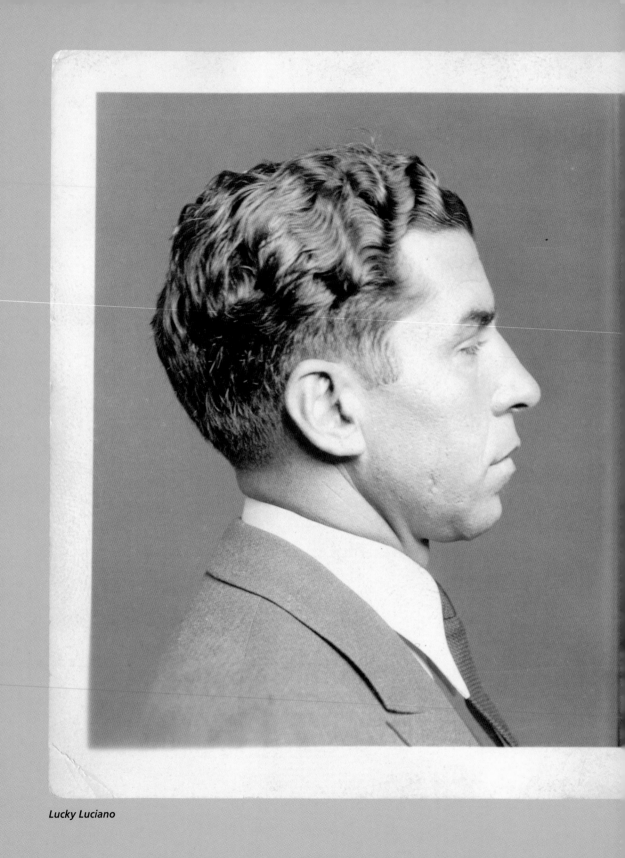

Lucky Luciano

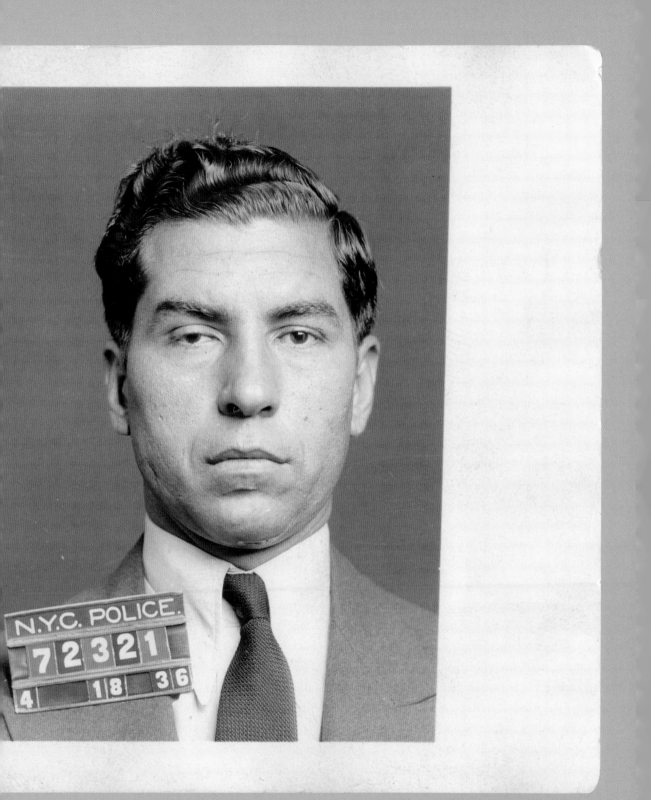

Following spread: Meyer Lansky

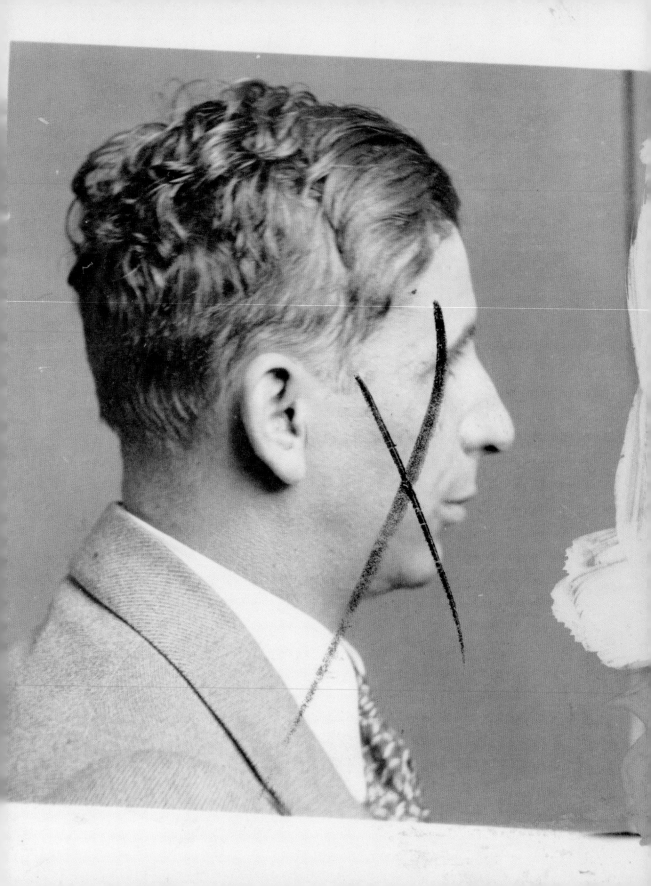

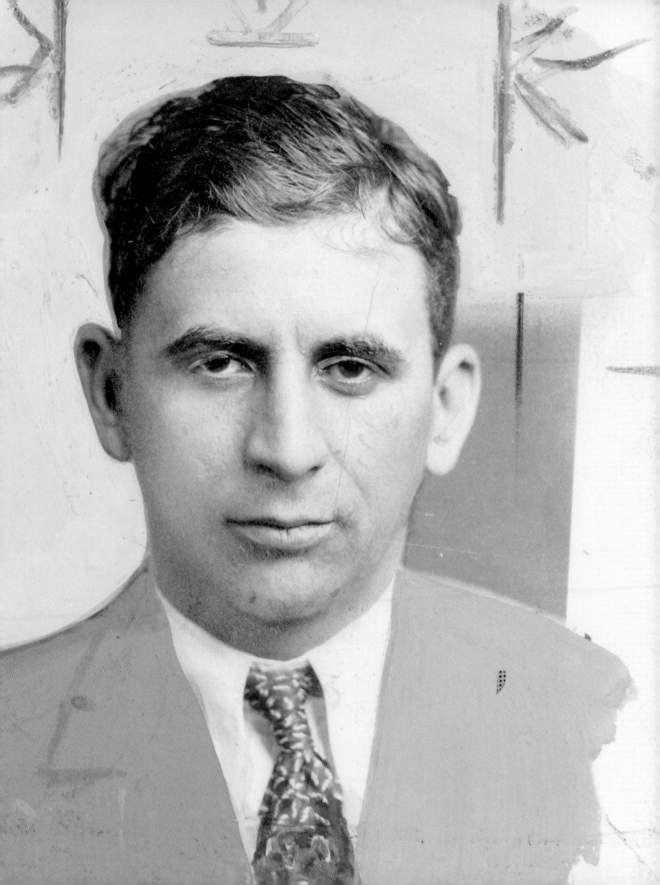

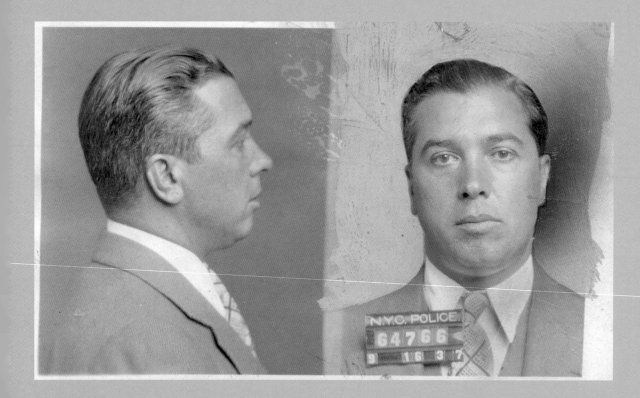

Joe Adonis Born Giuseppe Doto in Italy in 1902, Joe Adonis entered the United States illegally in 1915. During the Prohibition era he controlled the bootlegging on Broadway and Manhattan Avenue. He was a permanent member of the Crime Syndicate with responsibility for corrupting policemen and politicians, and he took on a more major role while Lucky Luciano was in prison between 1936 and 1946. Summoned to appear before a senatorial commission of enquiry into the Mafia, he refused to testify, citing the Fifth Amendment of the American Constitution, which states that no one can be "compelled in any criminal case to be a witness against himself." In August 1953, Joe Adonis was finally deported to Italy. He was arrested by the Italian police in June 1971, and in November he died of a heart attack during an interrogation at 69 years old.

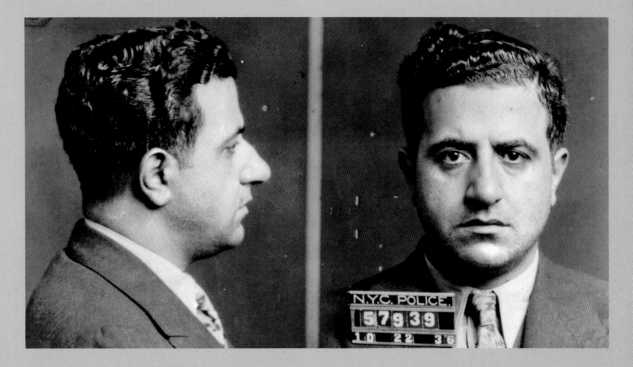

Albert Anastasia Born Umberto Anastasio on February 26, 1902, in Calabria, Italy, he was nicknamed the "Mad Hatter" and the "Lord High Executioner." He entered the United States illegally at the age of 15 and became an American citizen in 1943. In 1920 he was charged with murder and sentenced to death, but after 18 months of incarceration in Sing Sing prison in the state of New York, he was acquitted, since all four witnesses for the prosecution had disappeared. He was one of Lucky Luciano's henchmen at the murder of Joe Masseria in 1931. For services rendered, Luciano put him in charge of Murder Inc., along with Louis "Lepke" Buchalter. In 1951, he became the head of one of the five Mafia families in New York. In 1955, he was sentenced to one year in prison for tax evasion. On the orders of Vito Genovese he was shot dead at 55 years old on October 25, 1957, while sitting in a barber's chair in the Sheraton Park Hotel in New York.

Dutch Schultz Arthur Flegenheimer was known mostly as Dutch Schultz, "the Dutchman," or "the Beer Baron of the Bronx." Born in 1902 in the Bronx, to German-Jewish parents, Dutch Schultz was regarded as the Al Capone of New York. During Prohibition, Dutch Schultz controlled bootlegging and illegal lotteries in Harlem. In 1928, he extended his territory to Manhattan, provoking a gang war with his main rivals, who included **Jack "Legs" Diamond**.

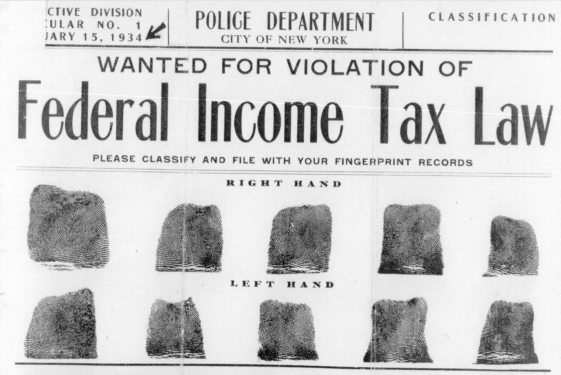

DETECTIVE DIVISION | **POLICE DEPARTMENT** | CLASSIFICATION
CIRCULAR NO. 1 | CITY OF NEW YORK
JANUARY 15, 1934

WANTED FOR VIOLATION OF

Federal Income Tax Law

PLEASE CLASSIFY AND FILE WITH YOUR FINGERPRINT RECORDS

RIGHT HAND

LEFT HAND

DESCRIPTION—Age 31 years; height 5 feet, 7 inches; weight 165 pounds; medium build; brown hair; gray eyes; fair complexion. B-50149.

Wanted by the Internal Revenue Service, United States Government, New York City. They hold warrant for indictment of the above charge.

Kindly search your Prison Records as this man may be serving a sentence for some minor offense.

If located, arrest and hold as a fugitive from justice, and advise Detective Division, by wire.

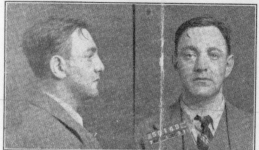

ARTHUR FLEGENHEIMER
ALIASES DUTCH SCHULTZ, ARTHUR SCHULTZ, GEORGE SCHULTZ, JOSEPH HARMON AND CHARLES HARMON

TELEPHONE SPring 7-3100

JOHN F. O'RYAN,
Police Commissioner

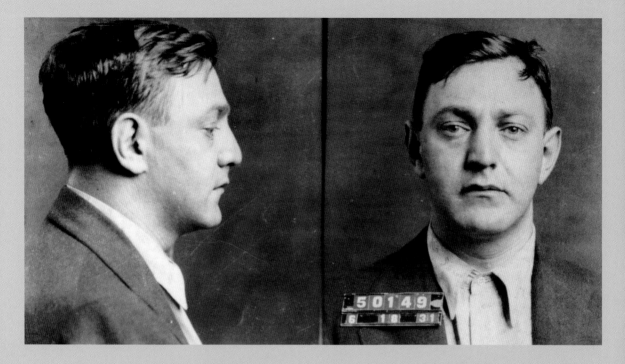

In January 1933, charged with tax evasion by the public prosecutor Thomas Dewey, Dutch Schultz was liable to a sentence of 43 years of imprisonment. At this point he fled, and the New York police issued a wanted notice (opposite). After more than 23 months on the run, he gave himself up on November 28, 1934. His lawyer, Dixie Davis, obtained his release by making a bail payment of $75,000. In 1935, still faced with a federal trial, he formed a plan to murder Dewey. Lucky Luciano and the members of the Crime Syndicate opposed his plan, and it was decided that Schultz should be disposed of by Murder Inc. On October 23, 1935, in a New Jersey restaurant, Dutch Schultz was shot dead by **Charlie "The Bug" Workman** (following spread), and a team of killers appointed by Lepke Buchalter. He died at 33 years old after 20 hours of agony, refusing to give the police the names of his murderers.

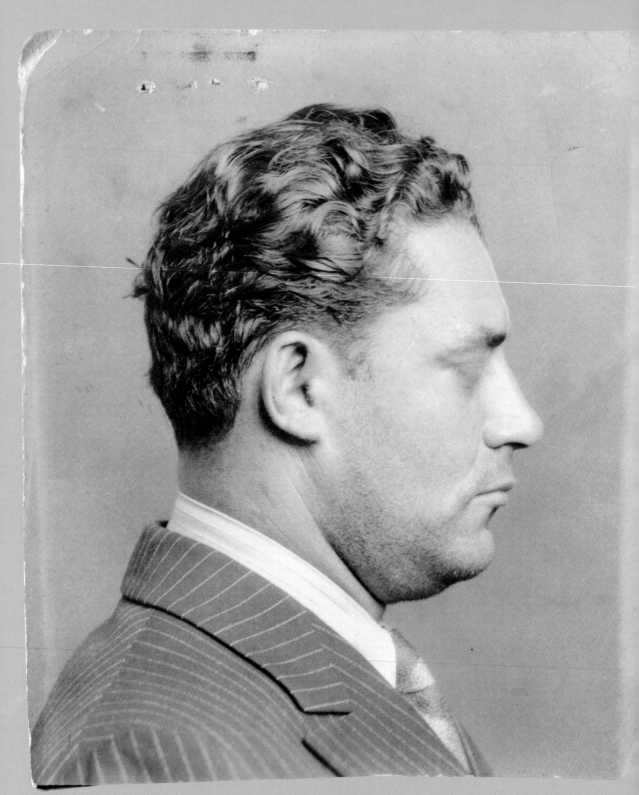

Charlie "The Bug" Workman

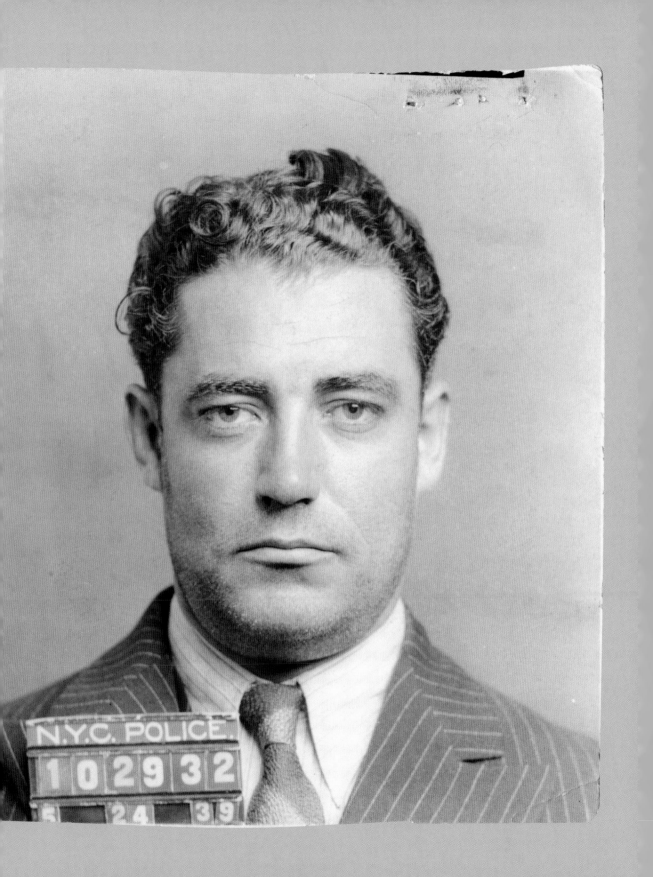

N.Y.C. POLICE
1 0 2 9 3 2
5 24 39

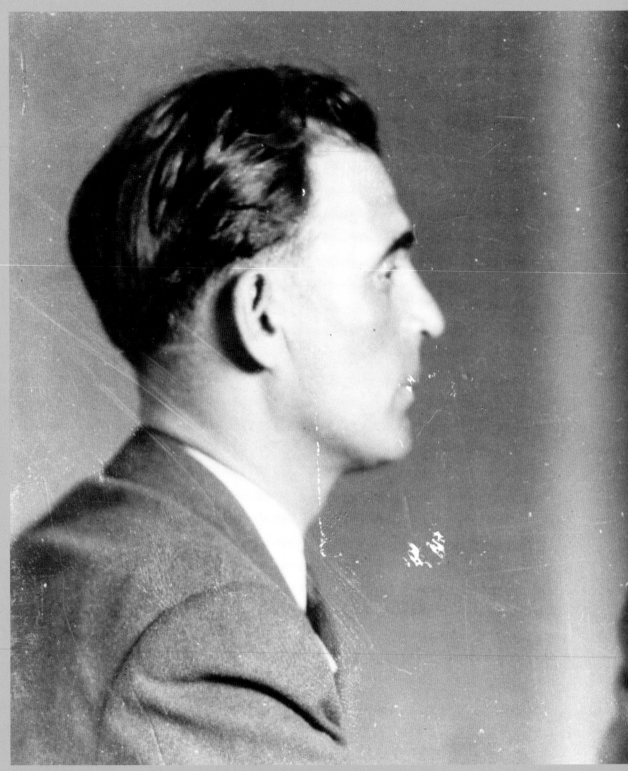

Jack "Legs" Diamond

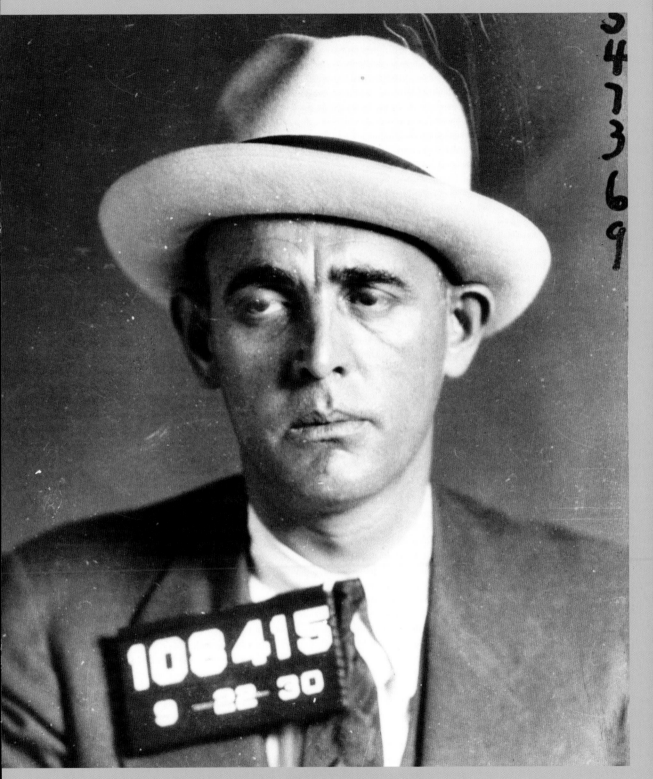

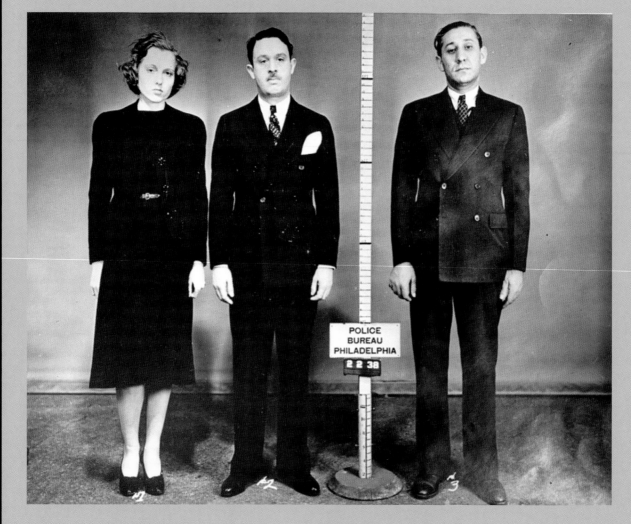

The photograph above is dated February 2, 1938. Center, **J. Richard "Dixie" Davis**, Dutch Schultz's lawyer. On July 14, 1937, Dixie Davis was found guilty of racketeering, sentenced to one year in prison, and struck off the list of lawyers. He died at 65 years old of a heart attack in 1970. Right, **George Weinberg**, Dutch Schultz's associate and accountant. In 1935, after Schultz's murder, Weinberg collaborated with the FBI and agreed to testify against his former associates. On January 29, 1939, he stole the pistol of one of the police officers responsible for protecting him and shot himself in the head. He was 37 years old. Left, **Hope Dare**, known under the name of Rose Rickert. She was a revue girl and Dixie Davis's girlfriend.

Opposite: Hope Dare

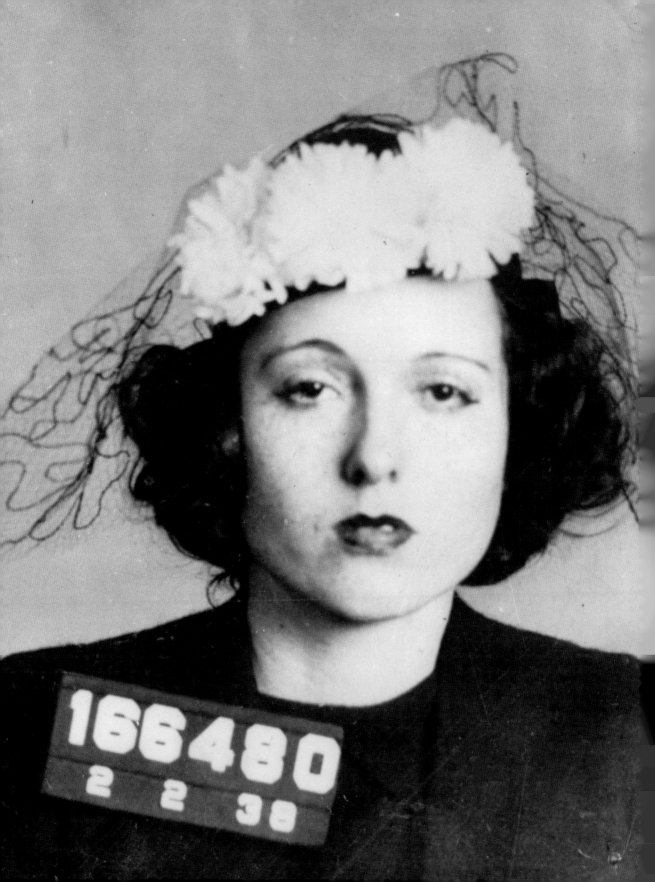

Louis "Lepke" Buchalter and Jacob "Gurrah" Shapiro

Louis "Lepke" Buchalter and Jacob "Gurrah" Shapiro Born in 1897 and 1899, respectively, in New York, Buchalter and Shapiro were in charge of **Murder Inc.**

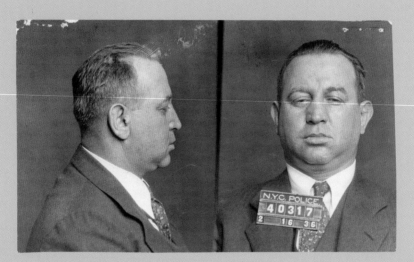

Jacob "Gurrah" Shapiro in 1936

In October 1936, Buchalter and his closest associate, Jacob "Gurrah" Shapiro, were sentenced to two years of imprisonment for racketeering and extortion. Released on bail, the two men fled after their sentence was confirmed by the court of appeals. Shapiro gave himself up in April 1938; Buchalter did so 16 months later following a vast manhunt orchestrated by the FBI. In 1939, Abe Reles, known as "Kid Twist," a killer hired by Murder Inc. who was charged with several murders and liable to receive the death penalty, agreed to cooperate with the authorities in order to escape the electric chair. He provided detailed information about 95 murders paid for by the Syndicate, including that of Joseph Rosen, an industrialist shot dead in 1936 on the orders of Buchalter. In 1941, Lepke Buchalter was found guilty of murder and sentenced to death. He was put to death at the age of 47 by electrocution on March 4, 1944, in Sing Sing prison, and at that time was the only American Mafia boss to have been sentenced to death. On May 5, 1944, his associate Gurrah Shapiro was sentenced to 15 years of imprisonment for conspiracy and extortion. He died at the age of 48 during his prison term in 1947.

Lepke Buchalter on June 12, 1933, and August 25, 1939

Lepke Buchalter on June 12, 1933

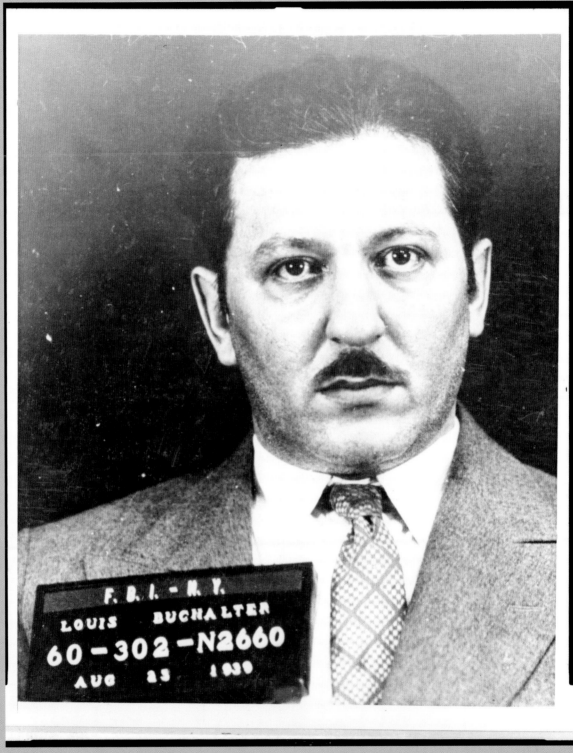

Lepke Buchalter on August 25, 1939

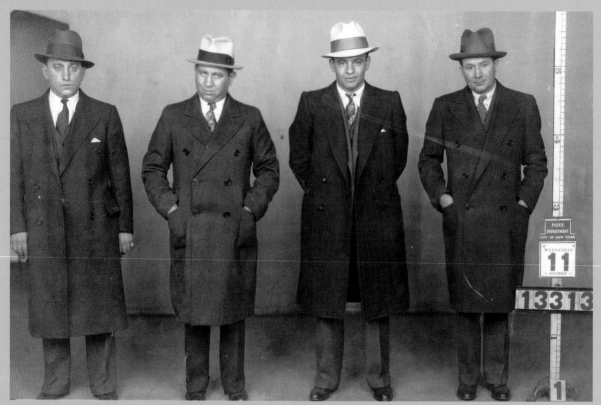

Louis Kravitz, Gurrah Shapiro, Philip Kovolick, and Hyman Holtz

Abe "Kid Twist" Reles On November 12, 1941, just before testifying against Buchalter before a federal grand jury, and despite the protection of six police officers, Abe Reles (according to the police) committed suicide at the age of 35 by throwing himself out of a window on the sixth floor of a hotel. The underworld said of him, "the canary that can sing, but cannot fly."

Frank Costello Born Francesco Castiglia in 1891 in Calabria, he emigrated to the United States in 1895. He was an influential member of "the Commission," nicknamed "Prime Minister" because of his relationships with legal institutions and politicians. In 1950 and 1951, he was targeted by the Estes Kefauver Senatorial Commission set up to fight organized crime in the United States. Summoned many times to appear at public hearings that were broadcast on television, Costello became the most famous mafioso of his time. In 1953, he was found guilty of contempt of the Senate and sentenced to 18 months in prison. In 1957 a murder attempt on him was orchestrated by Vito Genovese, and he decided to retire while at the same time maintaining a position of influence. He died at the age of 82 of a heart attack in 1973.

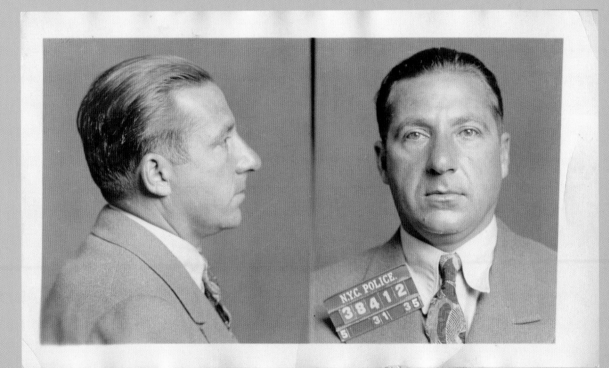

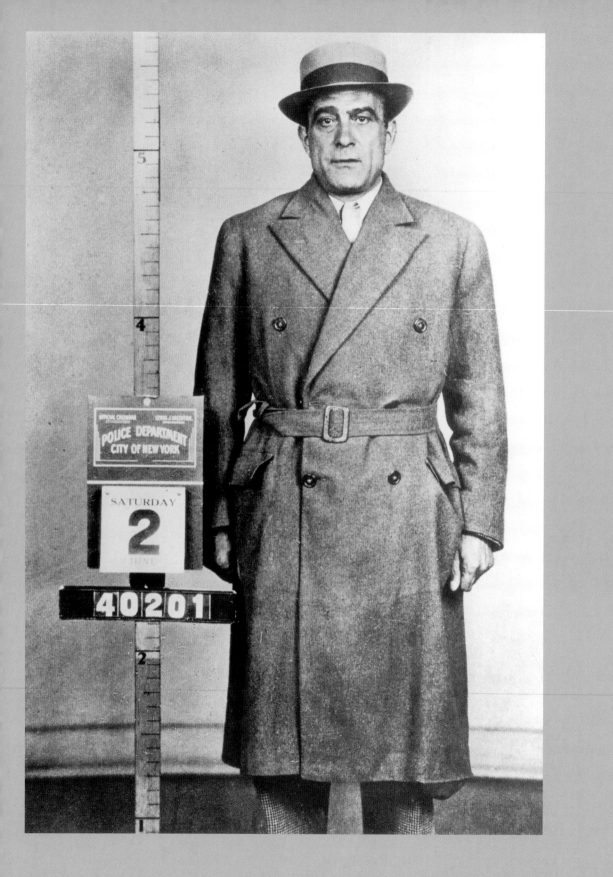

Vito Genovese Born in the Naples region in 1897, Genovese emigrated to the United States in 1913 and became an associate of Lucky Luciano in 1917. In 1937, he was charged with murder and fled the United States to return to Italy.

After nine years in exile, Genovese went back to New York in 1945. He was immediately apprehended by the American authorities but was acquitted at his trial after the main witness for the prosecution was found poisoned. From 1946 on, he established his position as the head of the New York Crime Syndicate by organizing the murders of his main rivals, Willie Moretti and Albert Anastasia. Genovese became the most powerful mafioso in organized crime in America. In 1959, Frank Costello, Lucky Luciano, and Meyer Lansky entrapped him in a drug trafficking affair. He was arrested and sentenced to 15 years of imprisonment. He died in 1969, at the age of 71, while serving his sentence.

Benjamin Siegelbaum, known as Bugsy Siegel Born in 1906 in Brooklyn, Bugsy became a member of the "Commission" and of Murder Inc. An FBI report stated that "Bugsy Siegel is implicated, directly or indirectly, in at least 30 murders."

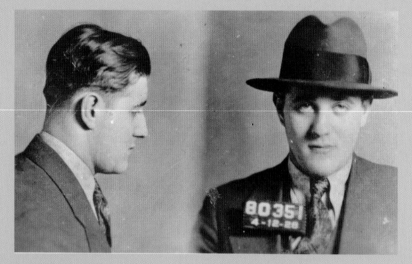

In the late 1930s, Bugsy left New York for California and took charge of racketeering in the movie industry. At the end of 1946, with the financial support of the leading members of the Syndicate, he invested in the gambling industry and opened the Flamingo Hotel and Casino in Las Vegas.

In the first few months, a great deal of money was lost, and Siegel was suspected of embezzlement. The Syndicate decided to dispose of him. On June 19, 1947, Bugsy was shot dead at 41 years old with a bullet through his head, at the home of his girlfriend, actress Virginia Hill, in Los Angeles.

Bugsy Siegel's mug shot, taken on April 12, 1928, when he was arrested for "disorderly" conduct

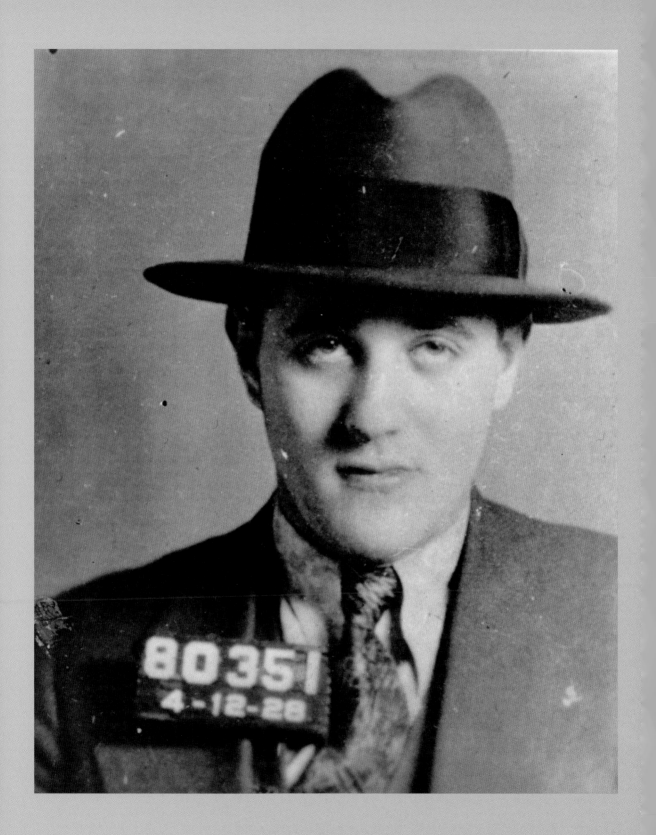

Mickey Cohen Meyer Harris "Mickey" Cohen, born in 1914 in New York, was a professional boxer in the 1930s, then became an associate of Bugsy Siegel on the west coast. After Siegel's execution in 1947, he took over control of racketeering in the movie industry and gambling in Las Vegas.

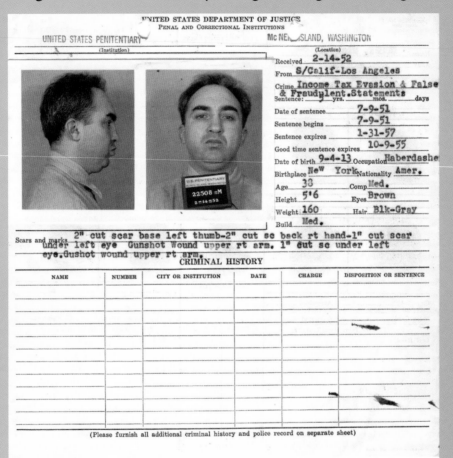

Cohen escaped several murder attempts, including a bomb attack on his home. In 1950, he was found guilty of tax fraud and sentenced to four years in prison. A further charge of tax fraud in 1961 led to a prison sentence of 14 years. He was incarcerated in Alcatraz and then in Atlanta. During his prison term, a fellow prisoner attempted to murder him with an iron bar. He was released in 1972 and died at the age of 62 in 1976. Mickey Cohen was one of the best-known mafiosi on the west coast, befriending numerous stars such as Frank Sinatra and Sammy Davis, Jr. He inspired James Ellroy's characters in *L.A. Confidential* and *White Jazz*.

Irving Wexler, known as Waxey Gordon
During the Prohibition era, he became one of the most powerful bootleggers in New Jersey.

In 1933, Gordon was accused of attempting to evade federal taxes. The charge at the trial estimated his undeclared net income at $1,338,000 for 1930 and $1,026,000 for 1931. Gordon was sentenced to ten years of imprisonment. Released in 1940, he declared: "Waxey Gordon is dead. From now on call me Irving Wexler, businessman." On August 2, 1951, he was arrested by federal agents for selling heroin and sentenced to 25 years of imprisonment. He died a year later of a heart attack while serving his sentence in Alcatraz.

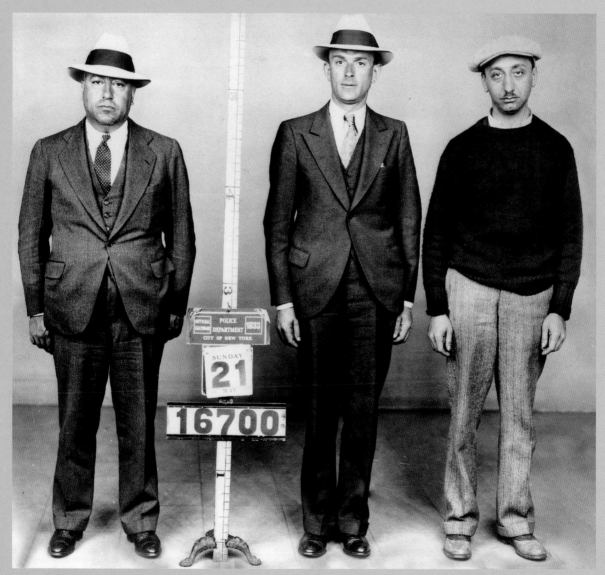

Waxey Gordon, Hymie Pincus (Harry Klein), and Albert Aront

Frank Sinatra The relationships between Frank Sinatra and certain Italian-American Mafia bosses have been the subject of much speculation and rumor. Under the Freedom of Information Act, the FBI has recently declassified 2,400 pages of the Sinatra dossier and published them on its website. These documents reveal two significant facts. In 1946, at the instigation of Lucky Luciano, the leading Mafia bosses went to Cuba for a meeting known as the Havana Conference. According to the FBI, Sinatra traveled to Havana at least twice with the intention of meeting Lucky Luciano: in December 1946 and January 1947. He is suspected of having transported several million dollars for Luciano. Sinatra had close links with Sam Giancana, a powerful underworld boss in Chicago from 1957 to 1966, who was murdered in 1975.

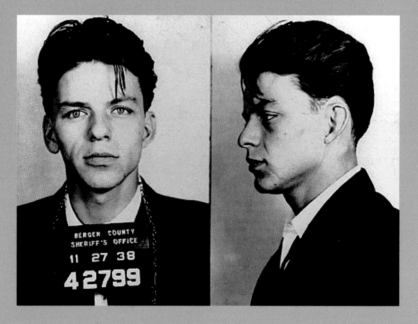

Extract from the record of arrest:

Frank Sinatra, Arrest #42799, Bergen County Sheriff's Office, Hackensack, New Jersey, was arrested on November 26, 1938, charged with Seduction. Disposition was marked, "Dismissed."

Frank Sinatra, Arrest #42977, was arrested on December 22, 1938, charged with Adultery. On the second and ninth days of November 1938, at the Borough of Lodi, [New Jersey,] under the promise of marriage, Sinatra did then and there have sexual intercourse with the said complainant, who was then and there a single female of good repute.

The report noted that Sinatra was released on a $1,500 bond, and that the complaint was withdrawn when it was determined that the woman involved was married. The complaint was changed to adultery, and the bond reduced to $500. That charge was also dismissed.

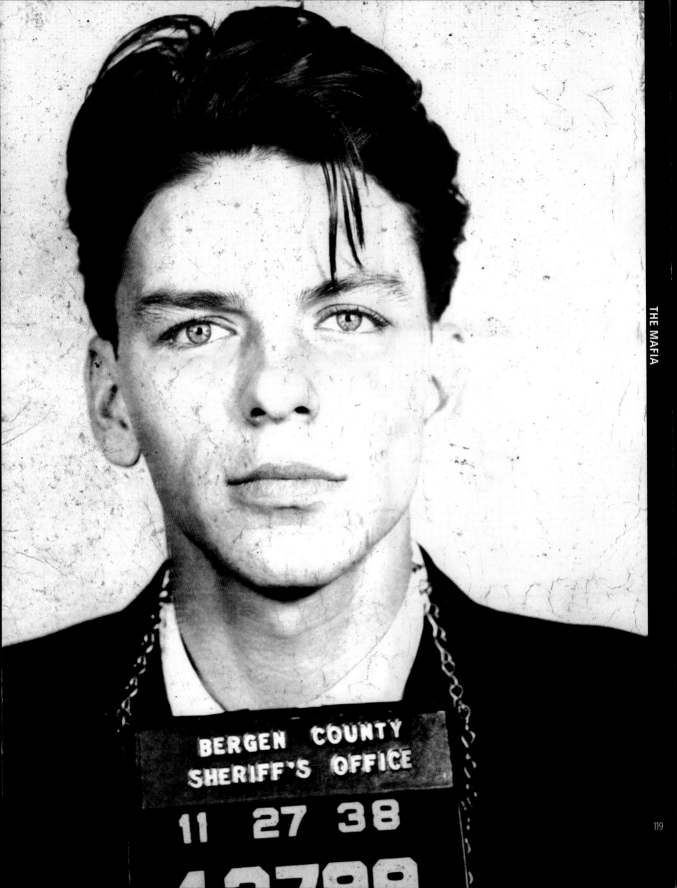

BERGEN COUNTY
SHERIFF'S OFFICE

11 27 38

42788

Violette Nozière, "l'Empoisonneuse" (the Poisoner) On August 28, 1933, Violette Nozière, age 18, was arrested and charged with parricide and the attempted murder of her mother. A week earlier, during the night of August 21, she had poisoned her parents by making them swallow a powerful sleeping drug, and she had then turned on the gas in the apartment to give the impression that they had committed suicide. Only the mother was able to be revived.

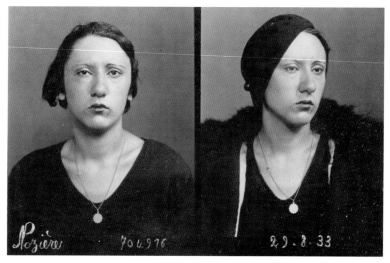

During the trial, the defense tried in vain to justify the parricide by describing the incestuous relations that had been forced on Nozière by her father. In October 1934, she received a death sentence, which was then commuted to life imprisonment on December 25, 1934. Released on August 29, 1945, Violette Nozière was rehabilitated on March 18, 1963, by the court in Rouen. She died on November 18, 1966.

The Papin Sisters On February 2, 1933, in Le Mans, France, Léa and Christine Papin, servants aged 21 and 28 respectively, savagely murdered their mistress and her daughter following a violent argument. The police discovered the mutilated, enucleated bodies of the victims and found the two sisters upstairs in their bedroom, wearing bathrobes and lying in the same bed.

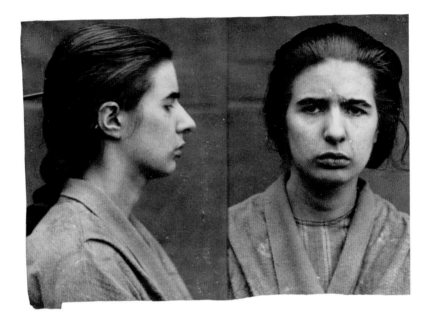

Léa Papin

The court and the psychiatrists declared the sisters to be of sound mind and responsible for their actions. Christine Papin was charged with double murder and given a death sentence, which was commuted to hard labor for life. Suffering from depression, she was interned in the Rennes psychiatric hospital in 1934, where she died in 1937 at the age of 32. Léa Papin, accused as an abettor, was sentenced to 10 years of hard labor and 20 years of enforced exile. Released in 1943, she died in Nantes in 2001 at the age of 89.

Following spread: Léa (left) and Christine (right) Papin

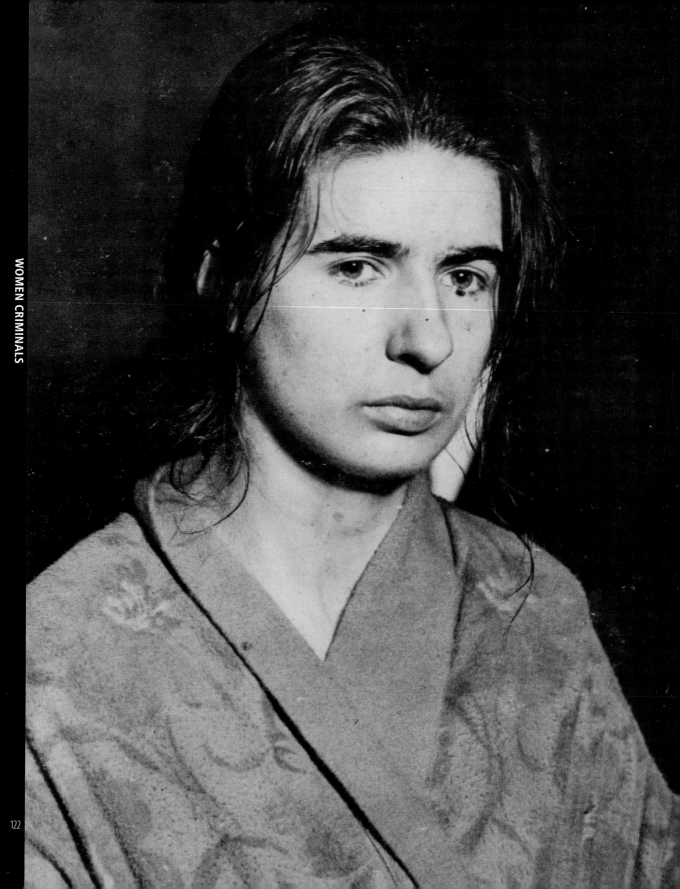

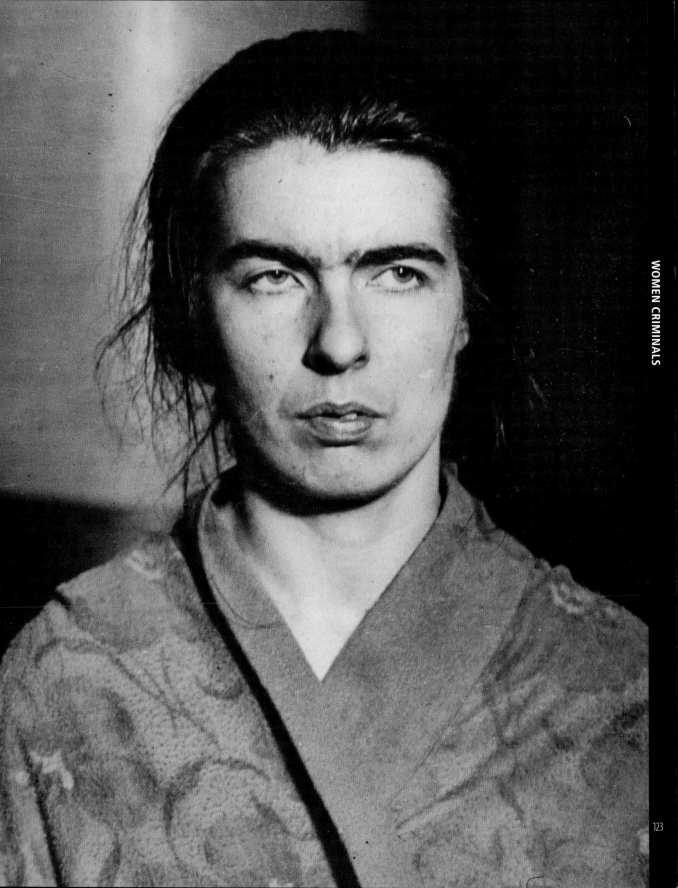

Leonarda Cianciulli died of a cerebral hemorrhage on October 15, 1970, in the criminal insane asylum of Pozzuoli. She would go down in history as the **"soap-maker of Correggio."**

Cianciulli murdered three women. The first was named Faustina Setti; she vanished on December 17, 1939. Then, in the summer of 1940, Cianciulli killed Francesca Soavi. The last of her three victims, Virginia Cacioppo, was murdered on November 30, 1940.

Above: Leonarda Cianciulli in a criminial asylum in Aversa
Opposite: Cianciulli with her eldest son, Giuseppe, who was tried as an accomplice, during their trial in 1946; he was acquitted

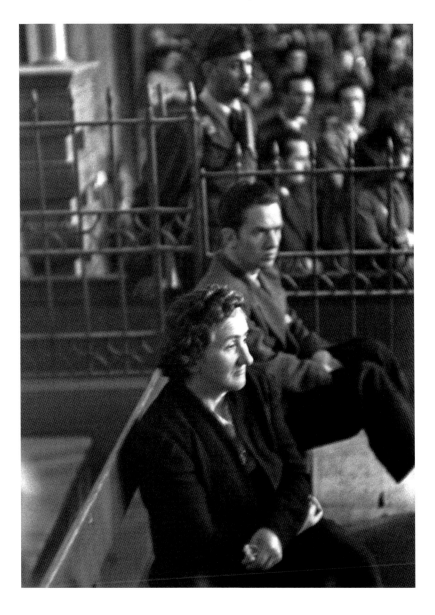

It was the sudden disappear-
ance of Cacioppo that led Reggio
Emilia's chief police investigator
to order a search of Leonarda
Cianciulli's home. There, the police
discovered the remains of the
unfortunate victims.

Within hours of her arrest, she
confessed to the murders, insist-
ing that she had acted alone.
She had killed all three women,
dismembered them, and boiled
their corpses in lye to make soap
and candles.

Paul Gorguloff On May 6, 1932, in Paris, Paul Gorguloff fired five shots from a 7.65-caliber revolver at the president of France, Paul Doumer.

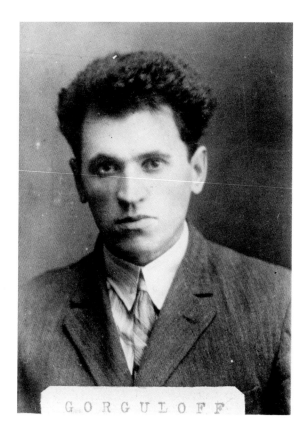

GORGULOFF

Paul Doumer was rushed to the Beaujon Hospital, where he died on May 7 at 4:30 A.M. Gorguloff, a Russian émigré, said that he had killed the president in protest against France's passive attitude to Bolshevik Russia: "I am neither a monarchist nor a Communist. I die for my own idea, like the Russian peasant being oppressed by the Reds."

On July 25, 1932, the trial opened at the district court for the Seine region. The defense lawyer made a plea of insanity. On July 27, Paul Gorguloff was sentenced to death. Despite protests from the League of Human Rights, he was guillotined on September 14 in front of the Parisian La Santé prison.

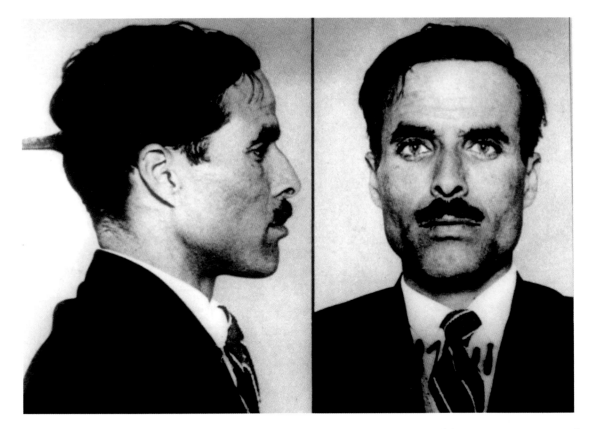

Habib Bourguiba Born August 3, 1903, in Monastir, Tunisia, Bourguiba became one of the leaders of the Tunisian independence movement at the beginning of the 1930s. In an atmosphere of colonialist repression, he was put under house arrest in southern Tunisia from 1934 to 1936.

Arrested on April 10, 1938, following a bloody demonstration causing dozens of deaths, Habib Bourguiba was incarcerated in the Tunis civil prison. Charged with conspiracy against state security and incitement to civil war, he was taken to the Teboursouk prison and then to France. During the Occupation, Bourguiba made an invocation on behalf of the Allied troops in April 1942, which resulted in imprisonment by the Germans until April 1944 (June 1943 according to other sources). He was arrested again in January 1952 for calling on the Tunisians to increase their level of resistance activity. After the declaration of independence on March 20, 1956, Bourguiba became the first president of the Tunisian Republic, from July 25, 1957, to November 6, 1987. He died on April 6, 2000.

PRÉFECTURE DE POLICE. Paris, le 4 Janvier 1934.

 DIRECTION
 de la
 POLICE JUDICIAIRE.

 C I R C U L A I R E.

 Il y a mandat d'arrêt en date du 28 décembre 1933
 de Monsieur le Juge d'Instruction de BAYONNE contre le nommé
 STAVISKY, Sacha, né le 20 novembre 1886 à SOBODKA (Russie),
 dit ALEXANDRE, Serge, dit BOITEL.

 SIGNALEMENT:

 Taille: 1 m 73,
 Cheveux châtain moyen,
 Visage rasé, teint clair,
 Corpulence svelte,
 Point cicatriciel à 0 cm 5 au-dessous de la racine
 du nez;(sur le dos du nez);
 Point cicatriciel à 1 cm au-dessus de l'aile gauche
 du nez.

 Rechercher très activement cet individu et, en cas
 de découverte du recherché lui-même ou d'un renseignement
 susceptible d'orienter les recherches, aviser d'urgence
 Monsieur le Directeur de la Police Judiciaire.-

 LE DIRECTEUR DE LA POLICE JUDICIAIRE

 Xavier GUICHARD.-

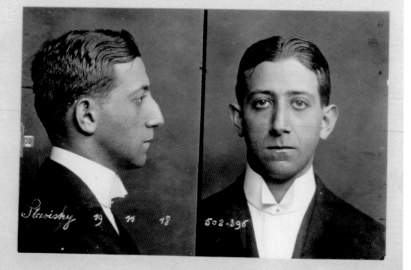

The Stavisky Affair In December 1933, Sacha Stavisky succeeded in embezzling more than 235 million francs from the Crédit Municipal bank in Bayonne, France, with the complicity of the city's deputy mayor. Thanks to the protection he received from certain political circles, he managed to evade the police.

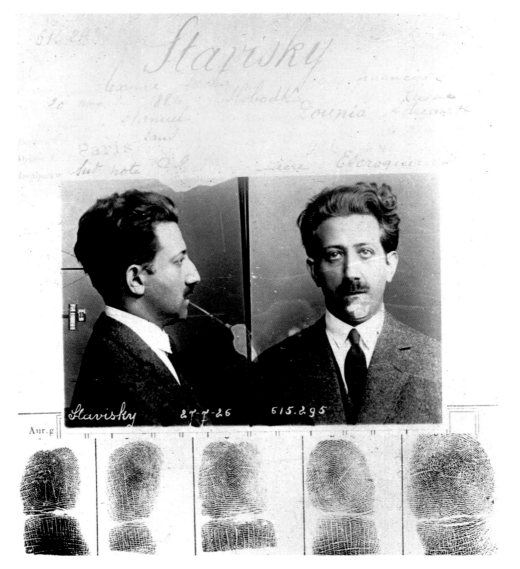

On January 2, 1934, Stavisky was located in Chamonix, France, in his chalet called "Le Vieux Logis" (The Old Home). On January 8, the police entered the chalet and found him dying, with a bullet in his head and a revolver in his hand. The inquest concluded that it was suicide, but the public immediately suspected that politicians had orchestrated the murder of the crook who knew too much. The satirical French magazine *Le Canard Enchaîné* ran the headline: "Stavisky committed suicide with a bullet shot from ten feet (six meters). That's what it means to have 'a long arm'."

Extract from Sacha Stavisky's police record:

February 1912, sentenced to 16 days in prison and fined 25 francs for confidence trickery.

July 1915, sentenced to six months of imprisonment and fined 100 francs.

1916, sentenced to six months in prison for fraud.

November 1918, the date of the anthropometric photo, 15 days in prison for swindle.

In 1920, he was sentenced to two years in prison for another fraud. Sentence annulled by the appeal court, acquitted in 1921. Known as the "bank crook," he was arrested in July 1927 and released on bail.

Intelligent, well-spoken, and attractive, Stavisky is a highly suspect individual. Extremely dangerous. . . . The law will certainly have to deal with him in the future. Mr. Stavisky is surrounded by a gang of criminals who are in his pay, including **George Hainnaux, known as "Jo la Terreur"** (Jo the Terror).

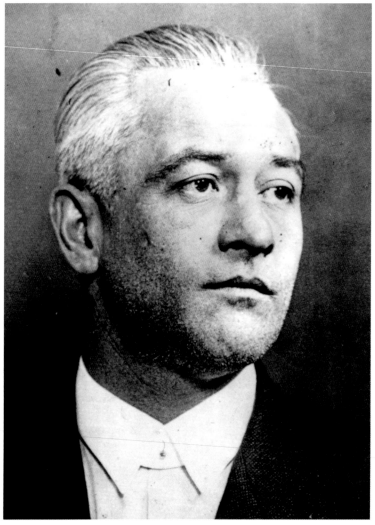

George Hainnaux, known as "Jo la Terreur"

The Stavisky affair became the biggest political and financial scandal of the Third French Republic, causing the resignation of Prime Minister Camille Chautemps and leading to violent anti-parliamentary riots in Paris on February 6, 1934. Following these events, Eugène Deloncle, known as "Marie," and **Jean Filliol, known as "le Tueur" (the Killer)**, both dissidents in the Action Française, founded the secret committee of revolutionary action known as the Cagoule. This small, extreme right-wing group was responsible for a series of attacks, including one on September 11, 1937, against the General Confederation of French Employers and the Metallurgical Industries Group, and for the murder of anti-fascist Italians who had taken refuge in France. During the Second World War, the leading members of the Cagoule split between collaboration and the Resistance.

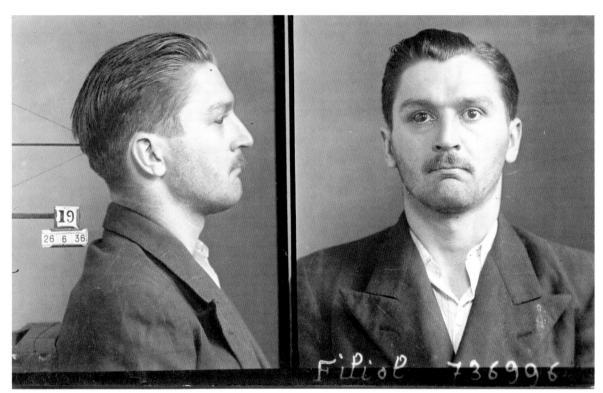

Jean Filliol fled to Spain in 1946. He was sentenced to death in absentia for collaboration and murder.

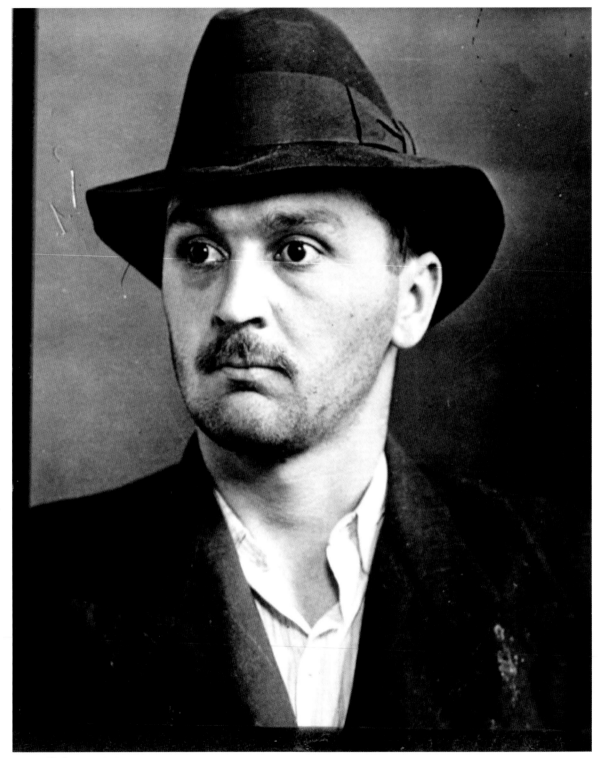

Jean Filliol, June 1936

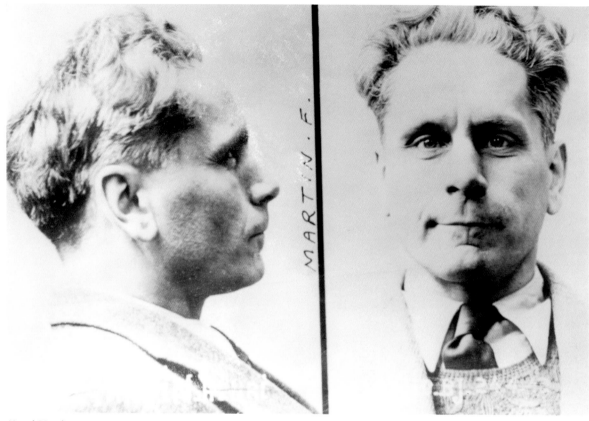

Henri Martin on June 4, 1957

At the end of 1937, the head of the Cagoule's intelligence service, **Doctor Henri Martin, known as "le Bib,"** escaped being arrested along with the other leading members of the organization. Martin managed to flee to Italy. He returned to France in 1940, was arrested in March 1942 by the Vichy police, then escaped and joined a Maquis Resistance group in Lyon. At the end of the war he disappeared. In October 1948, the trial of the Cagoule opened at the district court for the Seine region. Henri Martin was sentenced in absentia. He was arrested on June 4, 1957, for illegal activities in connection with "events in Algeria." Released on November 29, 1957, arrested again in 1960 for plotting against French president Charles de Gaulle, then rereleased in April 1961, "le Bib" was sentenced in absentia again in October 1963 to ten years for conspiracy.

From the early days of the Great Depression in October 1929 until 1934, a number of gangsters were given, in turn, the title **Public Enemy #1** by the Department of Justice Division of Investigation, renamed the FBI (Federal Bureau of Investigation) in 1935. Most of them would become real icons of American popular culture.

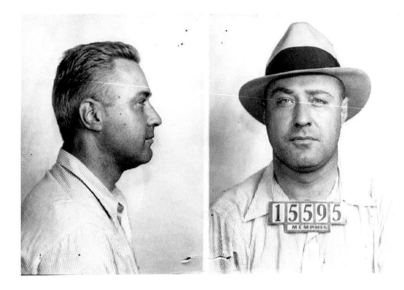

George "Machine Gun" Kelly
Born George Kelly Barnes in 1895, Kelly was sentenced to three years of imprisonment in February 1928 for smuggling liquor onto an Indian reservation. Released for good conduct early in 1930, he then held up several banks between July 1930 and November 1932. In July 1933, he kidnapped an oil magnate and obtained the largest ransom ever paid at the time in the United States: $200,000. Put on record by the FBI as an "expert machine gunner," he was arrested on September 26, 1933, in Memphis, Tennessee, sentenced to life imprisonment, and sent to Alcatraz. On July 18, 1954, he died of a heart attack in the Federal Penitentiary at Leavenworth, Kansas, after 21 years in detention.

ord from: _U S Prison_ _____ (Address) _Alcat_

On the above line please state whether Police Department, Sheriff's Office or County Jail

Date of arrest _Recd Se_

Charge _Kidna_

Disposition of case _____

Residence _F4. N_

Place of birth _Chic_

Nationality _Am_

Criminal specialty _G_

Age _39_ Build

Height _5-10½"_ Comp.

Weight _180_ Eyes

Scars and marks _Mol_

Rt. E. Sm

Cheek.

CRIMINAL HISTORY

NAME	NUMBER	CITY OR INSTITUTION	DATE	CHARGE
R Kelly	#44131	U.S.P. Leavenworth Kans	Transfer to Alcat	

117-a₃

(Please furnish all additional criminal history and police record on separate sheet)

Bonnie & Clyde On May 23, 1934, Bonnie Parker and Clyde Barrow were shot dead in their car in a police ambush on a road near Sailes, Louisiana. There were some 167 bullet marks on the car's bodywork; Bonnie and Clyde were hit 50 times. Inside the car police found numerous license plates, nine handguns, four rifles, two shotguns, and 3,000 rounds of ammunition.

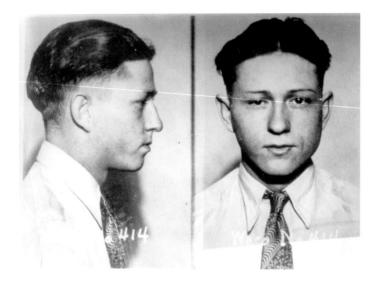

Clyde Champion Barrow

Born March 24, 1909, in Telico, Texas, Clyde was first arrested in 1926 for car theft. In January 1930, while he was wanted for burglary, he met 19-year-old Bonnie Parker. She was married to a certain Roy Thornton, who was in prison for murder. Clyde was arrested shortly afterward, but he escaped from prison using a pistol given to him by Bonnie. A week later he was arrested again. Released on parole in February 1932, he met up with Bonnie, and so began the two lovers' criminal epic. Bonnie and Clyde are believed to have committed 13 murders as well as numerous thefts and burglaries.

The FBI's list of crimes allegedly committed by Clyde Barrow includes:

Murder of a man in Hillsboro, Texas. Armed robberies in Lufkin and Dallas, Texas. Murder of a sheriff and wounding of another at Stringtown, Oklahoma. Kidnap of a deputy in Carlsbad, New Mexico. Theft of an automobile in Victoria, Texas. Attempted murder of a deputy sheriff in Wharton, Texas. Murder and robbery in Abilene, Texas. Murder in Dallas, Texas. Abduction of a sheriff and of the chief of police in Wellington, Texas. Murders committed in Joplin and Columbia, Missouri.

No anthropometric photo of Bonnie Parker exists because she was never arrested.

Opposite: Barrow Wanted poster
Following spread: Clyde Barrow in 1926

WANTED FOR MURDER
$600.00 REWARD
JOPLIN, MISSOURI

On April 13, 1933, these men shot and killed Detective Harry McGinnis and Constable J. W. Harryman at Joplin, Missouri, in suburban residence district.

Reward offered: $200.00 by the City of Joplin
$200.00 by the County of Jasper
$200.00 by the County of Newton
All rewards to be paid upon arrest and conviction

CLYDE CHAMPION BARROW

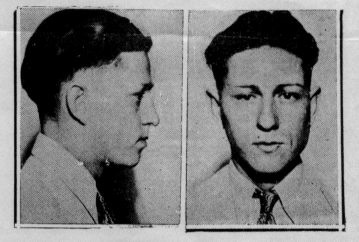

Age 23 years.
Height 5 ft. 7 in. BF.
Weight 125 pounds.
Hair Dark brown, wavy.
Eyes Hazel.
Complexion Light.
Occupation None
Home West Dallas, Texas.

This man is very dangerous; his record shows that he has killed at least three or four men before this and participated in several highway robberies.

FINGER PRINT CLASSIFICATION:
29 — MO 9
26 U 00 9

MELVIN IVAN BARROW

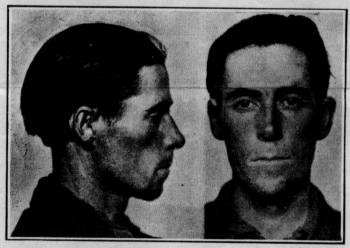

Age 31 years.
Height 5 ft. 5 in. BF.
Weight 110 pounds.
Hair Chestnut.
Eyes Maroon.
Complexion Ruddy.
Occupation Laborer.
Home Dallas, Texas.

This man was pardoned from the Texas Penitentiary on March 23, 1933, by Governor Ferguson.

FINGER PRINT CLASSIFICATION:
9 U 11 9
1 R 11 11

If more than one claimant for reward, parties offering reward will reserve right to apportion as they think proper.

These men made their getaway in a V-8 Ford Coach, Dark Green Color, 1932 model.

They were accompanied by two young women who lived with them in an apartment over the garage where the shooting occured.

The assistance and co-operation of all officers is requested in the apprehension of these men.

Notify Police Department, Joplin, Missouri

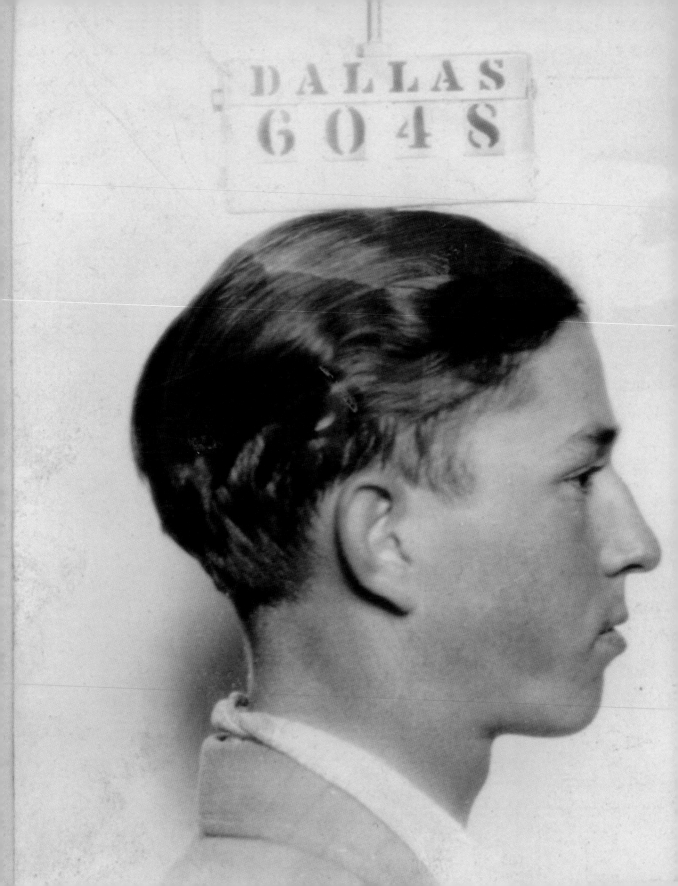

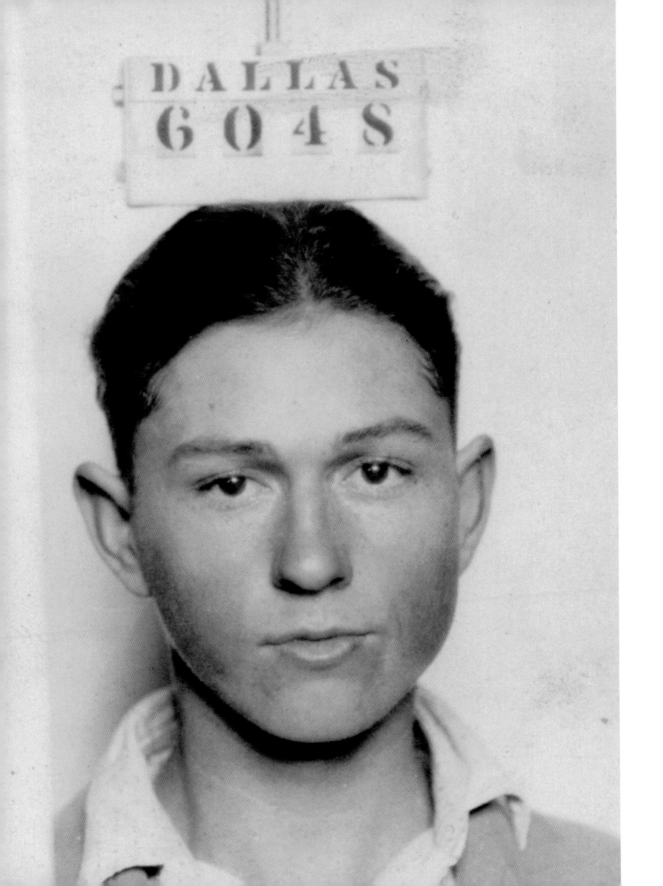

The Barrow-Parker Gang

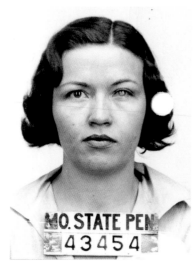

MO. STATE PEN 43454

Blanche Barrow Married to Clyde's brother "Buck," Blanche Barrow was arrested on July 29, 1933 and sentenced to ten years of imprisonment.

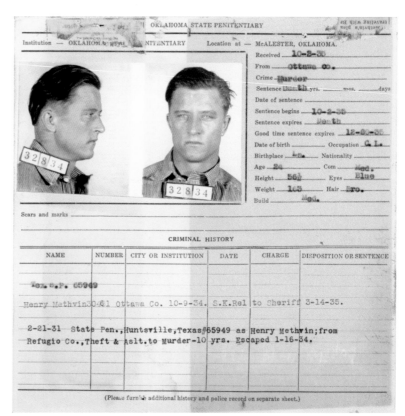

Henry Methvin Sentenced to ten years in prison for murder in 1931, Methvin escaped on January 16, 1934, during an attack organized by Bonnie and Clyde in which two prison wardens were killed. The gang took refuge on the Methvins' family farm near Sailes, Louisiana.

In exchange for the charges against her son being dropped in Texas, Ivy Methvin collaborated with the police and organized the ambush on Bonnie and Clyde on May 23, 1934. Texas honored the agreement. In Oklahoma, however, Methvin was pursued

for the murder of a policeman and received a death sentence, which was later commuted to life imprisonment. After eight years in prison he was given a conditional discharge. He died on April 19, 1948, crushed by a train in Louisiana.

John Dillinger Born June 22, 1903, Dillinger was the first criminal to be labeled "Public Enemy #1." Arrested for burglary in 1924, then accused of assault and battery with intention to steal and plotting to commit a crime, he was sentenced to mixed penalties, from 2 to 14 and 10 to 20 years of imprisonment. Released in May 1933 after eight and a half years of detention, Dillinger reformed his gang and committed numerous bloody heists.

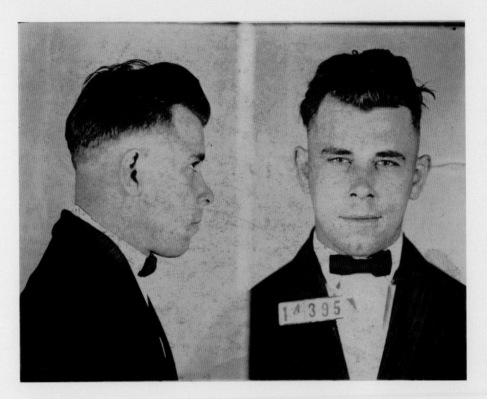

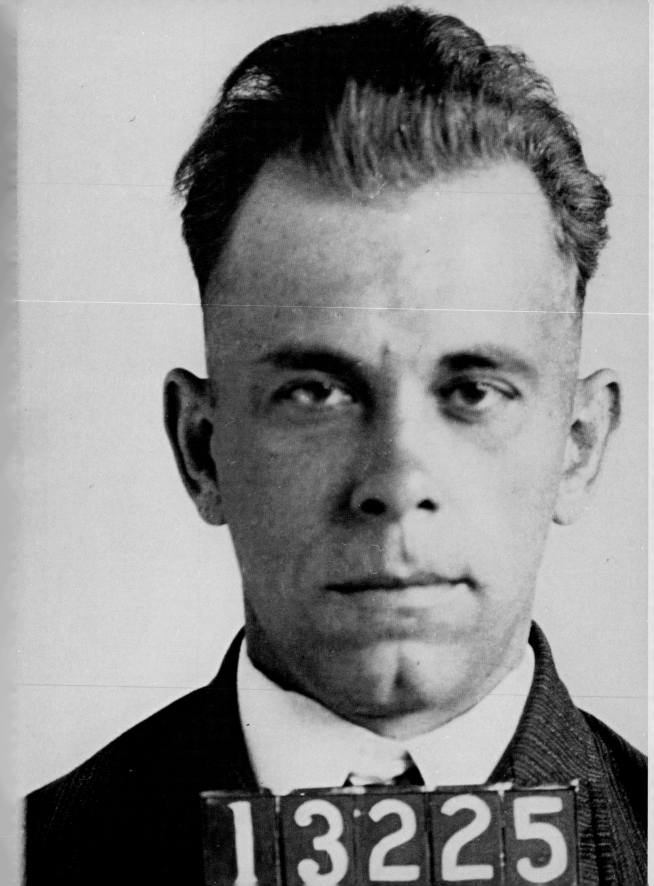

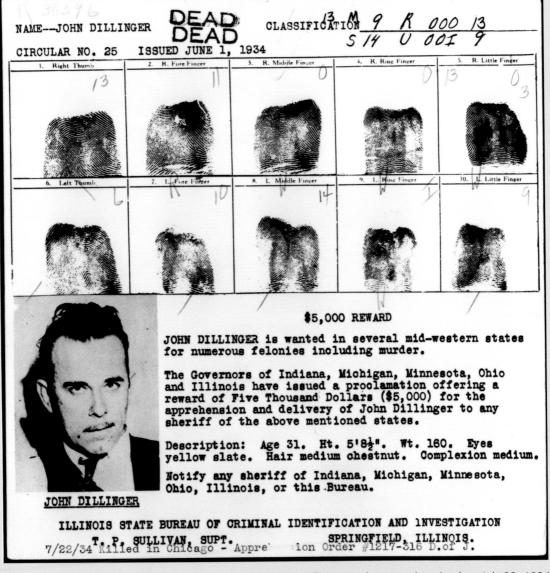

NAME—JOHN DILLINGER

DEAD DEAD

CLASSIFICATION

CIRCULAR NO. 25 ISSUED JUNE 1, 1934

1. Right Thumb 2. R. Fore Finger 3. R. Middle Finger 4. R. Ring Finger 5. R. Little Finger

6. Left Thumb 7. L. Fore Finger 8. L. Middle Finger 9. L. Ring Finger 10. L. Little Finger

$5,000 REWARD

JOHN DILLINGER is wanted in several mid-western states for numerous felonies including murder.

The Governors of Indiana, Michigan, Minnesota, Ohio and Illinois have issued a proclamation offering a reward of Five Thousand Dollars ($5,000) for the apprehension and delivery of John Dillinger to any sheriff of the above mentioned states.

Description: Age 31. Ht. 5'8½". Wt. 160. Eyes yellow slate. Hair medium chestnut. Complexion medium.

Notify any sheriff of Indiana, Michigan, Minnesota, Ohio, Illinois, or this Bureau.

JOHN DILLINGER

ILLINOIS STATE BUREAU OF CRIMINAL IDENTIFICATION AND INVESTIGATION

T. P. SULLIVAN, SUPT. SPRINGFIELD, ILLINOIS.

7/22/34 Killed in Chicago - Apprehension Order #1217-316 D.of J.

Arrested on September 22, 1933, John Dillinger was incarcerated in the county jail at Lima, Ohio. On October 12, after robbing a bank, four of his accomplices—Harry Pierpont, Russell Clark, Charles Makley, and Harry Copeland—mounted a veritable commando raid on the prison and freed Dillinger, fatally wounding a sheriff.

On January 23, 1934, Dillinger and three of his men were arrested in possession of three Thompson machine guns, two Winchester rifles, five bullet-proof vests, and more than $25,000 in cash. A month later he escaped from Crown Point prison in Indiana, having deceived the guards with a gun carved out of wood. Dillinger

was shot dead on July 22, 1934, by FBI special agents as he came out of a cinema in Chicago. He had just watched *Manhattan Melodrama,* starring Clark Gable, a movie whose French title is *L'Ennemi public n° 1* (Public Enemy #1). The 2009 American movie *Public Enemies* has Johnny Depp starring as Dillinger.

The Dillinger Gang

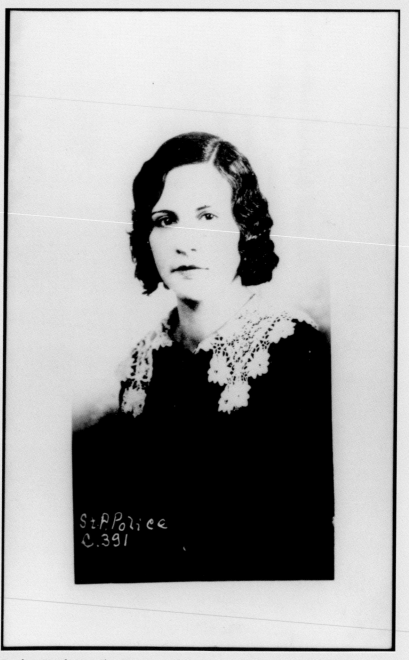

Evelyn Frechette The FBI arrested Evelyn Frechette, Dillinger's girlfriend, on April 9, 1934, in Chicago. She was sentenced to two years in prison and fined $1,000 for "aiding and sheltering a fugitive."

In March 1934, **Harry Pierpont** (top) and **Charles Makley** (bottom) were found guilty of murdering the sheriff during the attack at the Lima jail on October 12, 1933, and sentenced to death. While attempting to escape on September 22, 1934, Makley was killed and Pierpont was wounded. A month later, on October 17, 1934, Pierpont was executed by electric chair.

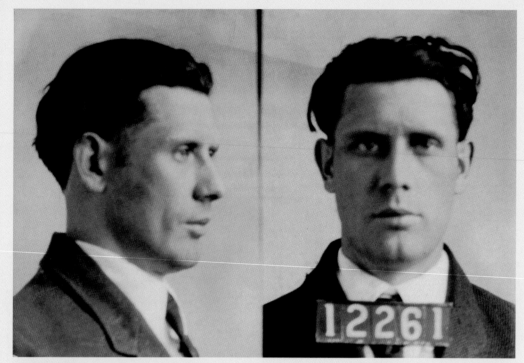

Russell Clark

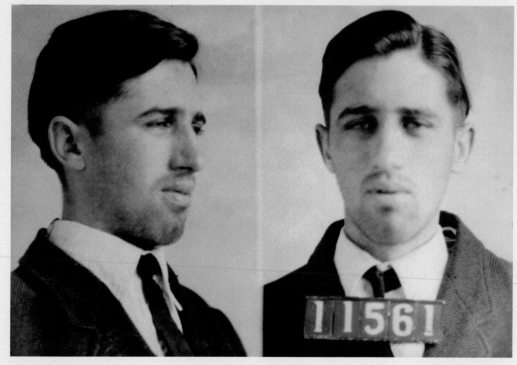

Homer Van Meter

Russell Clark was arrested in December 1927 after robbing a bank in Huntertown, Indiana. He escaped in 1933, but was then recaptured in 1934, along with Dillinger, Makley, and Pierpont, and was sentenced to life imprisonment. Suffering from cancer, Russell Clark was released for medical reasons in August 1968 after 34 years in prison. He died in Detroit on December 24, 1968.

Homer Van Meter was charged with car theft on January 11, 1924, then sentenced to a term of 10 to 21 years in prison for robbing the passengers on a train in Indiana. After being given a conditional discharge in May 1933, he joined the Dillinger gang and "Baby Face" Nelson. He was shot dead by police on August 23, 1934.

Harry Copeland, one of Dillinger's accomplices, was arrested in Chicago in November 1933. He died in Detroit on December 7, 1963.

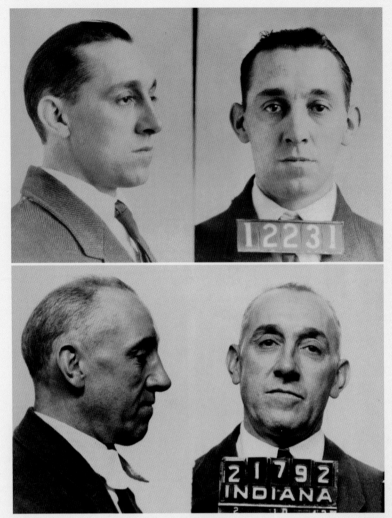

Harry Copeland in 1933 (top) and 1942 (bottom)

"Baby Face" Nelson Born Lester Joseph Gillis on December 6, 1908, in Chicago, he was known as "Baby Face" Nelson because of his youthful appearance and height of just 5'5" (1.63 m). His first conviction was for car theft when he was 14 years old. Then in 1931, he was sentenced to one year in jail for armed robbery. In February, while awaiting sentence for another heist, he escaped from prison. In April 1934, he joined the Dillinger gang and killed an FBI agent who was trying to question him. On June 30, "Baby Face" and Dillinger committed a bank robbery in South Bend, Indiana, during the course of which a police officer was killed. In July, after Dillinger's death, "Baby Face" fled Chicago and went to California. He was stopped for speeding in a small town, but the policeman, failing to recognize him, gave him a fine of five dollars and let him drive off in his car . . . which was loaded with machine guns, rifles, and ammunition. On November 27, 1934, "Baby Face" was fatally wounded during a shoot-out with FBI agents.

WANTED

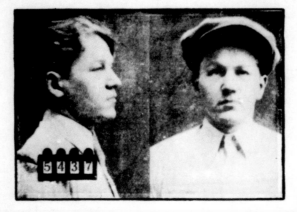

LESTER M. GILLIS,

aliases GEORGE NELSON, "BABY FACE" NELSON, ALEX GILLIS, LESTER GILES,

"BIG GEORGE" NELSON, "JIMMIE", "JIMMY" WILLIAMS.

On June 23, 1934, HOMER S. CUMMINGS, Attorney General of the United States, under the authority vested in him by an Act of Congress approved June 6, 1934, offered a reward of

$5,000.00

for the capture of Lester M. Gillis or a reward of

$2,500.00

for information leading to the arrest of Lester M. Gillis.

DESCRIPTION

Age, 25 years; Height, 5 feet 4-3/4 inches; Weight, 133 pounds; Build, medium; Eyes, yellow and grey slate; Hair, light chestnut; Complexion, light; Occupation, oiler.

All claims to any of the aforesaid rewards and all questions and disputes that may arise as among claimants to the foregoing rewards shall be passed upon by the Attorney General and his decisions shall be final and conclusive. The right is reserved to divide and allocate portions of any of said rewards as between several claimants. No part of the aforesaid rewards shall be paid to any official or employee of the Department of Justice.

If you are in possession of any information concerning the whereabouts of Lester M. Gillis, communicate immediately by telephone or telegraph collect to the nearest office of the Division of Investigation, United States Department of Justice, the local offices of which are set forth on the reverse side of this notice.

The apprehension of Lester M. Gillis is sought in connection with the murder of Special Agent W. C. Baum of the Division of Investigation near Rhinelander, Wisconsin on April 23, 1934.

JOHN EDGAR HOOVER, DIRECTOR,
DIVISION OF INVESTIGATION,
UNITED STATES DEPARTMENT OF JUSTICE,
WASHINGTON, D. C.

June 25, 1934

BUREAU OF CRIMINAL APPREHENSION
IDENTIFICATION DIVISION
488 WABASHA STREET
ST. PAUL 2, MINNESOTA

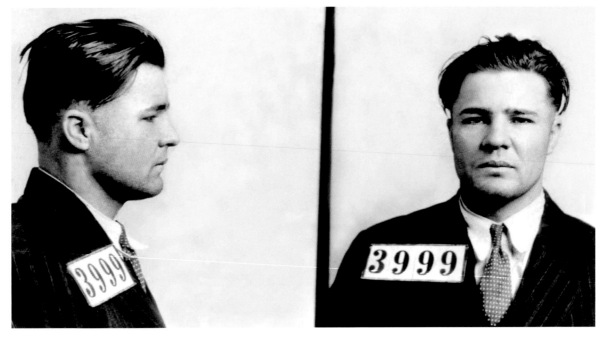

Charles Arthur "Pretty Boy" Floyd Born in 1904, Floyd was convicted in 1925 for a series of armed robberies, then released in March 1929 and arrested again during a hold-up in November 1930. Sentenced to 15 years in prison, he escaped while being transferred to the penitentiary where he was due to serve his sentence. On December 12, 1931, he carried out two heists in a single day in Oklahoma. Declared a "public enemy," Floyd was accused of having participated in the massacre that took place in Kansas City on June 17, 1933. On that day, he and his gang attempted to free a former accomplice who was being transferred to Leavenworth Penitentiary in Kansas. Four policemen and the prisoner were killed, sending shockwaves through America. "Pretty Boy" Floyd was shot dead by FBI agents on October 22, 1934, in East Liverpool, Ohio.

Alvin Karpis Known as "Old Creepy," Karpis was born Alvin Karpowicz in 1907, in Canada. Arrested for theft in 1924, he escaped, then was recaptured in 1926, and sentenced to ten years of imprisonment. During his incarceration in the penitentiary at Lansing, Kansas, he met **Fred Barker** in May 1930. Both were released in 1931, and their partnership became the Karpis-Barker gang, one of the most formidable of the 1930s, responsible for a succession of kidnappings and bloody hold-ups.

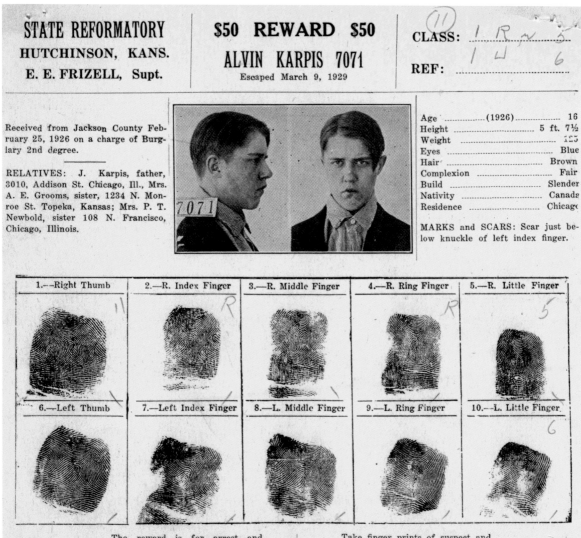

STATE REFORMATORY
HUTCHINSON, KANS.
E. E. FRIZELL, Supt.

$50 REWARD $50
ALVIN KARPIS 7071
Escaped March 9, 1929

CLASS:
REF:

Received from Jackson County February 25, 1926 on a charge of Burglary 2nd degree.

RELATIVES: J. Karpis, father, 3010, Addison St. Chicago, Ill., Mrs. A. E. Grooms, sister, 1234 N. Monroe St. Topeka, Kansas; Mrs. P. T. Newbold, sister 108 N. Francisco, Chicago, Illinois.

7071

Age(1926)............... 16
Height 5 ft. 7½
Weight 125
Eyes Blue
Hair Brown
Complexion Fair
Build Slender
Nativity Canada
Residence Chicago

MARKS and SCARS: Scar just below knuckle of left index finger.

1.—Right Thumb	2.—R. Index Finger	3.—R. Middle Finger	4.—R. Ring Finger	5.—R. Little Finger
6.—Left Thumb	7.—Left Index Finger	8.—L. Middle Finger	9.—L. Ring Finger	10.—L. Little Finger

The reward is for arrest and detention until prisoner is delivered to an officer of this Institution.

Take finger prints of suspect and mail them to us and we will wire you whether or not you have the man.

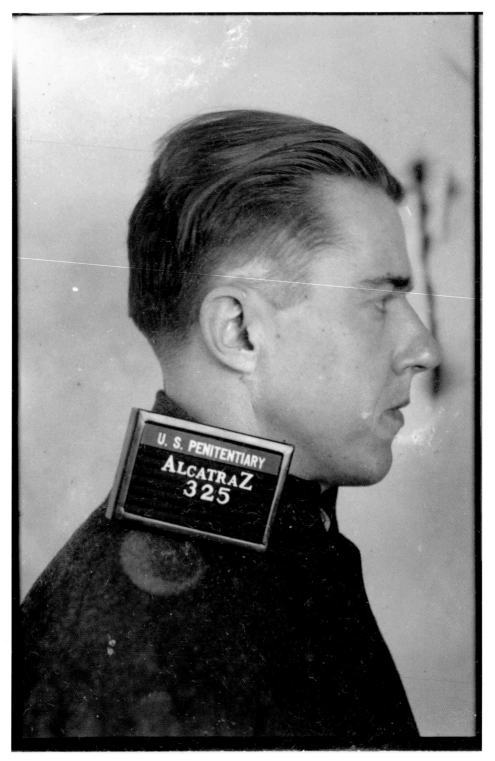

Alvin Karpis

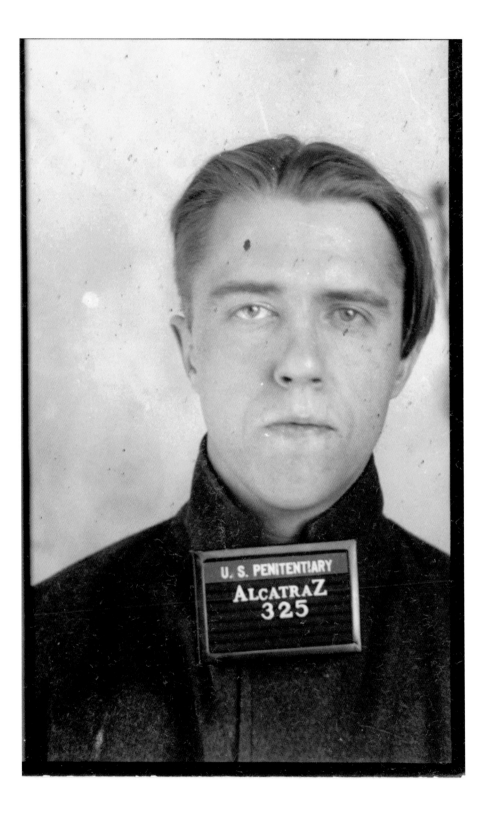

$1,200.00 REWARD $1,200.00

Twelve Hundred Dollars.
WANTED

For the Murder of C. R. Kelly, Sheriff of Howell County, Missouri, on December 19, 1931

8008

Gangsters of Kimes-Inman Gang of Oklahoma Missouri Kansas and Texas

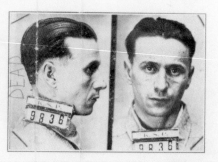

9836

ALVIN KARPIS **FRED BARKER**

DESCRIPTION: ALVIN KARPIS, alias George Dunn, alias R. E. Hamilton, alias Ray Karpis, alias Raymond Hadley, alias George Haller; Age 22; Height 5-9¾; Weight 130 lbs.; Hair-brown; Eyes-blue; Scars-cut SC base L. hand; Occupation, Worked in bakery. FPC 1-R-II-5
1-U-UU-8

Karpis is ex-convict having served State Reformatory Hutchinson, Kansas, 1926, No. 7071 Also State Penitentiary Lansing, Kansas, May, 1930, Crime Burglary.

DESCRIPTION: FRED BARKER, alias F. G. Ward, alias Ted Murphy, alias J. Darrows; Age 28; Weight 120 lbs.; Height 5-4; Build-slim; Complexion-fair; Hair-sandy; Eyes-blue; Teeth-lower front gold, two upper front gold. Sentenced State Reformatory, Granite, Oklahoma. Robbery 1923. Sentenced State Penitentiary Lansing, Kan., March, 1927.
FPC 29-I-20
20-O-22

These men acting together murdered Sheriff C. R. Kelly, West Plains, Missouri in cold blood when he attempted to question them.

The Chief of Police and Sheriff at West Plains, Missouri, will pay a reward of $300.00 each for the arrest and surrender of either of these men to Howell County, Missouri officers. $200.00 additional will be paid on conviction. We will come after them any place.

An additional Reward of $100.00 each will be paid for the arrest and surrender to Howell County officers of A. W. Dunlop and Old Lady Arrie Barker, Mother of Fred Barker. Dunlop is about 65 years of age; slender, white hair, full blood Irishman. Mrs. Barker is about 60 years of age. All may be found together on farm. We hold Felony Warrants for each of these parties.

Police and other authorities: Keep this Poster before you at all times as we want these Fugitives. If further information is desired Wire Collect Chief of Police or Sheriff at West Plains, Missouri.

James A. Bridges
Chief of Police

Mrs. C. R. Kelly
Sheriff

West Plains, Missouri

JOURNAL PRINT, West Plains, Mo.

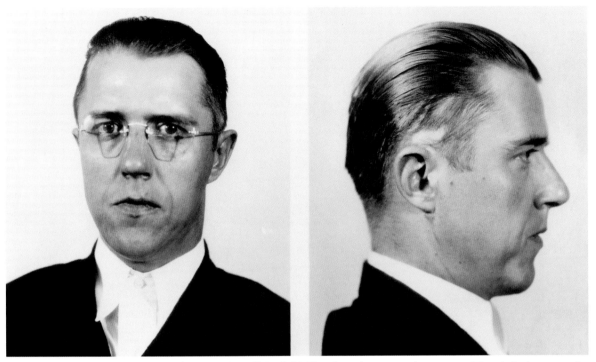

In 1936, Alvin Karpis was arrested in New Orleans by the head of the FBI, J. Edgar Hoover, himself (according to the FBI, but contested by Karpis). He was held for 26 years in Alcatraz, from August 1936 until April 1962, when the penitentiary closed. Karpis was then transferred to McNeil Island Penitentiary in Washington State and was held there until 1969. After 33 years in prison, he was given a conditional discharge and deported to Canada, his country of origin. Karpis died in Spain in August 1979.

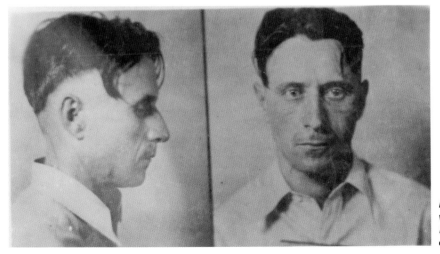

Fred Barker, partner with Alvin Karpis, killed by FBI agents on January 16, 1935

The Lindbergh Affair On March 1, 1932, Charles Lindbergh, Jr., the 20-month-old son of the famous aviator and Anne Morrow Lindbergh, was kidnapped. Despite the fact that a $50,000 ransom was paid, in numbered gold certificates, the baby's body was found buried a few miles from the family's home in Hopewell, New Jersey.

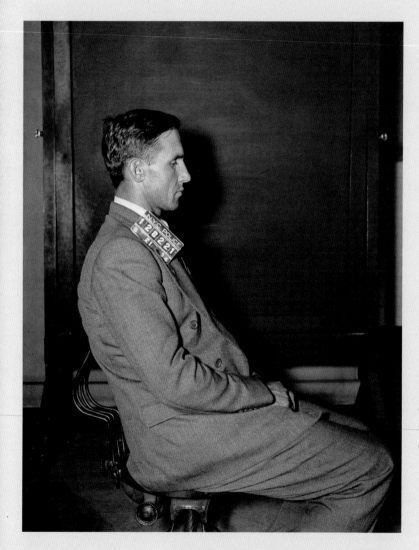

Thirty months later, in September 1934, some gold certificates from the ransom were registered at a bank in New York. They had been cashed in at a gas station. The car's license plate number was found, and its driver was identified: Bruno Richard Hauptmann, of 1279 East 222nd Street in the Bronx. Born in Germany in 1899, he was already convicted of robbery, and he had entered the United States illegally in November 1923. Hauptmann was arrested at home on September 19, 1934. Some $13,000 was found in his garage. Handwriting experts concluded that his writing was similar to that on the ransom demands. On February 13, 1935, following what was described then as "the trial of the century," Bruno Richard Hauptmann was declared guilty of first-degree murder and sentenced to death. He was executed by electric chair on April 3, 1936.

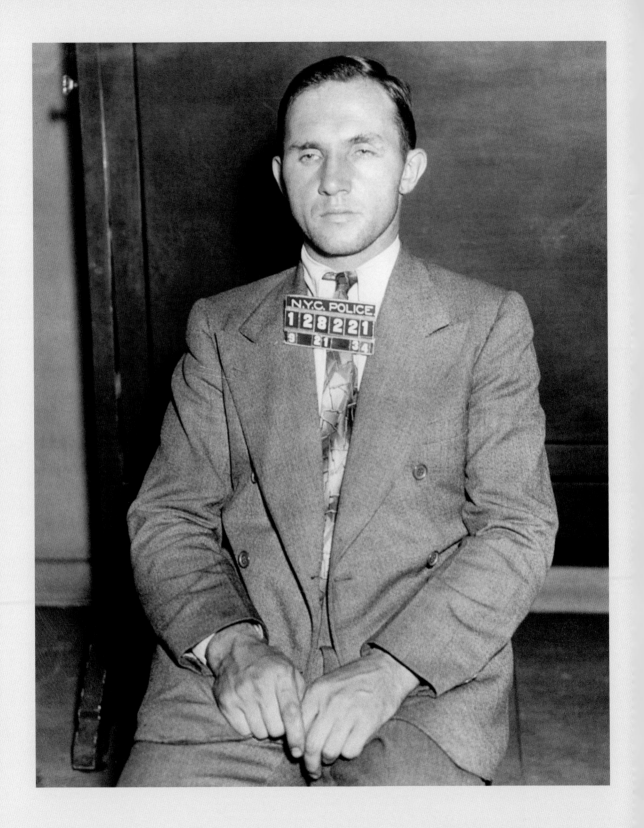

Eugen Weidmann Born February 5, 1908, in Frankfurt am Main in Germany, Weidmann was a serial killer who became the last person to be publicly executed in France. Between July 21 and December 8, 1937, he murdered five people for derisory sums of money. Arrested in December 1937, he was held in the same cell as Henri Charles Désiré Landru (see page 71) in the Versailles prison. After more than a year of investigation, his death sentence was pronounced in March 1939. On June 17, Eugen Weidmann was guillotined at the entrance to the Versailles prison, and many photographs of his execution were published. Shocked by so much publicity surrounding an execution, Prime Minister Edouard Daladier issued a statutory order abolishing public executions.

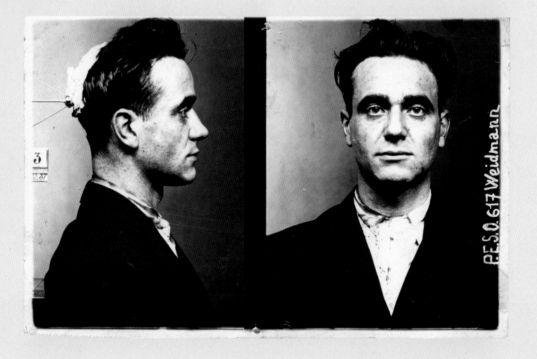

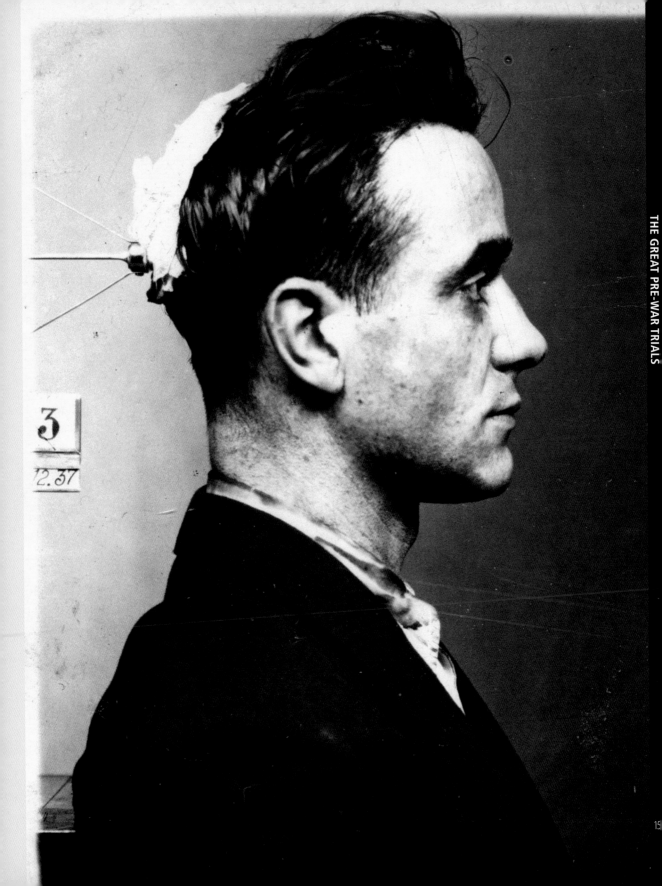

3

12.37

The Saboteurs In June 1942, two groups of German saboteurs landed from a submarine on the beaches of Long Island, New York, and Jacksonville, Florida. Equipped with explosives, detonators, and $175,000, the eight men had been sent to carry out acts of sabotage and espionage throughout the United States. As soon as they landed, however, two of them (Georg Dasch and Peter Burger) began to question whether this mission could be effective. On June 14, Dasch contacted the FBI in New York and negotiated his surrender. On June 19, he gave himself in, providing the identities of the other saboteurs as well as the places where they were likely to be. Between June 20 and 27, the eight men were arrested before they committed any crimes. Tried by a military court, they were sentenced to death, but J. Edgar Hoover, the head of the FBI, appealed to President Franklin Roosevelt on behalf of Dasch and Burger. Dasch was sentenced to 30 years in prison, and Burger to life. The six other saboteurs were executed on August 8, 1942. In April 1948, Dasch and Burger were released and deported to Germany.

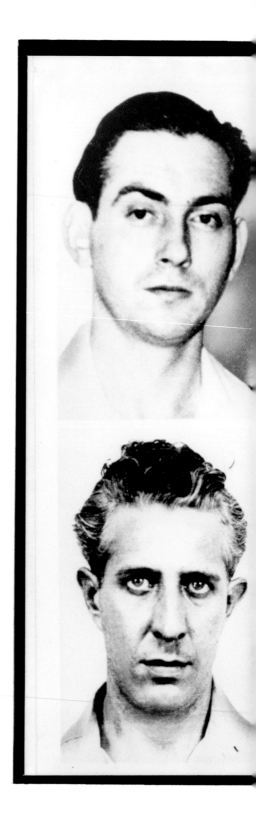

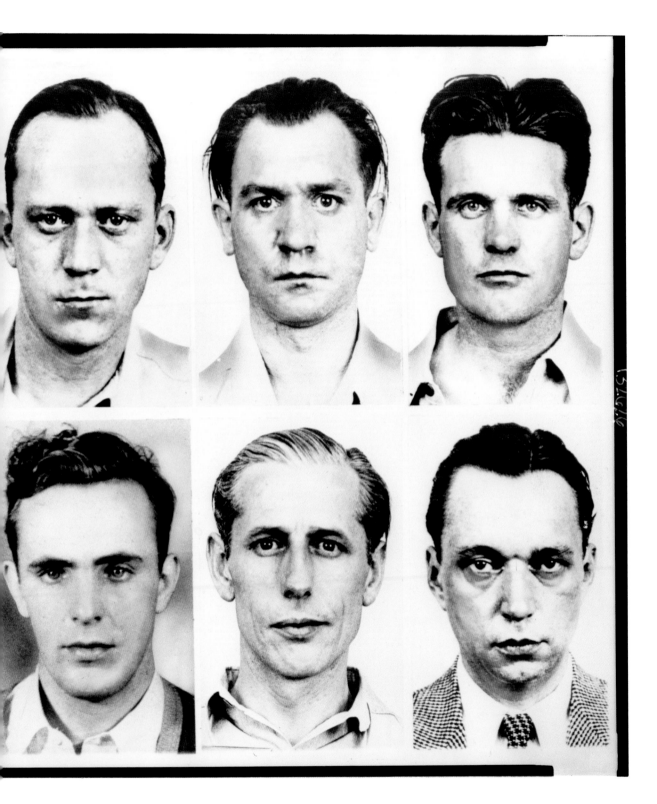

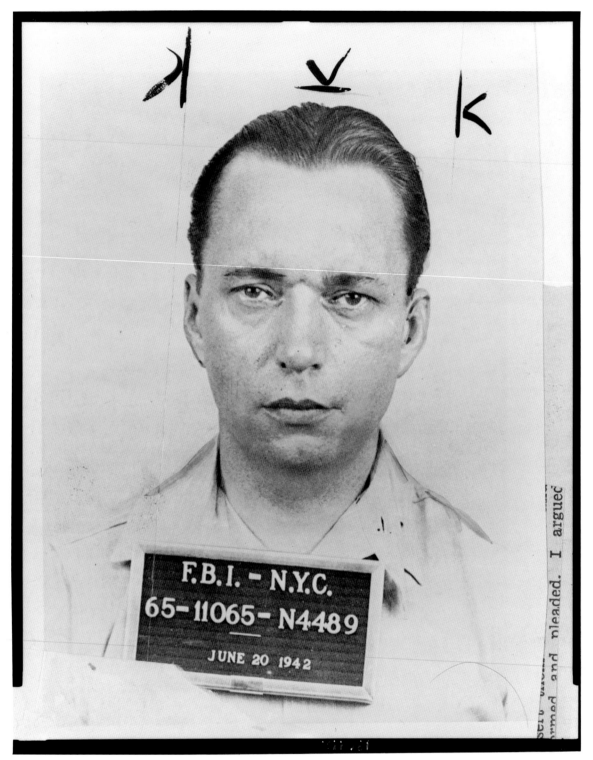

Peter Burger

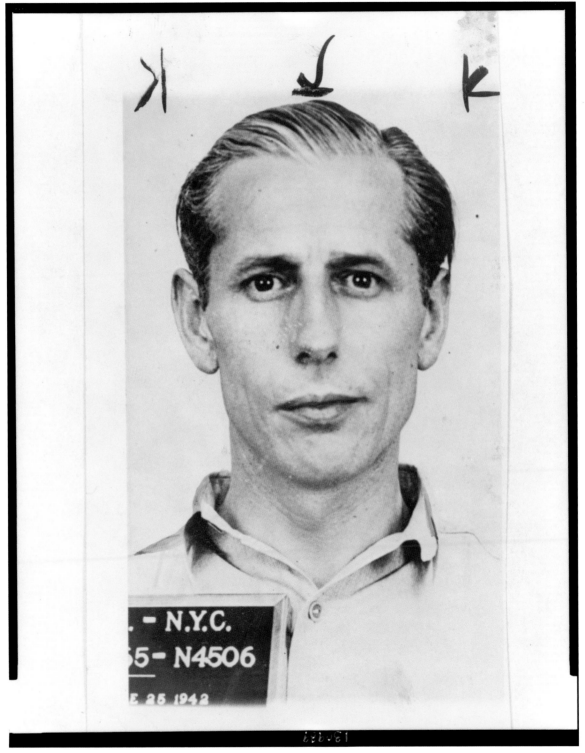

Georg Dasch

The "French Gestapo" In January 1942, the "French Gestapo" set up its headquarters at 93 rue Lauriston in Paris. Also known as "la Carlingue" in French, this den, founded and headed by Henri Lafont (born Henri Chamberlin) and ex-inspector Pierre Bonny, brought together common criminals, former policemen who had been dismissed, and members of the Parisian underworld. Their activities were as much for their own benefit as for that of the Germans and took numerous forms: looting, confiscation of goods, racketeering, score-settling, arresting Resistants, torture, murder . . .

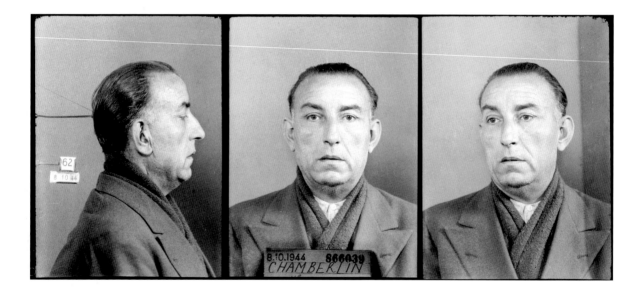

Henri "Lafont" Chamberlin, aka "Henri Norman" or "Monsieur Henri" Born 1902 in Paris, he had 11 convictions for theft, confidence trickery, and fraud between 1919 and 1939. He was sentenced three times to enforced exile. In June 1940, he was incarcerated for not having responded to the mobilization order, and during a prison transfer managed to escape. He then offered his services to the occupying authorities and created the "French Gestapo." He was provided with a German police card, and he recruited his men from Fresnes prison in the north of France. At the beginning of 1944, having become a naturalized German and been named a captain of the SS (Schutzstaffel), he created the North African Legion, whose job it was to track down the Resistants of the FFI (French Forces of the Interior).

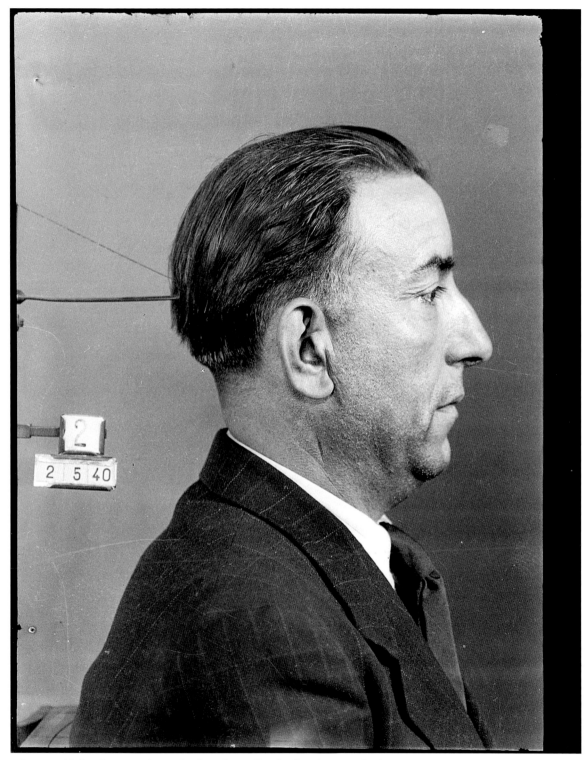

Above and following spread: Henri Lafont, born Chamberlin, photographed on May 2, 1940

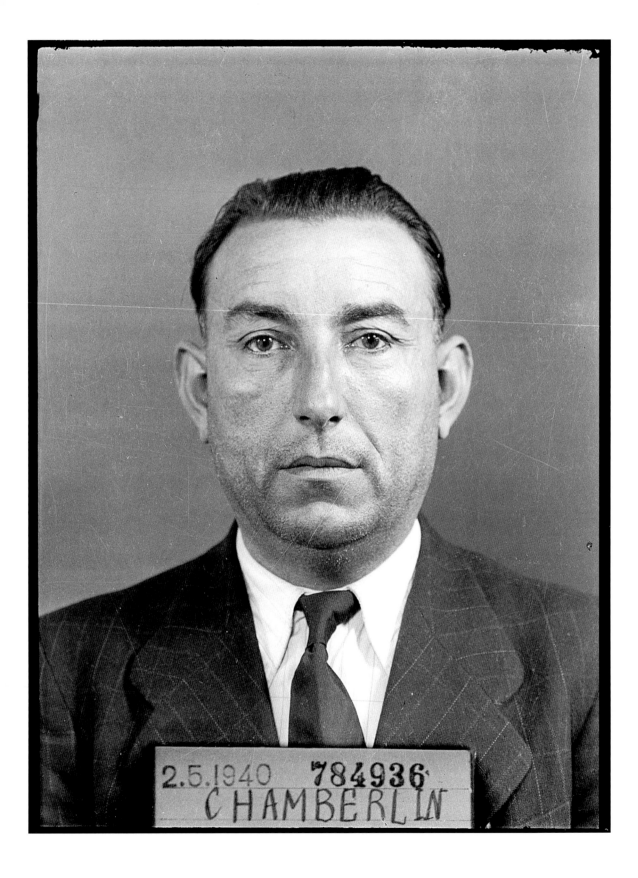

2.5.1940 784936

CHAMBERLIN

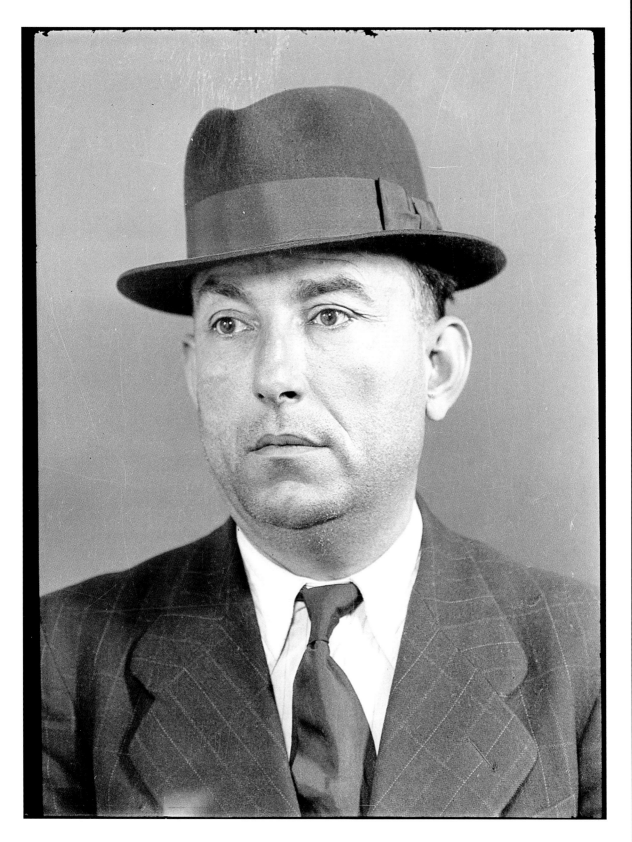

Pierre Bonny Former inspector in the criminal investigation department, Bonny was involved in several political and legal scandals during the Third French Republic.

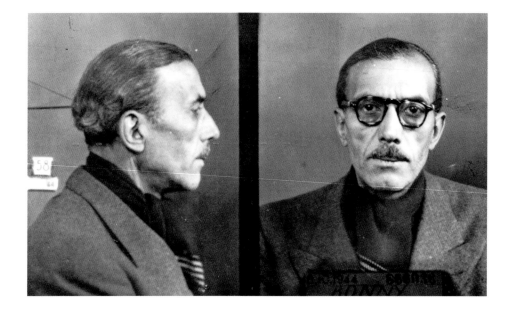

Bonny joined the police in 1918, at the age of 23. In 1923, the Seznec affair (see page 78) made him a celebrity during the course of a controversial search, he found evidence that enabled Seznec to be sent to a penal colony. In 1934, when he was about to be dismissed for an earlier episode of corruption, he "miraculously" rediscovered checkbooks that had disappeared "on a tram seat" during the Stavisky affair (see page 128). He was reinstated and described by the Minister of Justice at the time as "the top police-man in France." Shortly afterward, however, a commission of enquiry discovered that there had been falsification of evidence. In 1935, Bonny was dismissed for grave mis-demeanors and given a three year suspended sentence for misuse of his position and corruption. In April 1942, he joined Henri Lafont at the head of the "French Gestapo," specializing in interrogation and torture. Henri Lafont and Pierre Bonny were informed on by Joseph Joinovici and arrested on August 30, 1944. They were sentenced to death and executed by firing squad at the Fort de Montrouge, France, on December 26, 1944. It is said that just before he died, Bonny made a statement about Seznec: "I regret having sent an innocent man to the penal colony."

Joseph Joinovici

An immigrant in France, he was known as "Monsieur Joseph" or "le Chiffonnier milliardaire" (The Millionaire Ragman).

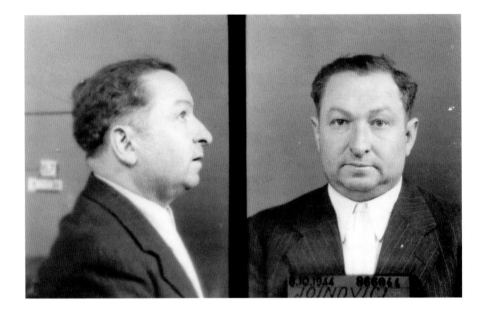

Born in 1905 of a Jewish family in Moldavia, Joinovici arrived in France in 1925 and became a scrap merchant. In September 1941, he was arrested by the Gestapo, then released at the request of Lafont, with whom he had close links. Categorized for four years as a "useful Jew," he sold scrap metal to the Germans and accumulated a colossal fortune.

At the same time, he showed himself to be a rather ambiguous character: He gave financial help to the "Honor of the Police" network of the Resistance at police headquarters, enabled many people—mainly Jews—to escape from the Gestapo, and supplied arms to the police during the insurrection in Paris.

At the time of the Liberation he had many protectors and was able to escape punishment. The law caught up with him in 1949, however, and he was sentenced to five years in prison for economic collaboration with the enemy, lost his French citizen's rights for life, and had his goods confiscated. In 1954, he was placed under house arrest in the south of France. In the hope of making use of the Law of Return, which applies to all Jews, he went to Israel. He was refused entry by the Hebrew state, however, owing to his past as a collaborator. Joinovici was extradited to France, where he was immediately imprisoned. He died ruined in 1965.

Paul Clavié The nephew of Henri Lafont and a leading member of the "French Gestapo," Clavié was sentenced to death for espionage in absentia in July 1942 and executed in 1944.

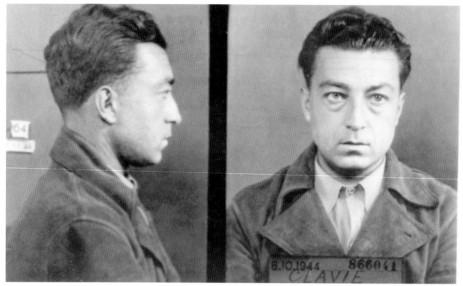

Paul Clavié

Jean Sartore, known as "le Chauve" (the Bald Man) Arrested on November 16, 1944, Sartore was a habitual offender known to the police; thanks to the Occupation he became one of the most powerful figures in the underworld. He financed the "French Gestapo" very effectively with the large fortune he had acquired by trafficking gold, foreign currency, chronometers, and gold cigarette lighters. He dealt with corrupt policemen, sold fake gold ingots, seized and plundered the possessions of Jews, and informed on smugglers who helped Jews escape into the unoccupied zone. He had contact with German Abwehr agents at the Hôtel Lutetia in Paris. He carried out numerous arrests on behalf of the Gestapo, some of which involved violence and torture.

Opposite: Jean Sartore, photographed on April 23, 1965, and his sentence to forced labor for life

... était arrêté le sieur SART...
... la rue de Lauriston dont le...
...te connu de la police, SART...
... des plus puissants seigne...
...ine, il se livra à de nom...
...te de l'occupant.

... française, avec la fortune...
...l'or, des devises étrangé-
...protection de LAFON et de...

...ux policiers" et à une...
... de nombreuses perquisitions, sai...
...s juifs et avoua avoir procédé à l'ouverture de...
...appartements dans Paris.

En Juin 1941, il dénonça à la Gestapo l'existence de jeunes " passeu...
spécialistes dans le passage en zônelibre, de juifs, d'or et de bijoux.

Il eut des contacts certains avec des agents de l'Abwehr, à l'Hôtel
Lutétia et partagea leurs activités.

Courant 1942, il effectua des transports de postes émetteurs vers l'
Algérie en vue de leur utilisation par le S.R. Allemand en Afrique du Nor...

Il procéda, pour le compte de la Gestapo à de nombreuses arrestation...
dont certaines furent accompagnées de violences et de tortures, dans di-
verses régions de France. C'est ainsi qu'en décembre 1942, il arrêta le
sieur GENTY agent du 2éme Bureau, le Commissaire de Police ESCUDE qui
devait trouver la mort dans les camps d'extermination allemands, le comma...
dant CLIFFAY, les époux LACOMBE. Il participa en Octobre 1943 à une souri...
re montée rue Casimir Périer, où furent arrêtés plusieurs personnes et en
Novembre 1943 à l'expédition de MONTBARD contre des maquisards où furent
arrêtés les sieurs LABILLE, RENE, STICK et où il blessait le jeune KACKEL...

En Juin 1943, il participait à une tentative de cambriolage des loc...
de la Direction Générale du Ravitaillement, à AUXERRE, où étaient entrepo...
des stocks de titres d'alimentation pour tout le département de l'Yonne. ...
participait à l'anéantissement de l'organisation clandestine de résistanc...
"Défense de la France".

A compter de Juillet 1944, SARTORE est considéré comme un des princ...
"tueurs" de LAFON se livrant à de nombreuses arrestations, exécutions, et...
tortures.

Enfin aux côtés de LAFON, SARTORE participa à de nombreuses opérati...
de contre-parachutage.

Le nommé SARTORE a été condamné le 8.5.1948 par la 11ème sous secti...
de la Cour de Justice de la Seine aux Travaux Forcés à Perpétuité, Dégra-
dation Nationale, 20 ans d'interdiction de séjour et confiscation des bie...

Fait au Parquet de la Cour de Justice de la
Seine

Le 1 OCT 1955

LE COMMISSAIRE DU GOUVERNEMENT

Nota. — Il importe de signaler, dans cet exposé, spécialement les circonstances qui attestent le degré d'audace ou de perversité du condamné
et de faire connaître son attitude, soit pendant l'instruction, soit à l'audience.

Il importe aussi de faire connaître, quand l'interdiction de séjour sera encourue, les lieux où il devra être interdit au condamné de paraître.

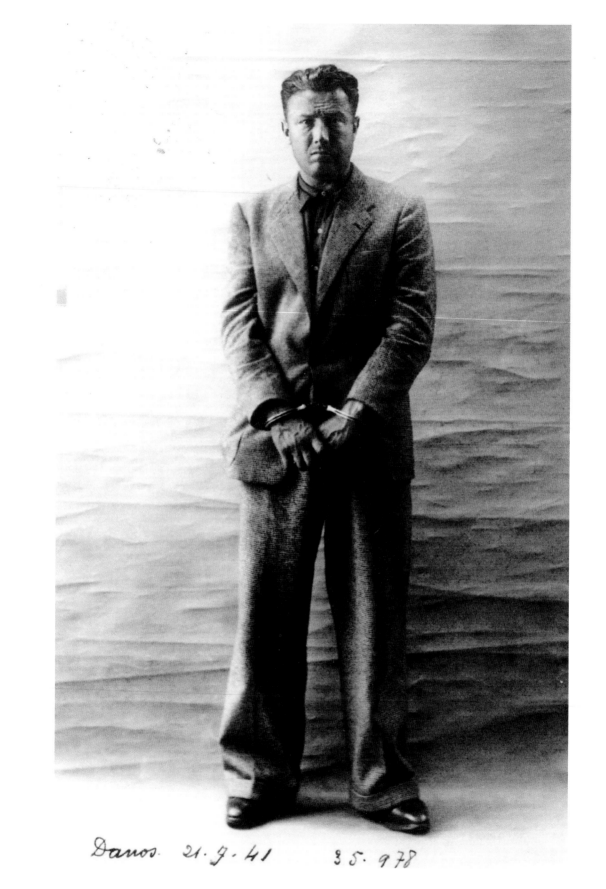

Danos. 21.7.41 35.978

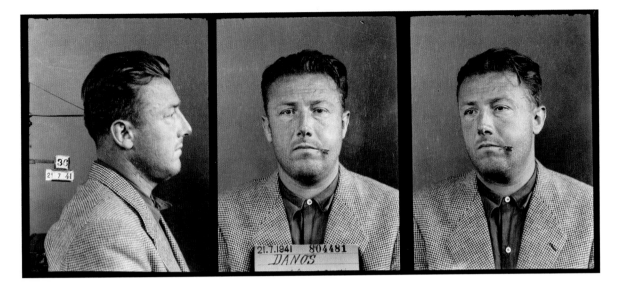

Abel Danos, known as "le Danois" (the Dane) and "le Mammouth" (the Mammoth) Born October 4, 1904, between 1919 and 1939, Danos received six convictions for burglary, possession of weapons, violence, breach of residence ban. . . . Arrested in July 1941 for his part in the first hold-up of the Occupation at the CIC bank (Crédit Industriel et Commercial) in Paris, he was released by Henri Lafont and became one of the killers for the "French Gestapo." When France was liberated, he joined a famous Paris gang called the "Gang des tractions." After four years on the run, he was arrested in November 1948 and sentenced to death for treason in 1949. He was executed by firing squad on March 14, 1952, at the Fort de Montrouge in Paris.

Following double page: Louis Estébétéguy, brother of Adrian Estébétéguy

His Wanted card says:
Taken on by Lafont as a porter at rue Lauriston in March 1943. His job was to bring visitors in to see Lafont or Bonny. Mr. Estébétéguy, who has three sentences, was in possession of a German police card, #03069CC. He was also armed with a 6.35-mm pistol. His reputation would appear to be dubious.

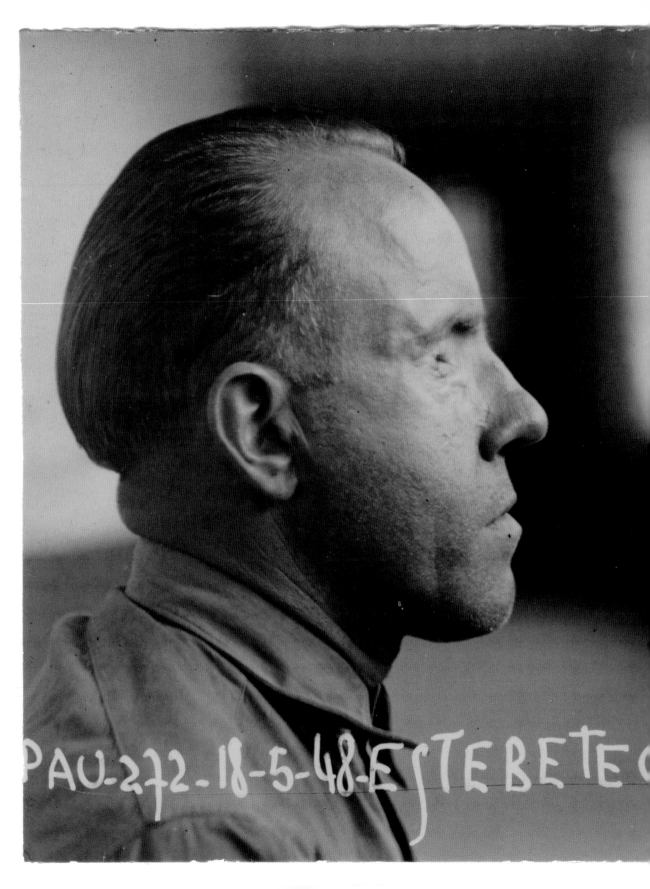

PAU·272·18·5·48·ESTEBETEC

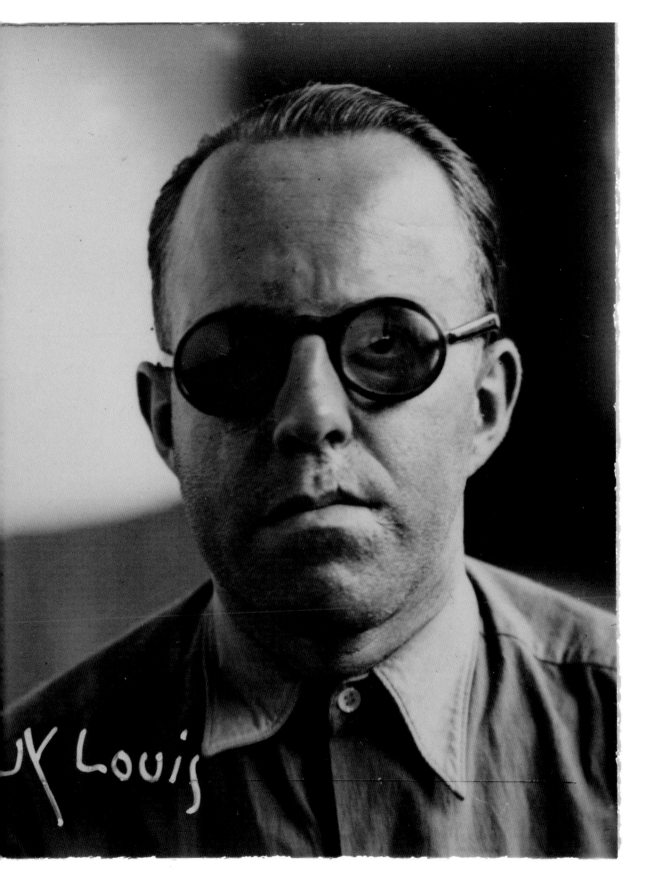

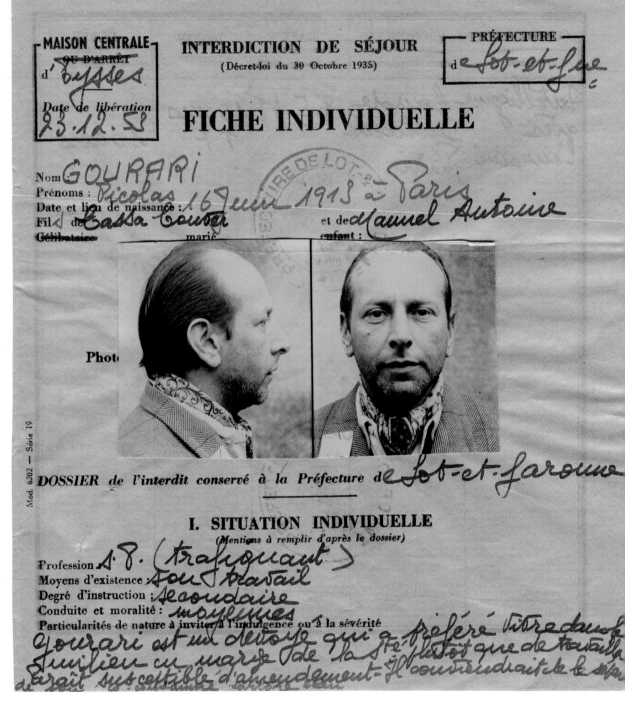

MINISTÈRE DE L'INTÉRIEUR

DIRECTION GÉNÉRALE DE LA SURETÉ NATIONALE

MAISON CENTRALE OU D'ARRÊT	INTERDICTION DE SÉJOUR	PRÉFECTURE
d'*Eysses*	(Décret-loi du 30 Octobre 1935)	de *Lot-et-Gne*
Date de libération 23.12.5?		

FICHE INDIVIDUELLE

Nom GOURARI
Prénoms : *Nicolas* 16 *Juin* 1913 à *Paris*
Date et lieu de naissance :
Fils de *Cassa Couser* et de *Mannel Antoine*
~~Célibataire~~ marié enfant :

DOSSIER de l'interdit conservé à la Préfecture de *Lot-et-Garonne*

I. SITUATION INDIVIDUELLE
(Mentions à remplir d'après le dossier)

Profession *A.P. (trafiquant)*
Moyens d'existence : *Son travail*
Degré d'instruction : *Secondaire*
Conduite et moralité : *moyennes*
Particularités de nature à inviter à l'indulgence ou à la sévérité *Gourari est un dévoyé qui a préféré vivre dans le milieu en marge de la Sté plutôt que de travailler ... serait susceptible d'amendement. Il conviendrait le le dép...*

Adrien Estébétéguy, known as "le Basque" A member of the "French Gestapo" right from the beginning, at the end of 1943, Estébétéguy decided to lie low for a while following a disagreement with Lafont. He knew of an escape channel called "Fly Tox" that organized passages abroad, and he paid a visit to a certain Doctor Petiot, from which he never returned.

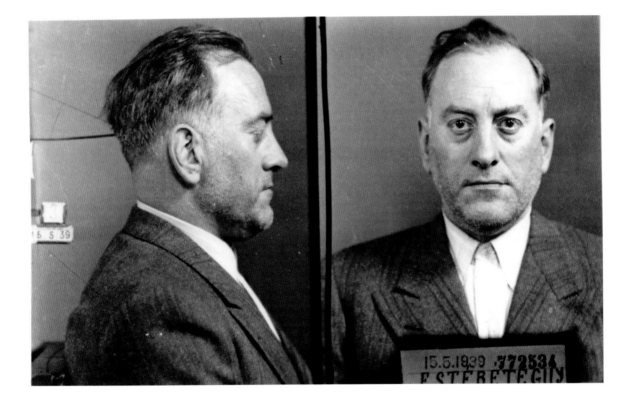

Opposite: Trafficker Nicolas Gourari, a member of "la Carlingue," was a close accomplice of Jean Sartore.

The French residence ban notice specifies:
Gourari is an errant who chose to live in the margin of society rather than work.

Dr. Marcel André Henri Félix Petiot Born on January 17, 1879, in Auxerre, France, Petiot was mayor of Villeneuve-sur-Yonne in 1927, then was elected member of the regional council in 1931.

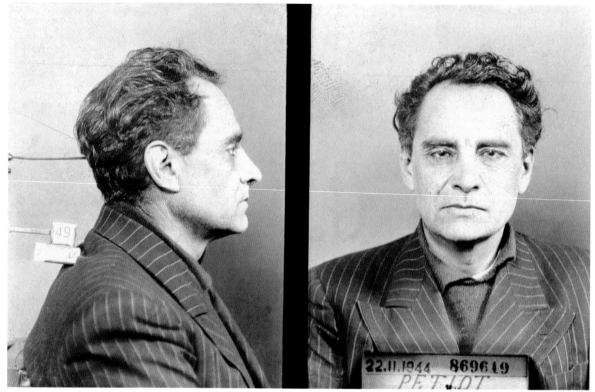

Petiot was dismissed from office in 1935 for various offenses: embezzlement, theft of electricity, false health insurance claims, and financial irregularities. In 1941, during the Occupation, he set up his medical practice in Paris in a private mansion at 21 rue le Sueur. Using the name "Doctor Eugène," he claimed to be at the head of an escape network, and in exchange for large sums of money offered to smuggle Jews and people sought by the German police into Spain or South America. Far from helping them escape, Petiot did away with his victims using a mixture of cyanide, potassium, and sulphuric acid in the cellar of his mansion. On March 11, 1944, thick smoke was seen coming out of his home. When the firemen came, they discovered an arm and some incinerated human skulls in a boiler. Nearby was a pile of dismembered bodies, waiting to be burned. Petiot escaped from the police and joined the French Forces of the Interior under the name of "Capitaine Valéry." He was unmasked and arrested on October 31, 1944. Found guilty of 26 murders by the district court for the Seine region, he was sentenced to death and guillotined in Paris on May 25, 1946.

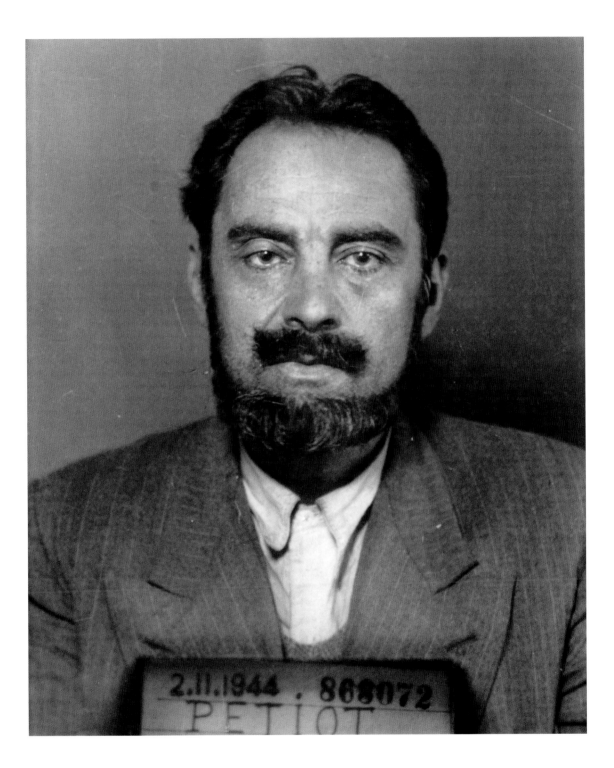

Hermann Goering On May 7, 1945, Marshall Goering was captured by the American army in Austria and interned in the American camp at Mondorf-les-Bains in Luxemburg. The Nuremberg Trial opened on November 20, 1945. Goering was the highest-ranking Nazi to appear before the tribunal. On October 1, 1946, he was sentenced to death for conspiracy to wage aggravated war, crimes against peace, war crimes, and crimes against humanity. Two hours before his execution, Hermann Goering committed suicide in his cell by swallowing a cyanide pill.

Amon Goeth Commandant of the concentration camp at Plaszow near Krakow, Poland, from February 1943 to September 1944, Goeth was arrested in May 1945 and went on trial before the Supreme National Tribunal of Poland on August 27, 1946. He was found guilty of the destruction of the Krakow ghetto and the death of 20,000 people, most of them Jews. Sentenced to death by hanging, Amon Goeth was executed on September 13, 1946, after giving the Nazi salute. In 1993, Ralph Fiennes played the role of Amon Goeth in Steven Spielberg's film *Schindler's List*.

Adolf Eichmann. A high-ranking Nazi official and member of the SS, Eichmann was responsible for the logistics of the "Final Solution." As head of the Office of Jewish Affairs at the Reich's Central Security Service, he organized the transportation of Jews to Auschwitz. In 1945 he fled to Austria, and in 1950 he settled in Argentina under the name "Riccardo Klement." On May 11, 1960, he was picked up on the streets of Buenos Aires by agents of Mossad, the Israeli secret service. His trial began in Jerusalem on April 11, 1961. The 15 charges against him included crimes against the Jewish people and crimes against humanity. Found guilty of all charges, he was sentenced to death and hanged on June 1, 1962.

Israeli police documents dated August 8, 1960 and February 27, 1961

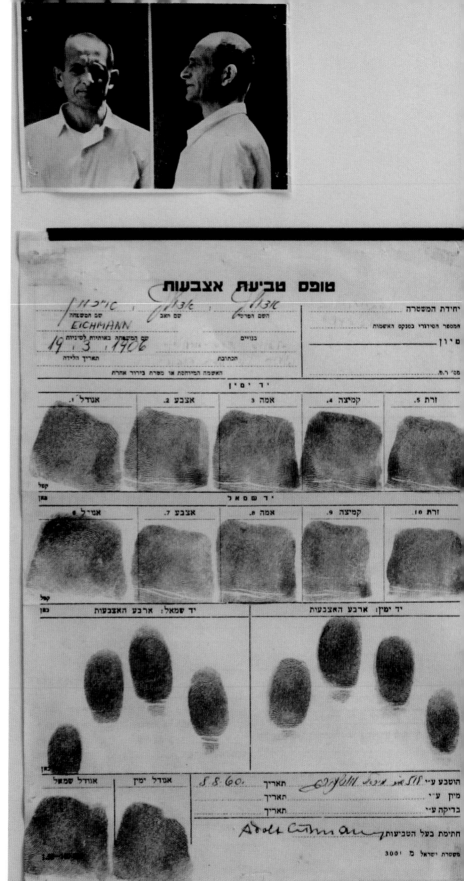

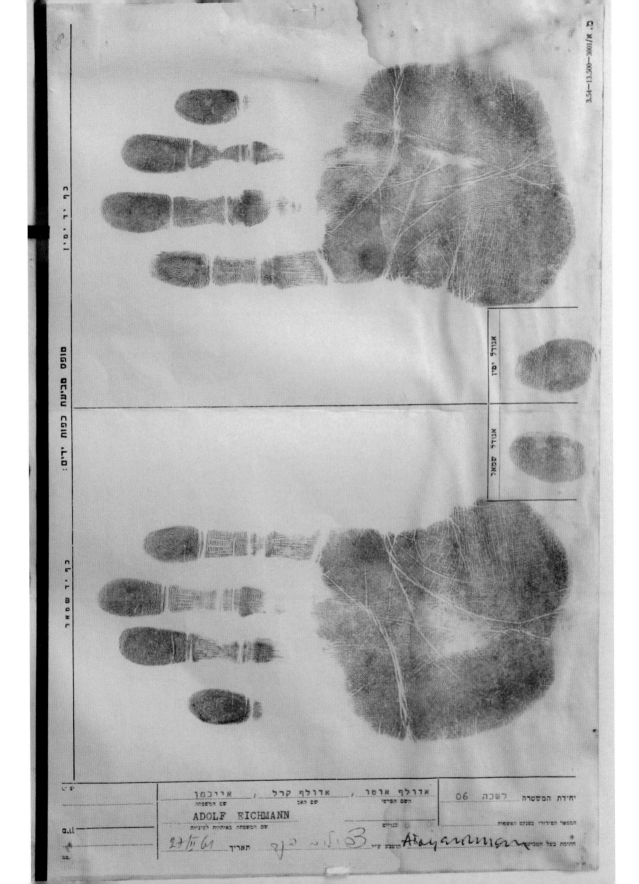

3.54—13.500—13001.א

כף יד ימין

אצבע אגודל

אצבע קמיצה

כף יד שמאל

טביעת אצבעות בלבד מ.ט:

כף יד שמאל

יחידת המשטרה לשכה 06

המספר הסידורי בסנקט האישאות

חתימת בעל הטביעות

יש

אדולף אוסר , אדולף קרל , אירכמן
השם הפרטי שם האב שם המשפחה

ADOLF EICHMANN
שם המשפחה באותיות לטיניות

כנויים

תאריך 27/5/61

Tokyo Rose During the Second World War, Radio Tokyo put out daily English-language propaganda broadcasts intended to demoralize the American troops in the South Pacific. Tokyo Rose was the generic name given to the female voices heard on the Japanese airwaves.

Photo taken on March 7, 1946, at Sugamo prison in Tokyo.

Iva Toguri D'Aquino had become the most famous of these Tokyo Rose voices, because she was an American citizen born in Los Angeles in 1916 to Japanese parents. After Japan surrendered in August 1945, she was arrested and held in various Japanese prisons. In September 1948, she was extradited to the United States, where she was tried for treason and sentenced to ten years of imprisonment. Released on January 28, 1956, she was later granted amnesty by President Gerald Ford on January 19, 1977. She died on September 26, 2006, having always denied that she had betrayed the United States.

Pierre Loutrel, known as "Pierrot le Fou" (Mad Pierrot) France's first "Public Enemy #1," he was the leader of the "Gang des tractions" after the Liberation.

Identification sheet for "Pierrot le Fou," dated 1946:

Pierre Loutrel, known as "Pierrot le Fou," born March 5, 1916, at Château-du-Loir (Sarthe [France]), son of Amédée and Brocard, Suzanne. Profession: navigator.

Wanted for: murder, armed assaults, member of the Gestapo [from 1941 to 1944].

Description: height 5'7" (1.71 m), hair dark red, eyes medium orange-colored, nose hooked but upturned at the base. Face shaven and mottled.

Distinguishing marks: numerous tattoos on the arms, 'Inch Alla' tattooed under a butterfly below the larynx. Very dangerous individual, always armed. Alcoholic, violent.

During a hold-up on November 6, 1946, "Pierrot le Fou" shot the jeweler who was resisting him. While putting his gun back in its holster he accidentally fired a bullet into his own bladder. He died of the wound shortly afterward, at the age of 30. He was buried secretly by his accomplices, including Jo Attia, on the Île du Chien in Limay, northeast of Paris. His body was not found until three years later, and his death was officially registered in 1959 after an anthropometric analysis was carried out on his skull.

Following two spreads: Mug shots of "Pierrot le Fou," including images of his skull

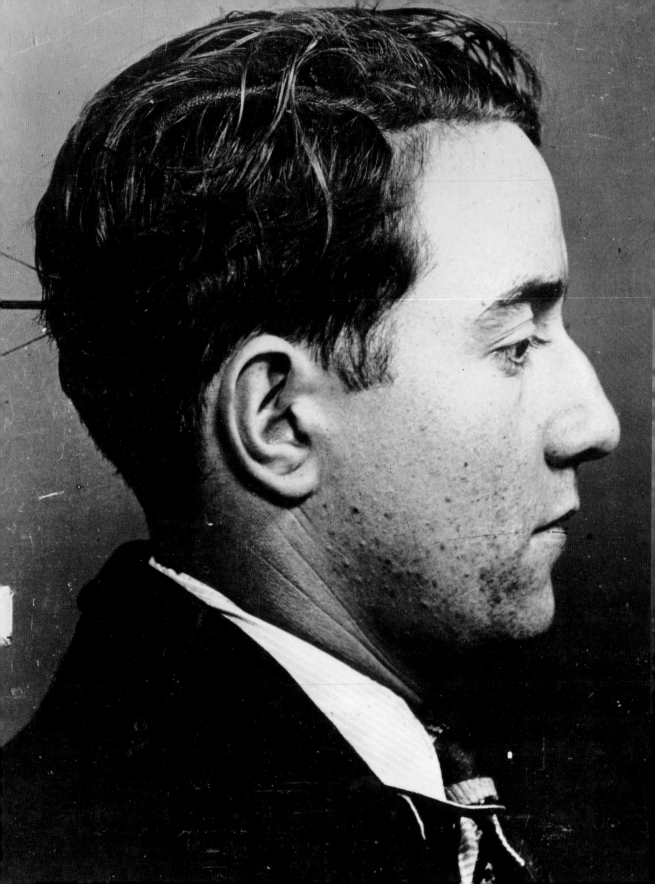

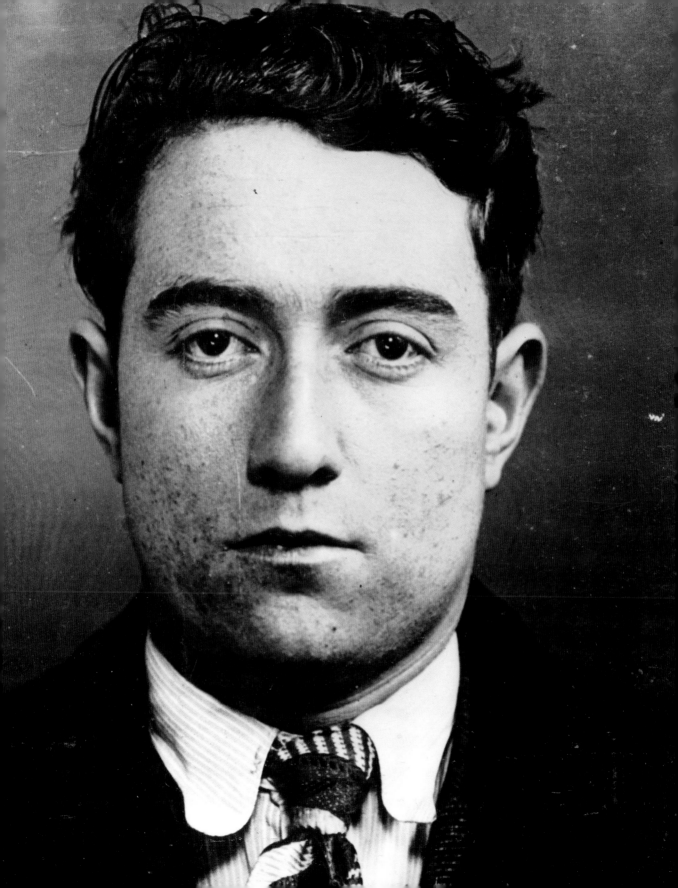

Émile Buisson, known as "Mimile" or "Mimile l'insaisissable" (the Elusive Mimile) Born August 19, 1902, in Saône-et-Loire, Mimile became the new French "Public Enemy #1" after the death of Pierrot le Fou.

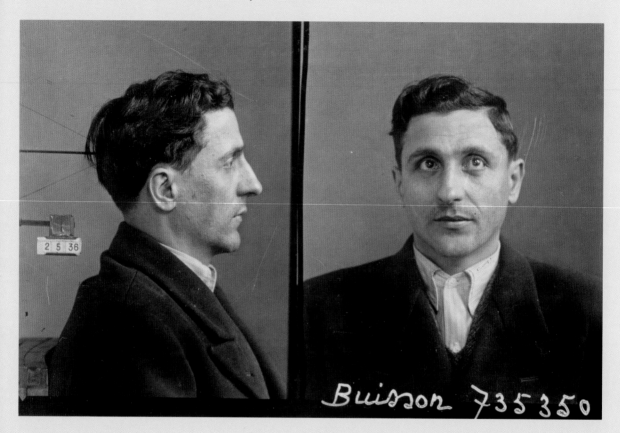

Starting in 1919, Buisson was convicted several times for theft, fraud, and armed robbery. On December 29, 1937, he organized the hold-up at the Crédit Lyonnais bank in Troyes, France, in which 1,800,000 French francs were stolen, a record sum at the time. He was arrested shortly afterward, but he took advantage of the 1940 debacle in France to escape. Other crimes to his name include the hold-up of CIC bank in Paris, with Abel Danos (see page 173), in February 1941—one security guard killed and almost 4 million francs of loot, in what was the first hold-up under the Occupation. He was arrested again in June 1941 and sentenced to hard labor for life. Passing himself off as insane, he was transferred to the psychiatric hospital in Villejuif, south of Paris, from which he escaped on September 3, 1947, along with "René la Canne." Over the next three years, Buisson committed a string of bloody hold-ups and executed two of his closest collaborators: Henri Russac, whom he accused of holding on to stolen jewelry, and Désiré Polledri, known as "Dédé l'Italien" (Dede the Italian). Arrested on June 10, 1950, by Inspector Roger Borniche, he was tried for three murders, eight attempted murders, and no fewer than 20 hold-ups. Buisson was sentenced to death and guillotined on February 28, 1956.

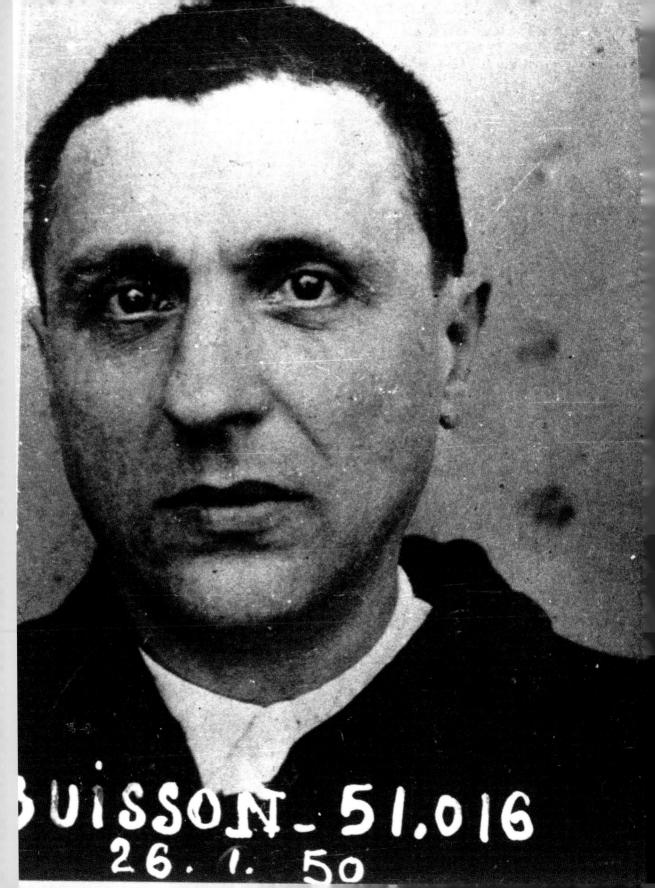

BUISSON. 51.016
26. 7. 50

Émile Buisson's Accomplices

Jean Alès, arrested and photographed on February 24, 1934

Louis Marie Danet, arrested and photographed on December 15, 1934

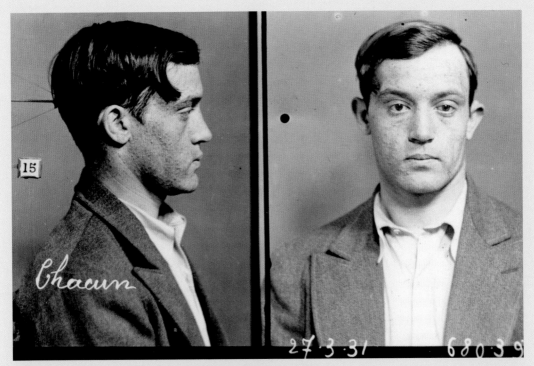

Albert Chacun, arrested and photographed on March 27, 1931

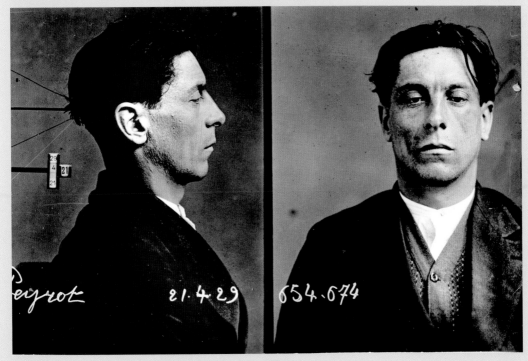

[?] Peyrot, arrested and photographed on April 21, 1929

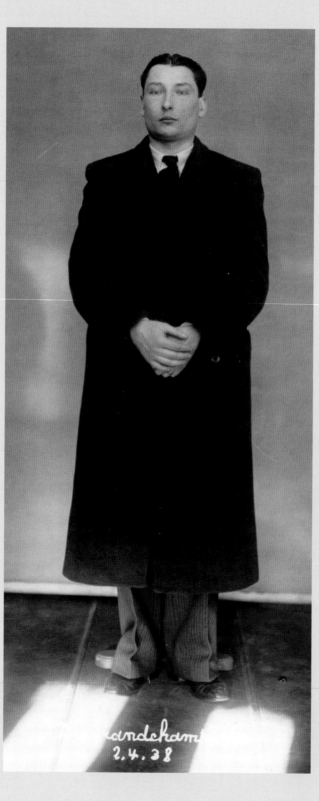

Charles Desgranchamps, known as "Charlot les grands pieds" (the Big Feet Tramp), was an accomplice of Émile Buisson during the famous Crédit Lyonnais bank hold-up in Troyes, France, on December 29, 1937. Desgranchamps was arrested and photographed on April 2, 1938.

René Girier, known as "René la Canne" (René the Walking-stick) and "René le Boiteux" (René the Gimp) Born in 1919 in the Rhône Valley, Girier had 11 convictions between 1948 and 1961 for theft, associating with criminals, possessing weapons, using a forged identity card. ... Nicknamed the "king of escapes," he escaped 11 times during eight years of imprisonment.

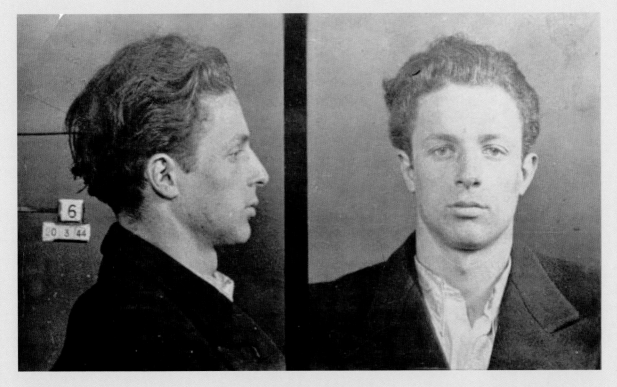

In 1947, while imprisoned for armed robbery, "René la Canne" simulated insanity and was admitted to the prison psychiatric hospital of Villejuif, from which he escaped along with Émile Buisson. In 1949, he was arrested again and incarcerated at the prison in Pont-l'Evêque in the north of France—that time he escaped over the roof. Four months later, on August 2, he was suspected of masterminding the hold-up at Van Cleef & Arpels in Deauville, a few miles north of Pont-l'Evêque, where jewels valued at 65 million old francs were stolen. In November 1950 he was imprisoned in La Santé and escaped while being transferred to Fresnes by sawing through the floor of a patrol wagon. In January 1951, "René la Canne" was arrested by Inspector Roger Borniche and sentenced to eight years of imprisonment. In 1956 he was given a conditional discharge. During his time in prison he became friendly with Princess Charlotte of Monaco (the mother of Prince Rainier II), who visited him in prison, and afterward he became her chauffeur for a while. Having served one last prison term for procuring in 1969, he finally retired from the criminal life and wrote several books, including *Je tire ma révérence* (*I Bow Out*; Paris: La Table Ronde, 1977). He died on January 28, 2000.

Jo Attia, known as "Jo le Moko" or "Jo le Boxeur" (Jo the Boxer)

Born June 10, 1916, Attia's first conviction, at the age of 19, was for theft. In 1937, like many underworld figures at the time, he did his military service at the "Bat d'Af" (battalions of Africa), where he made friends with Pierre Loutrel, later known as "Pierrot le Fou." From 1940 to 1945, he is said to have alternated between organized crime and activities with the Resistance, although there is no concrete evidence to support this. On the contrary, at a hearing before special-division investigators in September 1944, Lafont (see pages 164–67) stated that Jo Attia had worked with the services of the "French Gestapo" and had informed on a network of Resistants. In 1943 Jo Attia was arrested by Lafont (probably due to an underworld dispute), handed over to the Gestapo, tortured, and transported as #34483 to the concentration camp at Mauthausen, Austria. On May 5, 1945, he was released from the camp, where according to numerous accounts he had shown exemplary endurance and courage. In 1946, he joined the "Gang des tractions" along with "Pierrot le Fou" and Abel Danos (see page 173). In 1955, he became a secret agent working for the Services spéciaux (French government spy services) in North Africa. He was arrested by the Spanish police and extradited to France. In March 1958 he was sentenced to one year in prison for concealing a corpse, that of Loutrel. He was given one last sentence in February 1966: two years in prison for fraud. Attia died of cancer of the larynx in 1974.

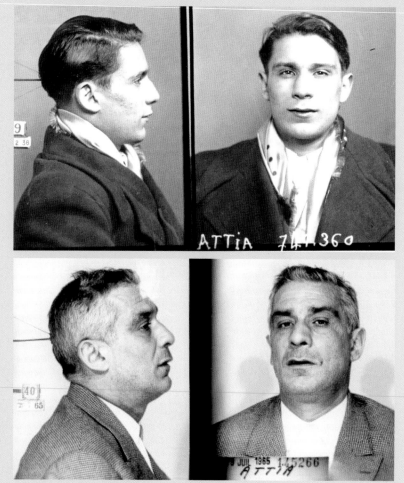

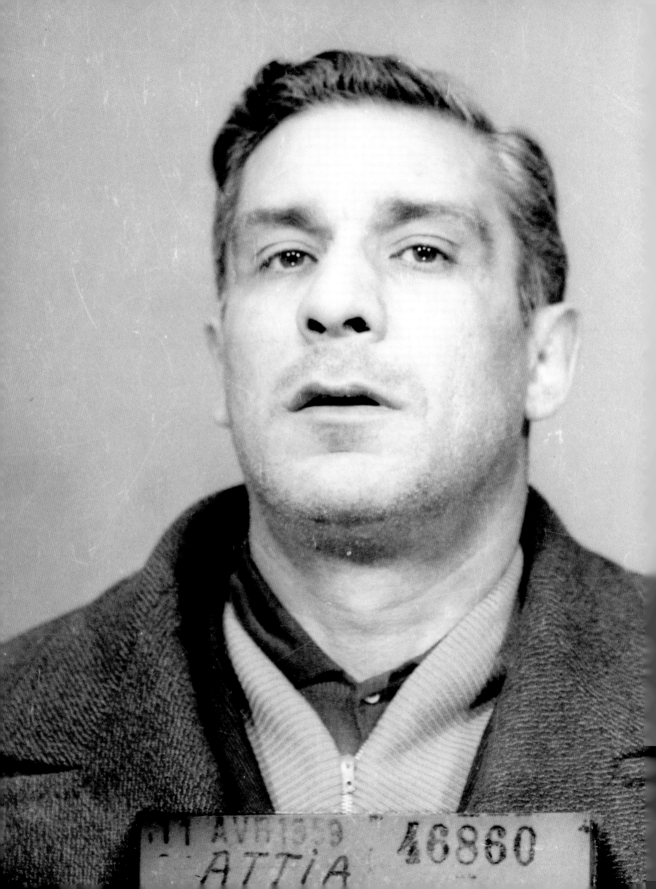

Between 1947 and 1957, at the time of the Cold War, the United States launched into an overzealous fight against Communism. Driven by Senator Joseph McCarthy, **the McCarthy witch hunt** reached its peak between 1950 and 1954. This period saw three major cases: The Hollywood Ten and the trials of Alger Hiss and the Rosenbergs.

The Hollywood Ten

In November 1947, ten screenwriters, directors, and producers were summoned to appear before the HUAC (House Un-American Activities Committee). The Hollywood Ten invoked the First Amendment of the United States Constitution guaranteeing freedom of expression and refused to answer questions about their possible membership in the Communist Party, which in America was illegal. They were all given prison sentences for contempt of Congress and placed on the Hollywood blacklist, which reduced them to unemployment or working in secret. Among them were **Ring Lardner, Jr.** and **Dalton Trumbo**.

Ring Lardner, Jr., screenwriter, had won the Oscar in 1942 for best original screenplay with *Woman of the Year,* starring Katharine Hepburn. He was sentenced to one year in prison and placed on the Hollywood blacklist until the mid-1960s, but he continued to work under various pseudonyms. In 1970 he won a second Oscar for the screenplay of *MASH.*

Dalton Trumbo, screenwriter, was incarcerated for 11 months at the federal penitentiary in Ashland, Kentucky. In 1953, using a pseudonym, he wrote *Roman Holiday,* which won the Oscar for best screenplay. In 1971 he wrote and directed *Johnny Got His Gun,* based on his own novel.

The Alger Hiss Trial Born November 11, 1904, in Baltimore, Maryland, Alger Hiss was a high-ranking official in the U.S. State Department. In August 1948, Whittaker Chambers, the editor in chief of *Time* magazine who was a reformed ex-Communist Party member and spy, accused Alger Hiss of having been a Communist in the 1930s and of being a Soviet spy.

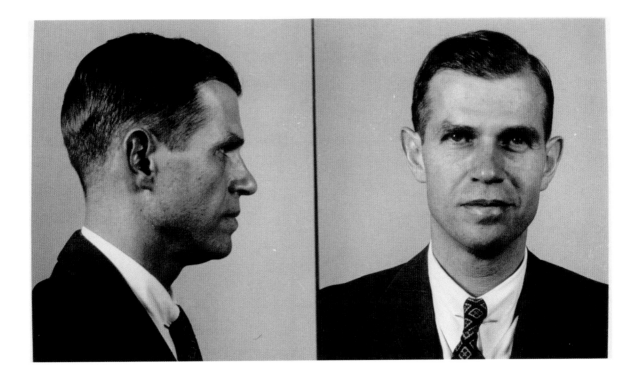

Tried by a federal grand jury, Hiss rejected the accusations of espionage outright and stated under oath that he did not know Chambers. In the course of a new hearing, he went back on his statement and admitted to having met Chambers in 1935. On January 25, 1950, the espionage charges were dismissed for lack of sufficient evidence, but he was sentenced to 44 months in prison for perjury. Until his death in 1996, Alger Hiss always denied having spied for the former USSR. In 1996, some secret documents dating back to the Cold War were declassified. One of them, dated March 30, 1945, refers to a Communist agent known under the name of "Ales." According to the National Security Agency, this is "probably" Alger Hiss. Despite these revelations, the question of his guilt remains controversial to this day.

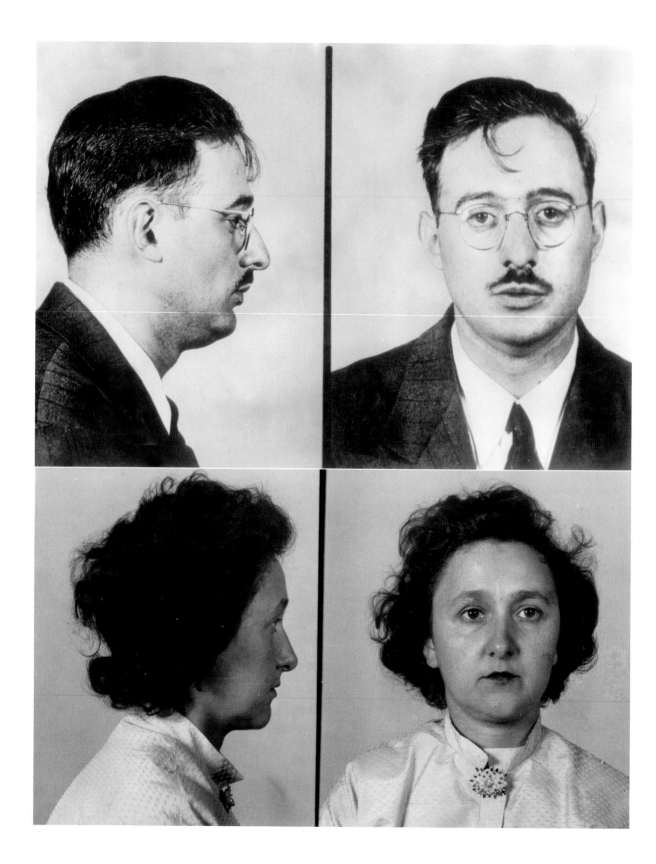

The Rosenbergs Julius Rosenberg was an electrical engineer, born May 12, 1918, in New York and married to Ethel Rosenberg, born September 28, 1915, in New York. Members of the American Communist Party, the Rosenbergs were arrested in 1950 by the FBI and accused of having handed over secrets concerning the atomic bomb to the Soviet Union.

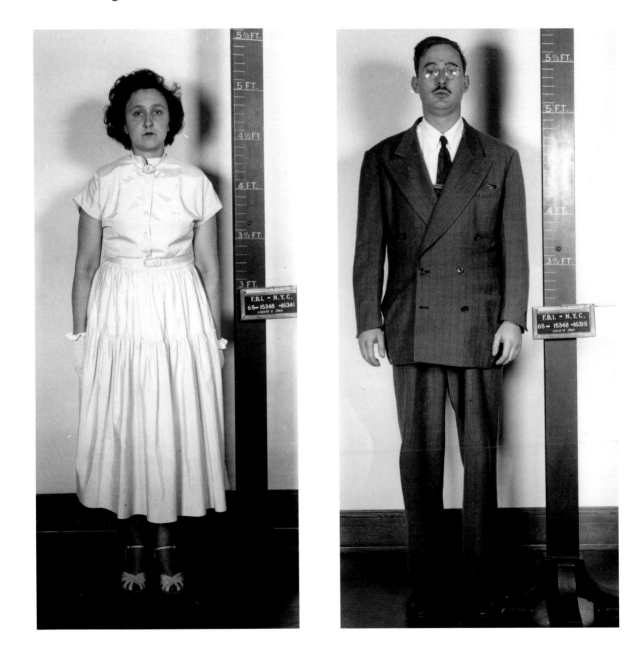

The man who informed on the Rosenbergs was **David Greenglass** (bottom), Ethel's own brother. Arrested on June 15, 1950, Greenglass admitted that with the help of his wife, **Ruth Greenglass** (top), he had passed on secret information to Julius Rosenberg during the time when he was working at the Atomic Research Center in Los Alamos, New Mexico. The trial began one year later, on March 6, 1951, but no material evidence was produced. A bargain was then proposed to the Rosenbergs under American law: Their lives would be saved in return for confessions. The couple refused and proclaimed their innocence. On April 5, 1951, Julius and Ethel Rosenberg were sentenced to death. The verdict sent a wave of indignation through the international community. President Dwight Eisenhower refused them a pardon, however, and the Rosenbergs were executed by electric chair on June 19, 1953. It was not until the Soviet Union came to an end and certain CIA files were opened in 1995 that proof was established that the Rosenbergs had indeed worked for the USSR since 1942.

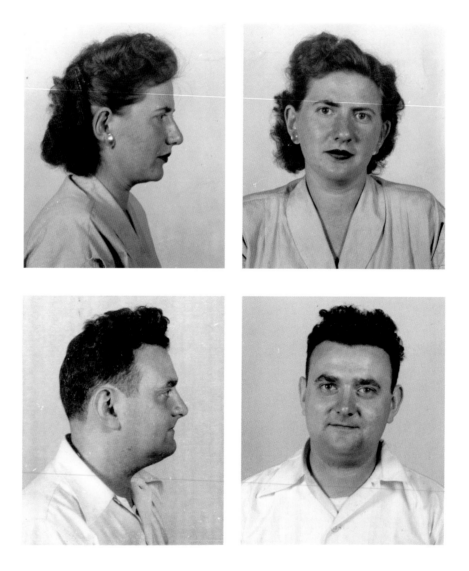

Fidel Castro In 1952 Fidel Castro was due to stand as an Orthodox Party candidate in the Cuban parliamentary election. Following a coup d'état by General Fulgencio Batista, however, the election was canceled. Castro brought legal action, but to no avail. On July 26, 1953, in opposition to the dictator, he led a group of guerrillas in an attack on the Moncada barracks in Santiago de Cuba. The operation failed. Fidel Castro was arrested on August 1 and sentenced to 15 years in jail. On May 15, 1955, he was granted amnesty and released. He then went to Mexico, where he met a certain Ernesto "Che" Guevara. The Cuban Revolution was underway.

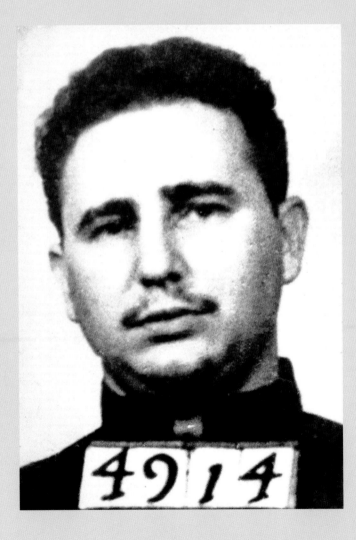

Paulo Leca, known simply as "Paulo" Born May 14, 1905, in Valle-di-Mezzana in Corsica. He became a powerful godfather in the Marseille underworld and enjoyed police protection in high places. Nicknamed "le roi de l'alibi" (the king of alibis), he had close relations with the head of French National Security.

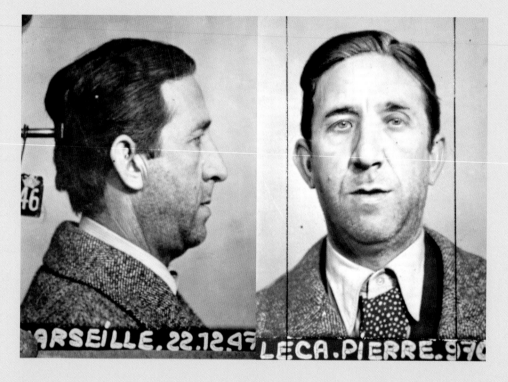

In 1938, Paulo's name was linked with the attack on the "gold train" between Marseille and Saint-Barthélemy, in which 180 kilos of gold were stolen, as well as diamonds and uncut rubies. After the war, he became one of the leading traffickers of contraband cigarettes, along with Jo Renucci. On August 3, 1949, on the French Riviera, he masterminded the heist of jewels belonging to the Begum, the wife of the Aga Khan (imam of a branch of Shiism)—one of the greatest fortunes in the world. More than 200 million francs' worth of diamonds and precious stones were stolen, including the Marquise, a 22-carat diamond. The press called it "the robbery of the century." In January 1950, after his henchmen were arrested, Paulo fled to the United States. After ten years on the run, he returned to France in August 1960 and gave himself in. He was tried in November 1961 at the court in Aix-en-Provence and was sentenced to two years of imprisonment. He died in 1966.

Jo Renucci, known as "Jo le Bègue" (Jo the Stutterer) Born July 6, 1908, in Marseille, Renucci was the boss of the Corsican underworld, linked to numerous crimes—possession of weapons, security van hold-ups, theft of Treasury bills. Acquitted again and again, he had close ties to the ruling party and was probably a hired hit man working for the SDECE (Service de documentation extérieure et de contre-espionnage; the French secret service at the time) in North Africa. In the 1950s he organized a smuggling operation to import American cigarettes from Tangiers to Marseille, creating a clan war for control of this illegal trade with his rival Antoine Paolini, known as "Planche," costing dozens of lives. During the same period, Renucci, in association with the Guerini clan and Lucky Luciano (see page 88), became a key figure in the French Connection, a major heroin smuggling racket between the south of France and the United States. In November 1958, Jo Renucci died of cancer at

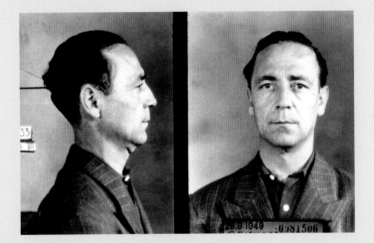

On September 29, 1949, Renucci was arrested in Marseille for involvement in the attack on a funeral procession at the Porte de Champerret in Paris. On Saturday, August 27, 1949, several members of the underworld came together for the burial of a murdered godfather. One of them was Ange Salicetti, known as "le Séminariste." Accompanied by his bodyguards, he drove in the funeral procession toward the Parisian cemetery of Pantin, where the burial was to take place. When the procession arrived at the Porte de Champerret, a car overtook the line of vehicles, drew up alongside Salicetti's car, and opened fire on it, literally riddling the passengers with bullets. Two bodyguards were killed, but "le Séminariste" emerged unscathed. Two police inspectors who witnessed the event formally identified Jo Renucci as the driver of the assailants' car. To produce an alibi, Renucci called on one of the most powerful godfathers of the Marseille underworld, Barthelemy Guerini. The case was dismissed.

Jo Renucci, photographed on September 29, 1949

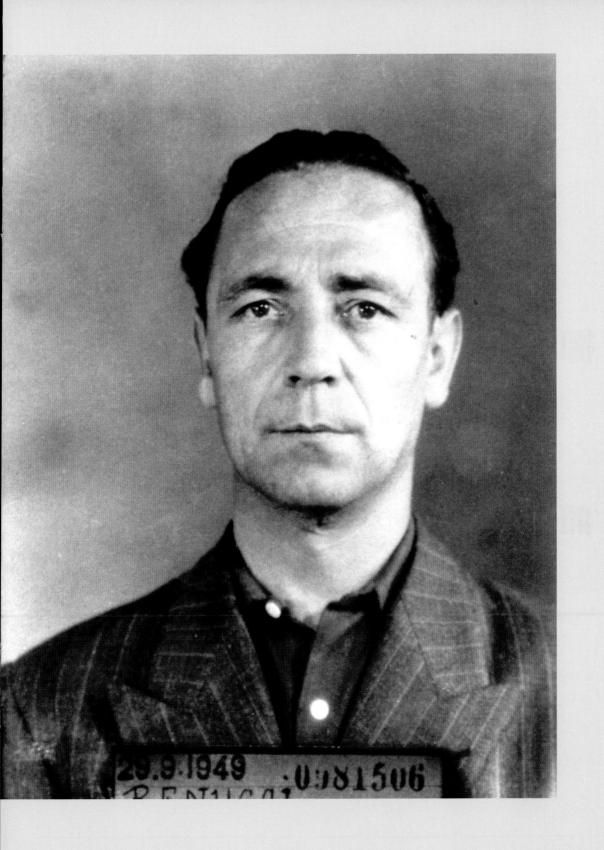

The Guerini Brothers Antoine Guerini was born in 1902, and Barthelemy Guerini, known as "Mémé," was born in 1908. The brothers originally came from Calenzana, Upper Corsica. Arriving in Marseille in the 1920s, they quickly became involved in procuring. During the Second World War, unlike Carbone and Spirito (see page 81), they joined the ranks of the Resistance and developed close links with the mayor of Marseille, Gaston Defferre. After the Liberation, the Guerini brothers became the most powerful godfathers in the Marseille underworld and remained so until the end of the 1960s. They invested in night clubs and diversified their activities: racketeering, prostitution, cigarette smuggling, and drug trafficking with Jo Renucci.

In Marseille on June 23, 1967, **Antoine Guerini** (opposite), aged 65, was shot dead in his car with eleven 11.43 bullets fired by two men on motorcycles. A week later, his body was buried in the presence of the whole family, in his native village of Calenzana. During the funeral, Antoine Guerini's villa in Marseille was burgled, and jewels were stolen. Wishing to avenge both the death of his brother and the affront of the theft, **Barthelemy "Mémé" Guerini** (right) informed the underworld that he demanded the return of the loot. On July 22, one of the burglars, 24-year-old Claude Mandroyan, came to return some of the jewels and was shot dead with eight bullets. With this crime, the writing was on the wall for the Guerini clan. "Mémé" was arrested in August. On January 15, 1969, the district court for the Seine region sentenced him to 20 years of imprisonment for being an accessory to murder. Suffering from cancer, he was granted a conditional discharge on March 4, 1978. He died in 1982 at the age of 73.

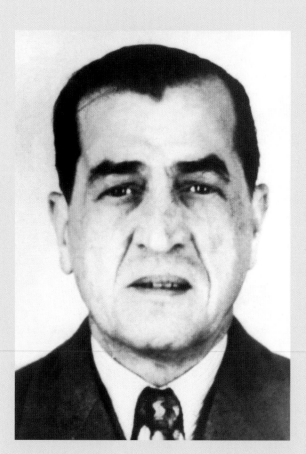

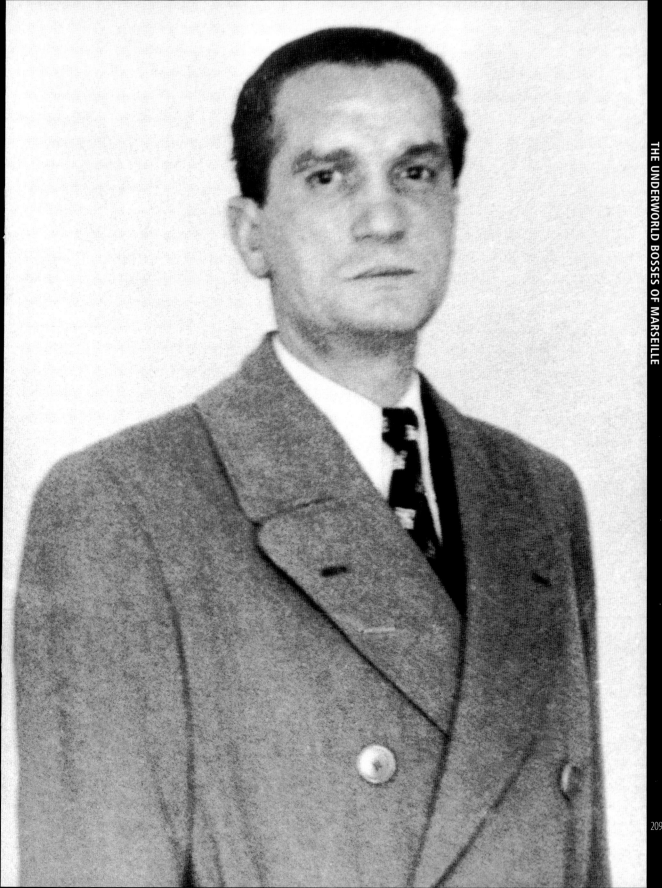

The Sam Sheppard Case On January 3, 1954, in a suburb of Cleveland, Ohio, Marilyn Sheppard was violently beaten to death in her own home.

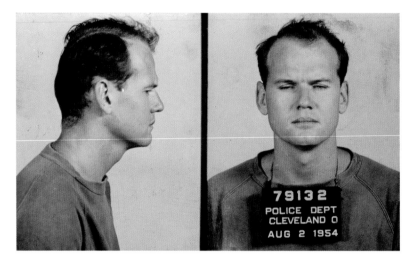

Her husband, osteopath **Dr. Samuel Reese Sheppard**, stated that he had been awoken on the morning of the crime by the screams of his wife, who was upstairs. He said that he had been struck on the head while trying to go to her aid and had lost consciousness before he could identify the attacker. The case received unprecedented media coverage. The press took sides against Dr. Sheppard and revealed an extramarital affair as a possible motive for the crime. Sheppard became the main suspect. On December 21, 1954, he was found guilty of second-degree murder and sentenced to life imprisonment. In 1964, after many appeals, the United States Supreme Court decided that Sam Sheppard had not had a fair trial. After ten years in prison he was released pending a new judgment. At the second trial, which began on October 24, 1966, the osteopath was found innocent. Sam Sheppard died on April 6, 1970, at the age of 47.

79132
POLICE DEPT
CLEVELAND O
AUG 2 1954

Civil Rights Movement

On December 1, 1955, in Montgomery, Alabama, **Rosa Parks**, a 42-year-old black American dressmaker, was arrested by the police for refusing to give up her seat on a bus to a white passenger. For this act of civil disobedience, Rosa Parks would come to be regarded as the "Mother of the Civil Rights Movement." On December 5 she was sentenced to a fine of $10 plus $4 in costs; she appealed against this judgment.

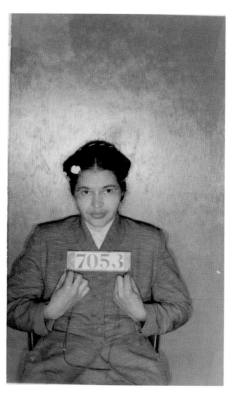

Rosa Parks was an emblematic figure in the struggle against racial segregation in the United States. She died on October 24, 2005.

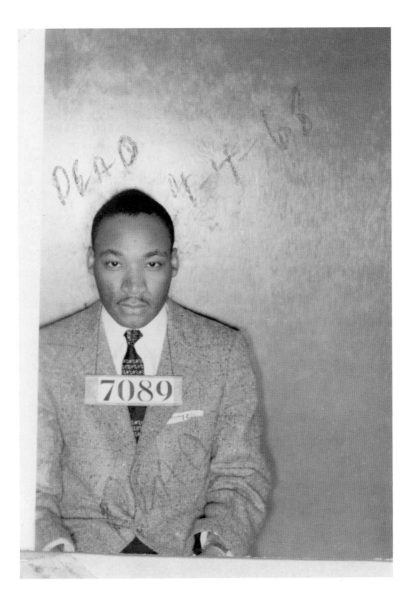

Martin Luther King, Jr., an unknown 26-year-old black pastor, and Ralph Abernathy (one of the future leaders of the Civil Rights movement in the United States), organized a protest and boycott campaign against the Montgomery County bus company that lasted 381 days. At a boycott demonstration on February 23, 1956, Rosa Parks, Martin Luther King, Ralph Abernathy, and 52 other black people were arrested, photographed, and put on file.

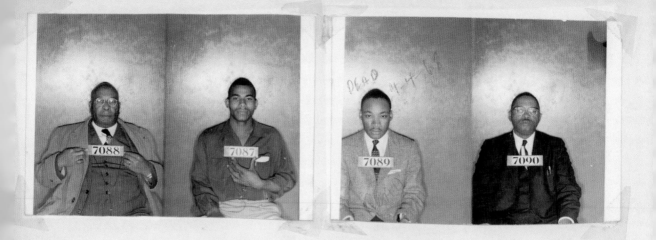

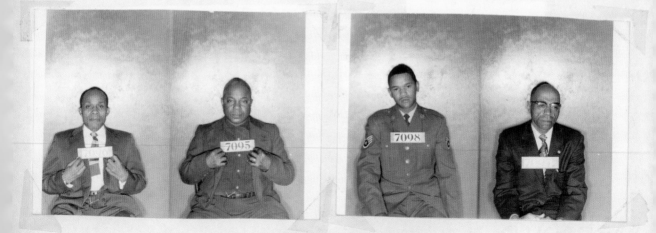

Martin Luther King, Jr., #7089, on February 23, 1956

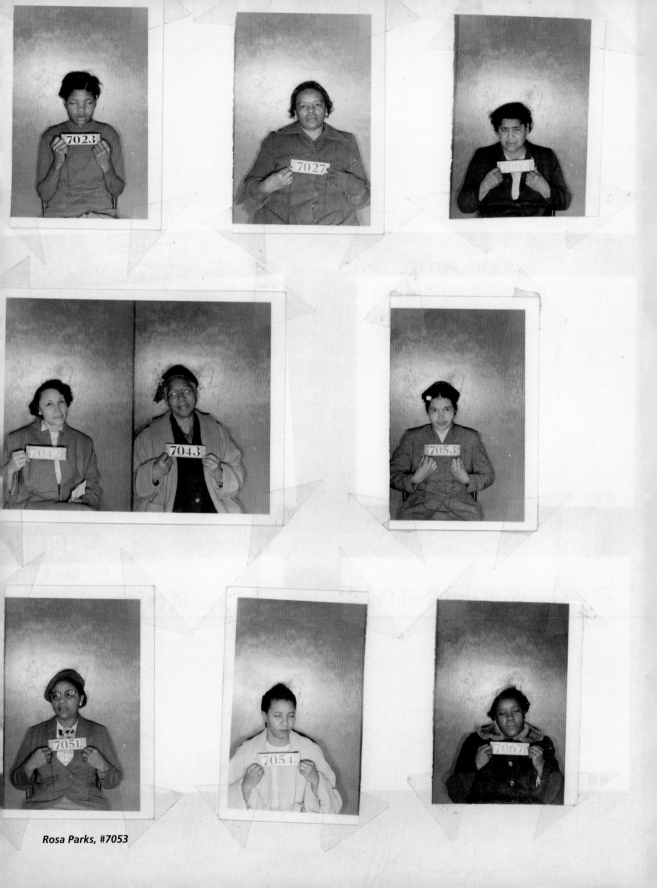

Rosa Parks, #7053

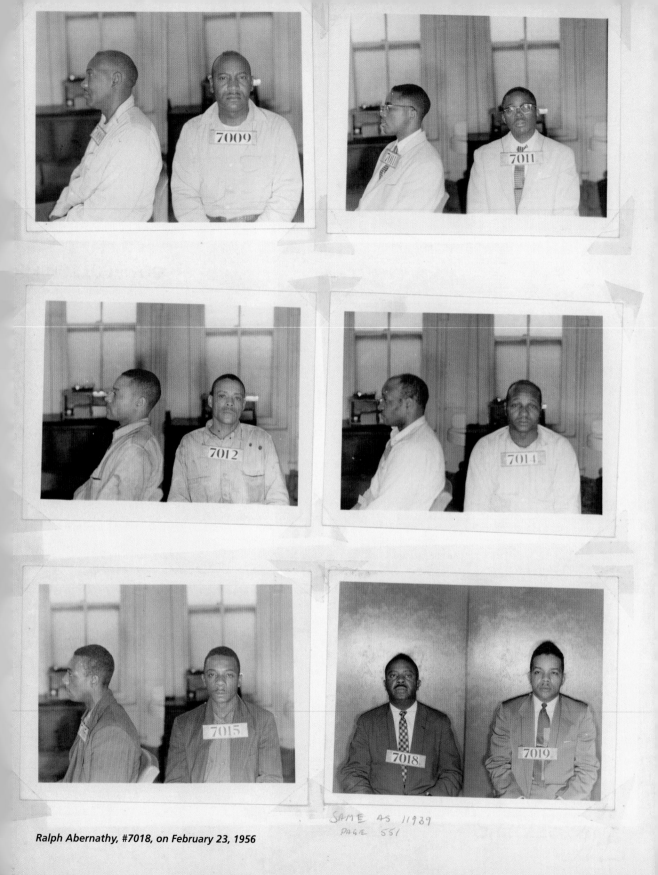

7009

7011

7012

7014

7015

7018 7019

SAME AS 11939
PAGE 551

Ralph Abernathy, #7018, on February 23, 1956

212

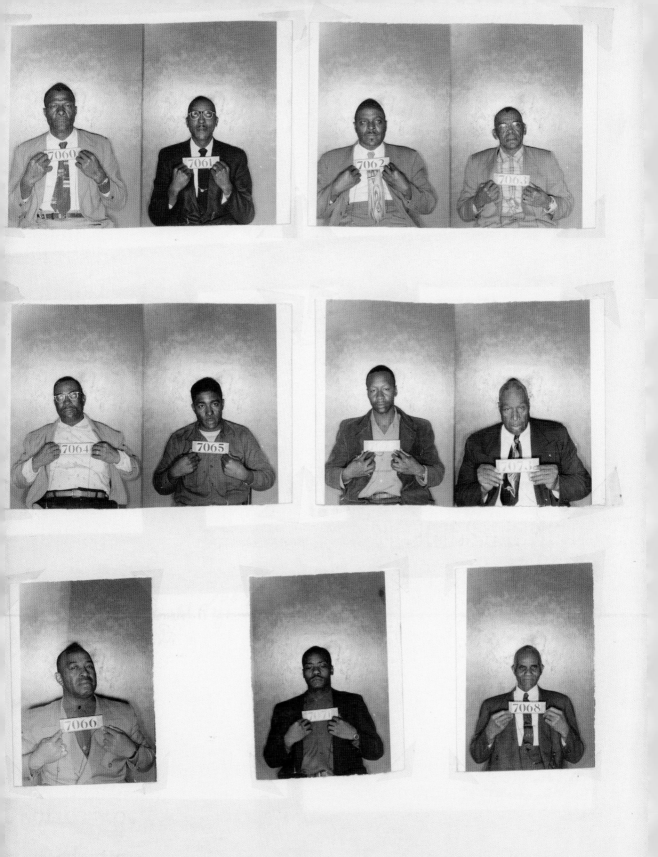

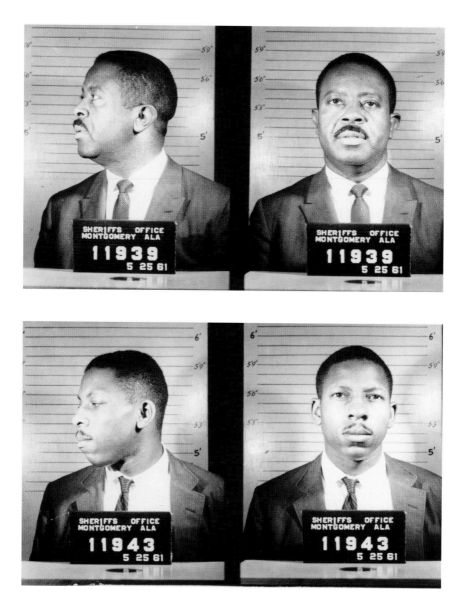

On November 13, 1956, the Supreme Court repealed the segregation laws for public transport in Alabama. This decision was subsequently tested by militants of the Civil Rights movement, who took **Freedom Rides** on interstate buses into segregated states.

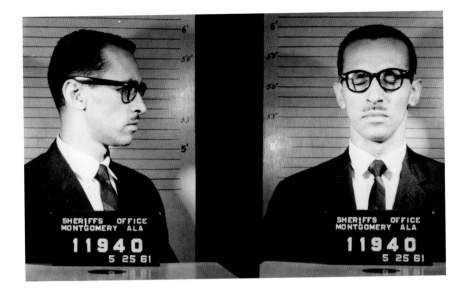

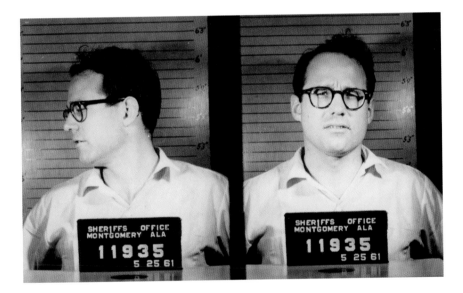

These militants were equally divided between blacks and whites, and a quarter of them were women. In May 1961 they were arrested in the southern states for violation of local laws. They included **George** **Bundy Smith** (opposite bottom), a future Appeals Court judge in New York, and three notorious clerics, **William Sloane Coffin** (bottom), **Ralph Abernathy** (opposite top), and **Wyatt Tee Walker** (top).

James Earl Ray On April 4, 1968, Martin Luther King, Jr., was assassinated in Memphis, Tennessee. Thanks to fingerprints taken from the crime weapon, the murderer was identified as James Earl Ray, an escaped prisoner from the Missouri State Penitentiary.

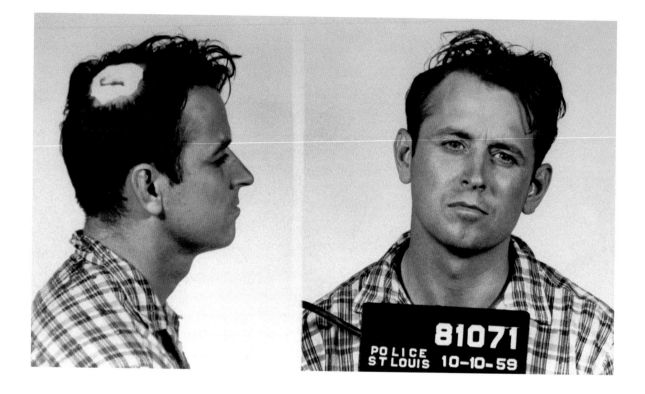

Following an epic manhunt, Ray was arrested two months later on June 8, at London's Heathrow Airport. On March 10, 1969, Ray pleaded guilty in order to avoid the death penalty. Three days later he retracted his confession and claimed that he was the victim of a vast conspiracy. Sentenced to 99 years in prison, for 30 years he continued to protest his innocence and demand a new trial, but without success. Even when Dexter King, the youngest son of Martin Luther King, spoke out in his support, his requests were rejected eight times, and various commissions of enquiry all concluded that he was guilty. As in the John Fitzgerald Kennedy case (see page 239), the theory of the isolated marksman was accepted, even though it was contested by numerous other theories as well. On June 10, 1977, after testifying before a congressional committee, James Earl Ray succeeded in escaping from the Brushy Mountain Penitentiary in Tennessee. On June 13, he was recaptured and sent back to prison. On April 23, 1998, he died at age 70 of hepatitis C.

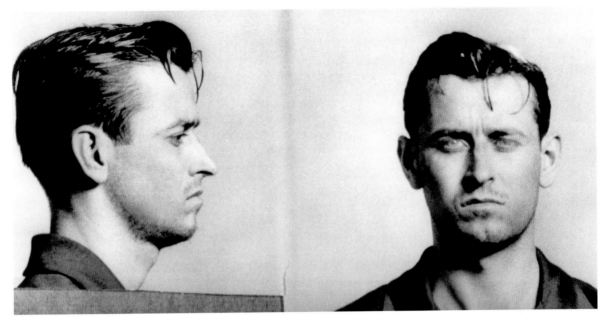

1952, arrest for armed robbery

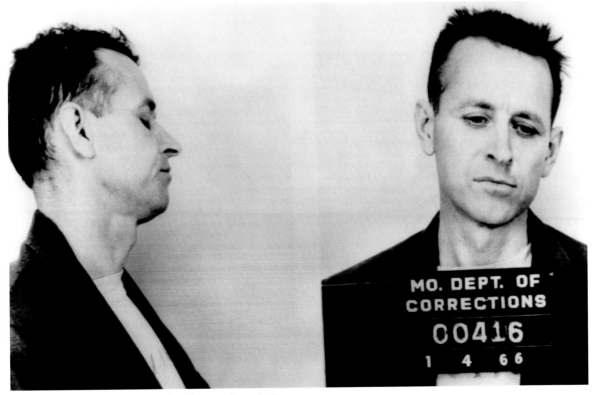

January 4, 1966, arrest for armed robbery and car theft

Malcolm X

Born Malcolm Little on May 19, 1925, in Omaha, Nebraska, Malcolm X committed several minor offenses in 1943 in Harlem, New York. He was arrested in 1946 for burglary and possession of a weapon and sentenced to eight to ten years in prison. After six and a half years in the penitentiary at Charleston, Massachusetts, he was released on parole on August 7, 1952. When he converted to Islam, Malcolm replaced his family name with X, to signify that he was abandoning his "slave name." As a spokesman for the Nation of Islam movement, he became one of the leaders of Black nationalism in the United States and advocated violent struggle as a means of achieving equality between the races. Malcolm X was assassinated on February 21, 1965, while making a speech in Harlem.

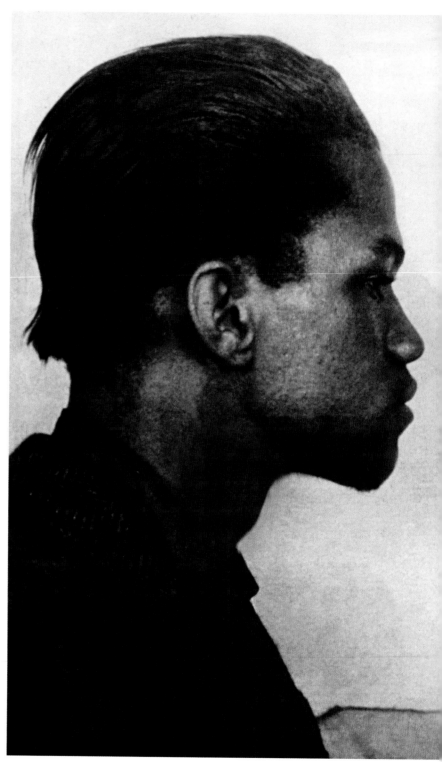

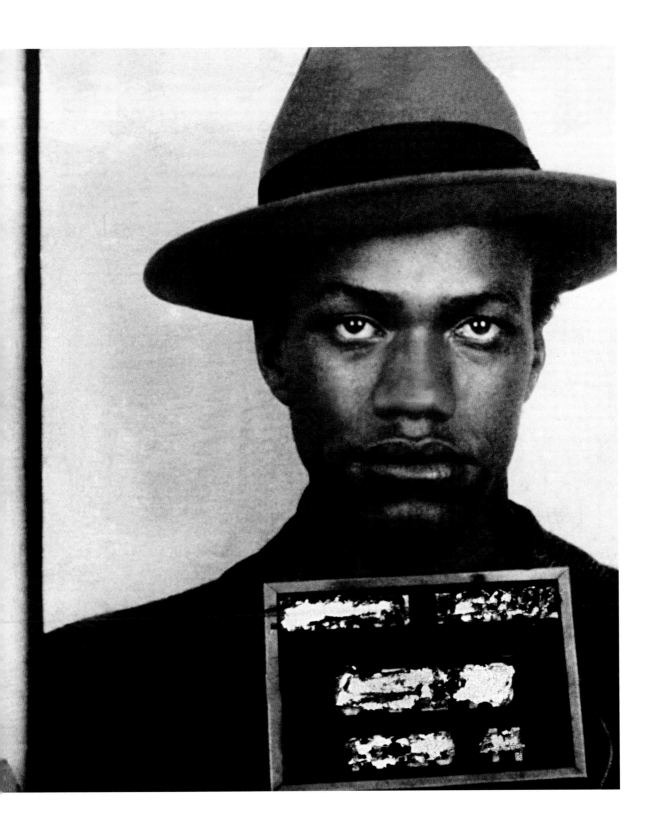

Freedom of Speech, Press, and Assembly

The comedian Lenny Bruce and the two legendary rock stars Janis Joplin and Jim Morrison took a provocative stand against the religious, moral, and political order of 1960s America. They were arrested several times for public order disturbances and obscenity on stage. In court they invoked the First Amendment of the U.S. Constitution, which guarantees freedom of expression.

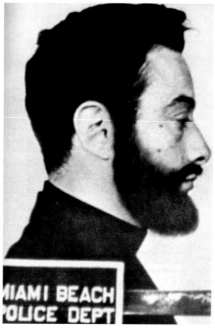

Lenny Bruce, arrested and photographed in 1951 for assuming the identity of a priest

Lenny Bruce Born Leonard Alfred Schneider on October 13, 1925, in New York. During the 1960s Bruce gave many stand-up performances in which he delivered a biting social critique of America. His caustic humor was used to provocative effect, attacking taboo subjects such as homosexuality, religion, drugs, racism, and politics. He was arrested several times and prosecuted for lewd language, obscenity on stage, and possession of narcotics. In 1964, when he was due to be sentenced in New York, the *New York Times* published a petition supporting him, signed by around 100 artists and intellectuals including Allen Ginsberg, Woody Allen, Bob Dylan, and Norman Mailer. On December 21 the prosecution bypassed the First Amendment and denounced the comedian's crude and obscene language. Lenny Bruce was sentenced to four months in prison. He was released on bail, and embarked on a lengthy, costly appeal procedure. On August 3, 1966, he was found dead in his home, killed by an overdose of morphine. Thirty-seven years later, on December 23, 2003, Lenny Bruce was granted a posthumous pardon by Governor George Pataki of New York.

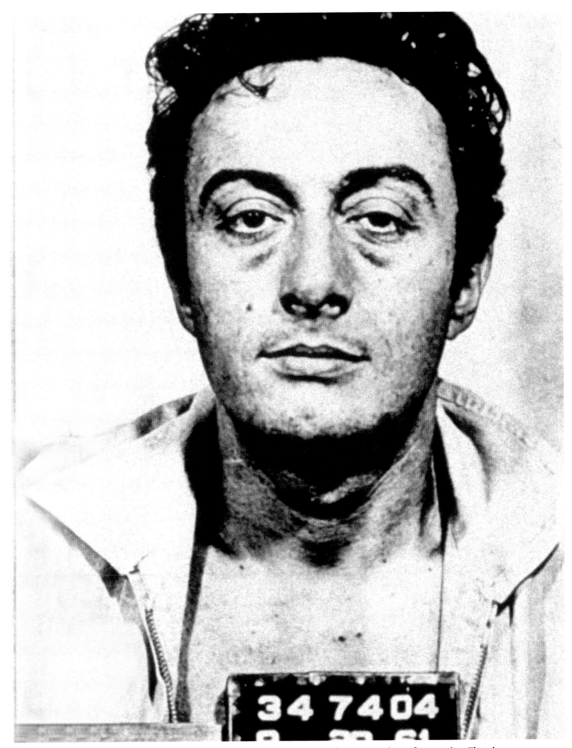

Lenny Bruce was arrested on September 29, 1961, in Philadelphia for possession of narcotics. The charges were later dropped.

Janis Joplin After a concert on November 17, 1969, in Tampa, Florida, she was arrested for disturbance of the public order and use of vulgar, obscene language on stage. Eventually the charges were dropped, and the singer was discharged. The court concluded that Janis Joplin's performance was a legitimate exercise of freedom of expression. On October 4, 1970, she was found dead as a result of a heroin overdose at the Landmark Hotel in Hollywood. She was 27 years old.

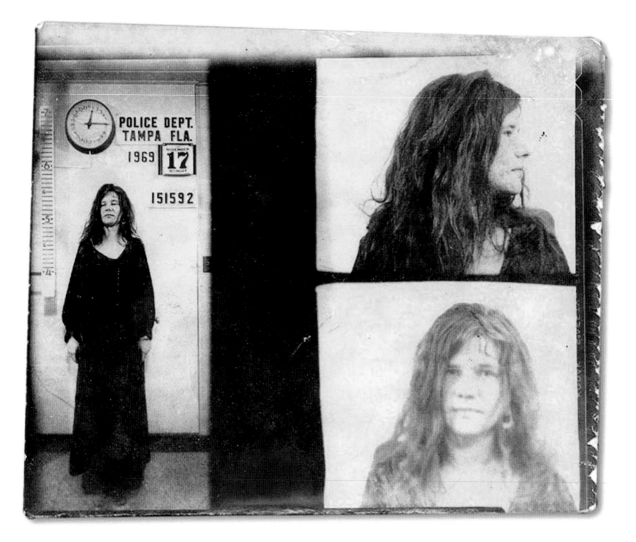

Jim Morrison In 1967 in New Haven, Connecticut, Jim Morrison, lead singer of The Doors, was arrested on stage for disturbing the public order, incitement to riot, and resisting the police, and was sentenced to a $25 fine. In March 1969 in Miami he was arrested again for, as stated on file, "lewd and lascivious behavior, indecent exposure, open profanity, and drunkenness"—notably accused of simulating masturbation on stage. Sentenced to six months of imprisonment then released on bail in 1970, he left the United States for France. On July 3, 1971, he died of an overdose in Paris at the age of 27.

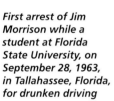

First arrest of Jim Morrison while a student at Florida State University, on September 28, 1963, in Tallahassee, Florida, for drunken driving

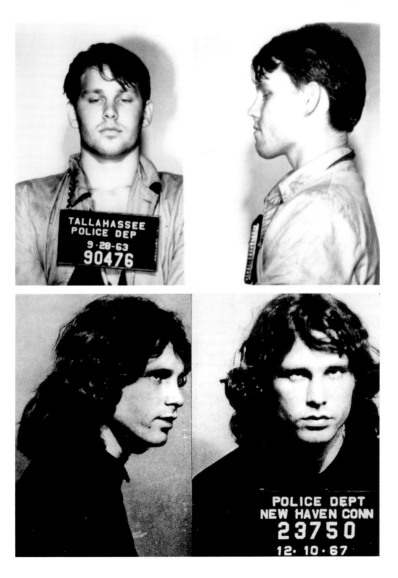

Morrison, after his arrest during a concert in New Haven, Connecticut, on December 9, 1967

Jane Fonda On November 3, 1970, American actress Jane Fonda was arrested at Cleveland Airport in possession of suspicious pills (which eventually turned out to be vitamins) and accused of "kicking" the policeman who questioned her. The charges were dropped. At the beginning of the 1970s she took part in many well-publicized activities to protest the war in Vietnam, going so far as to make a controversial visit to Hanoi to denounce the American military intervention.

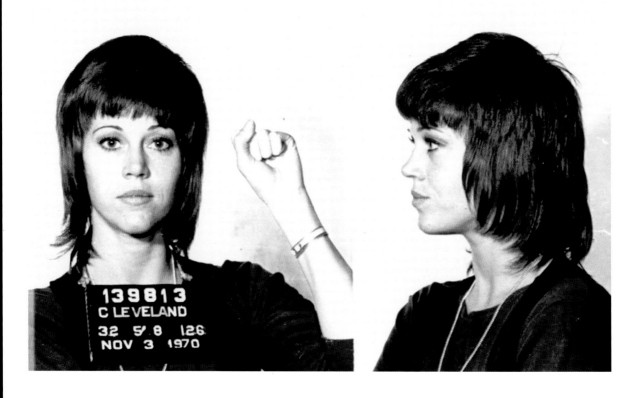

Johnny Cash On October 4, 1965, on his return from a trip to Mexico, the singer was arrested at the international airport in El Paso, New Mexico, for possession of amphetamine capsules and tranquilizers. He spent one night in prison, was fined $1,000, and was given a suspended jail sentence of 30 days.

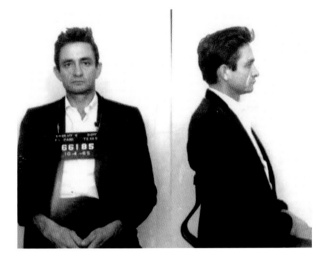

Elvis Presley In 1970, ten days after meeting President Richard Nixon at the White House, Elvis Presley was invited on a private visit to FBI headquarters. It was probably on this occasion that he went along with having his full face and profile photo taken. It is said that the head of the FBI, J. Edgar Hoover, refused to meet the King because he was "wearing all sorts of exotic dress."

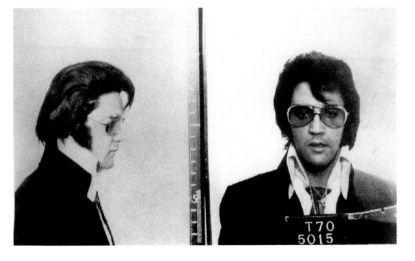

Jimi Hendrix Arrested at the airport in Toronto on May 3, 1969, for possession of drugs (heroin and hashish), which were found in his luggage, Hendrix stated in his defense that they had been put there without his knowledge. He was acquitted.

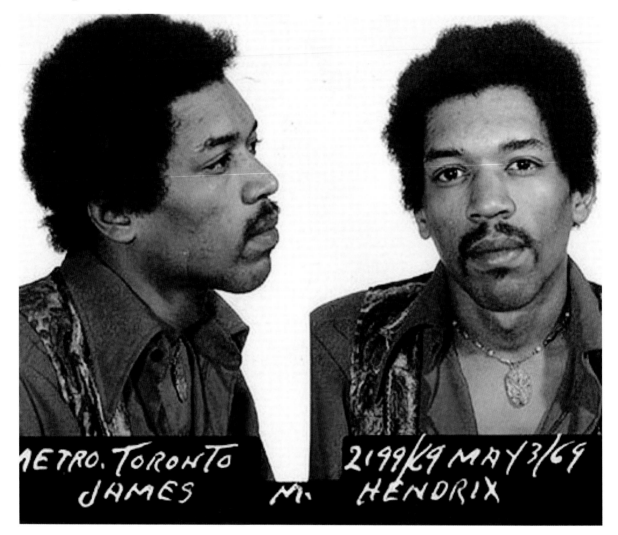

David Bowie In March 1976 Bowie was arrested after a concert at the Springfield Civic Center in Rochester, New York, for possession of drugs (eight pounds of marijuana). He was held for a few hours, then released on a $2,000 bail. The photo is dated March 25, 1976, three days after his arrest, when he appeared in court in Rochester. All charges were dropped.

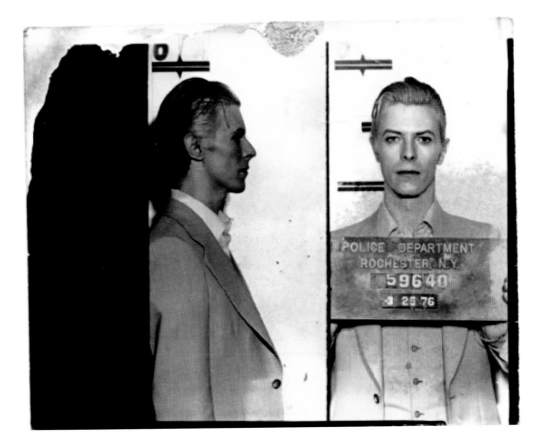

The Monster of Florence Between August 21, 1968 and September 8,1985, in the countryside around Florence, a serial killer—or perhaps more than one serial killer—committed sixteen murders.

The victims were young couples in search of privacy. In every case but one, they were attacked in their cars. The similarities didn't stop there: the same weapon—a .22-caliber Beretta automatic pistol—was used, and nearly all the murders took place in the summer, on weekends, or on days just before holidays.

In the early nineties, an anonymous tip led investigators to a farmer in the town of Mercatale: **Pietro Pacciani**, born in 1925, an ex-convict who had been found guilty of rape and murder.

Pacciani was arrested in 1993, found guilty the following year, and sentenced to fourteen consecutive life sentences. On appeal, however, the conviction was overturned. Italy's highest court ordered a new trial, but Pacciani died before it could take place. In fact, on February 22, 1998, he was found dead, under suspicious circumstances, in his home.

Pietro Pacciani in a photo taken during his trial in 1994

Surviving Pacciani were two fellow defendants, Giancarlo Lotti and Mario Vanni. Lotti, found guilty and sentenced to 24 years in prison, died in 2002. Vanni was sentenced to life imprisonment and released in 2004 due to serious health problems. He died on April 12, 2009.

The deaths of the only remaining suspects have left many questions unanswered: first and foremost, who ordered the murders, and for what ritual or diabolical purposes were they carried out?

BIGGS

Ronald, Arthur.

born on 8th August 1929 in BRIXTON/LONDON (Great Britain)
son of BIGGS given name not known
married to Renée ?
OCCUPATION : builder
NATIONALITY : British
IDENTITY HAS BEEN CHECKED AND IS CORRECT
DESCRIPTION : see photo and fingerprints, height 6'1", grey eyes, dark brown curly hair.
Scar on left wrist; long fingers.

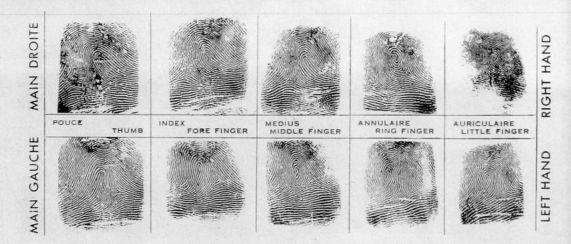

MAIN DROITE	POUCE THUMB	INDEX FORE FINGER	MEDIUS MIDDLE FINGER	ANNULAIRE RING FINGER	AURICULAIRE LITTLE FINGER	RIGHT HAND
MAIN GAUCHE						LEFT HAND

FINGERPRINTED AND PHOTOGRAPHED IN LONDON (Great Britain) in 1963

PREVIOUS CONVICTIONS :
 This man has a long criminal record in GREAT BRITAIN : convicted five times for robbery; twice for receiving; twice for taking and driving away motor vehicles without the consent of the owner; seven times for breaking and entering and burglary; etc.—— After the GLASGOW-LONDON mail train robbery on 8/8/1963, he was sentenced to 30 years' imprisonment; he escaped from WANDSWORTH prison in London on 8/7/1965 with three other prisoners.

MISCELLANEOUS INFORMATION :
 Was accompanied by : his wife; Robert Alves Anderson; Eric Flower; Patrick Doyle; Paul Seabourne; Francis Victor Hornett.—— Could be in the company of other members of the gang which robbed the mail train at Cheddington on 8/8/1963, are at large and are the subjects of the following I.C.P.O.-INTERPOL international notices : EDWARDS Ronald, notice 555/63 A 4786 of September 1963; REYNOLDS Bruce Richard, n°550/63 A 4782 of September 1963; WHITE James Edward, n°551/63 A 4783 of September 1963; WILSON Charles, Frederick, n°517/64 A 5167 of November 1964.—— A warrant of arrest will be issued shortly.—— EXTRADITION WILL BE REQUESTED.

REASON FOR THIS CIRCULATION :
 Done at the request of the BRITISH authorities in order to discover his whereabouts. If found please detain and inform immediately : The British Representative, International Criminal Police Organization, National Office, Criminal Investigation Department, New Scotland Yard, LONDON SW 1 (INTERPOL LONDON SW 1), and also : the I.C.P.O.-INTERPOL, General Secretariat, 37 bis rue Paul Valéry, PARIS (INTERPOL PARIS).

I.C.P.O. PARIS
August 1965

File N° : 387/65
Control N° : A. 5408

Ronald Arthur Biggs, known as Ronnie Biggs Born August 8, 1929, in London, Biggs was one of the "Great Train Robbers" who carried out the Glasgow-London mail train robbery on August 8, 1963, which yielded 2.6 million pounds sterling (worth 120 million dollars today). Biggs was arrested some months after the "Great Train Robbery" and sentenced in 1964 to 30 years of imprisonment. On July 8, 1965, after 15 months in jail, he escaped from Wandsworth Prison in southwest London by scaling a 25-foot wall using a rope ladder.

From 1970 to 2001 he lived in exile in Brazil, at a time when they did not have an extradition agreement with the United Kingdom. On May 7, 2001, after 36 years on the run, Ronnie Biggs, then 71 years old, in ill health, and ruined, returned to the United Kingdom. He was immediately arrested by the British police and taken to a high-security prison to serve the rest of his sentence. To this day he is still incarcerated in Norwich prison, in the western United Kingdom.

Following spread: Ronnie Biggs after his arrest by Detective Chief Superintendent Jack Slipper in Brazil—he was subsequently released.

Lieutenant Colonel Bastien-Thiry Born October 19, 1927, in Lunéville in northern France, Jean-Marie Bastien-Thiry was the chief organizer of the attack on General Charles de Gaulle at Petit-Clamart in Paris on August 22, 1962.

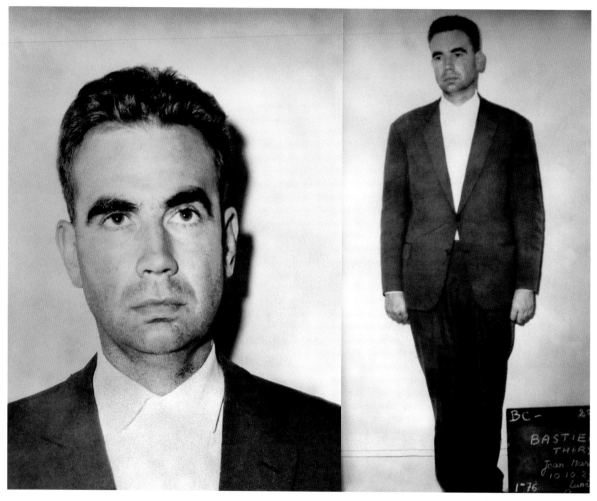

Bastien-Thiry was opposed to Algerian independence from France and was a member of the terrorist OAS (Organisation de l'armée secrète; Secret Armed Organization), which opposed de Gaulle—then president of France—for ending the French occupation in Algeria. On the day of the attack, six members of the OAS raked the presidential procession with machine gun fire. No one was killed, but several bullet marks were found on the Citroën DS that was carrying the French president. General de Gaulle said: "This time it was close. . . . Those people shoot like pigs." Bastien-Thiry was arrested on September 17, 1961, on his return from a mission in the United Kingdom. His trial by a military court lasted from January 28 to March 4, 1963. He was sentenced to death and executed by firing squad at the Fort d'Ivry, south of Paris, on March 11, 1963. This was the last political execution in France.

Lee Harvey Oswald Born October 18, 1939, he was arrested for the assassination of President John F. Kennedy in 1963.

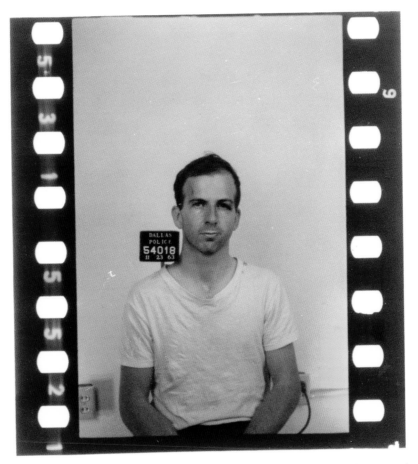

Dallas, November 22, 1963, 12:30 P.M.: from a window on the fifth floor of the Texas School Book Depository, several shots rang out. The president of the United States, John Fitzgerald Kennedy, was assassinated. After a series of eyewitness accounts, the search began for Lee Harvey Oswald, an employee of the depository who had rapidly been identified as the chief suspect. Forty-five minutes after the murder, Oswald shot a policeman who attempted to question him. He took refuge in a cinema, where he was eventually arrested. When charged, he denied both crimes, but the gun used to assassinate Kennedy was found and identified as his. Forty-eight hours after Kennedy's death, on November 24, Oswald was shot dead with a single bullet by Jack Rubinstein, known as Jack Ruby, in the basement of the Dallas police headquarters.

Following spread: Oswald, photographed on November 23, 1963

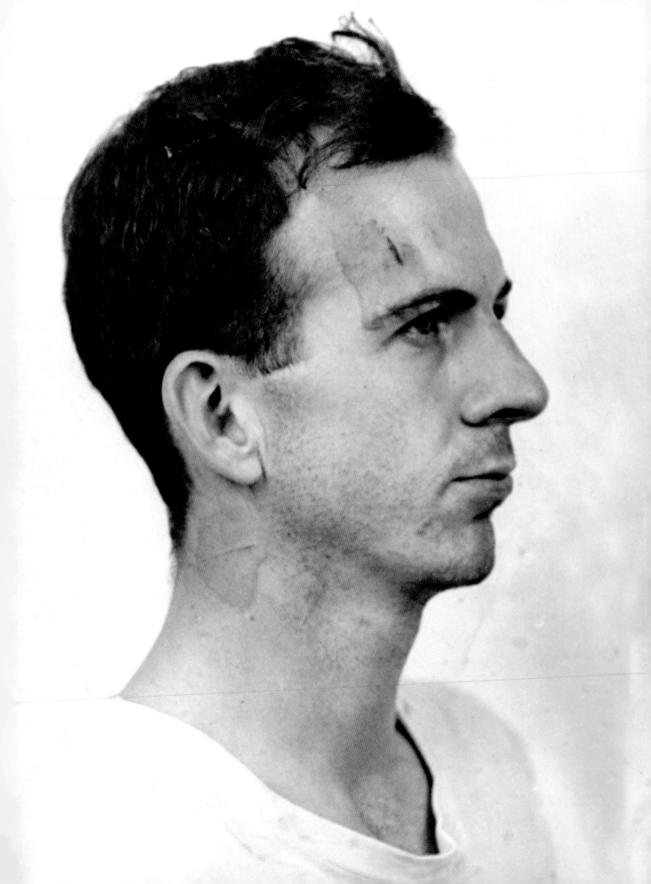

Jack Ruby Born Jacob Rubinstein on March 25, 1911, Jack Ruby was a strip club owner who was well known to the Dallas police, having been arrested eight times. The killer of Lee Harvey Oswald stated that he had wanted to avenge Jackie Kennedy and spare her a "painful" trial. On March 14, 1964, he was sentenced to death for murder. Suffering from cancer, he was never executed, and he died in a Dallas hospital on January 3, 1967.

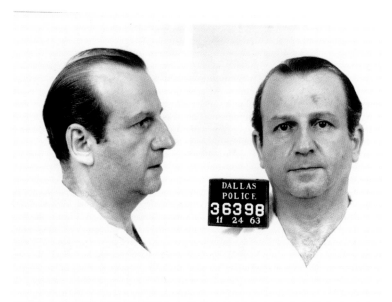

Above and opposite: Jack Ruby, photographed the day that he shot Lee Harvey Oswald

In 1964, the Report of the President's Commission on the Assassination of President Kennedy, known as the Warren Commission report—after its chairman, Chief Justice Earl Warren—concluded that Lee Harvey Oswald alone was responsible for Kennedy's assassination. For more than 40 years, this report has been questioned many times, proving the controversy of some of its elements. Both challenged and reaffirmed, the Warren Commission records were made public, with only minor amendments, by 1992. Remaining documentation relating to Kennedy's assassination is due for public release in 2017.

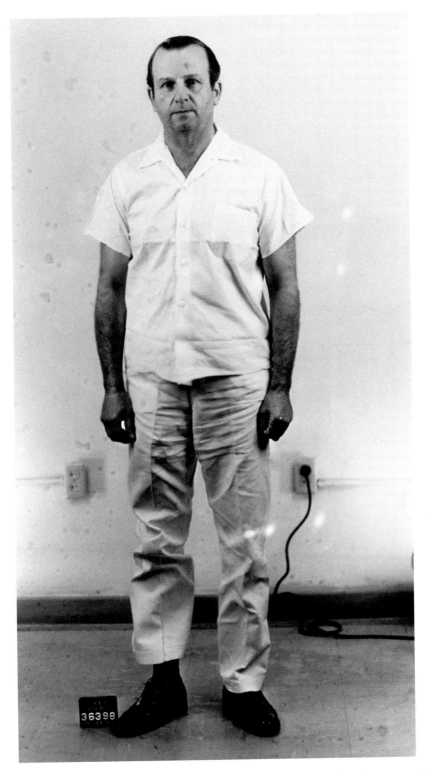

Following spread: Jack Ruby nine years earlier, arrested on December 5, 1954, for selling alcohol in violation of Texas law

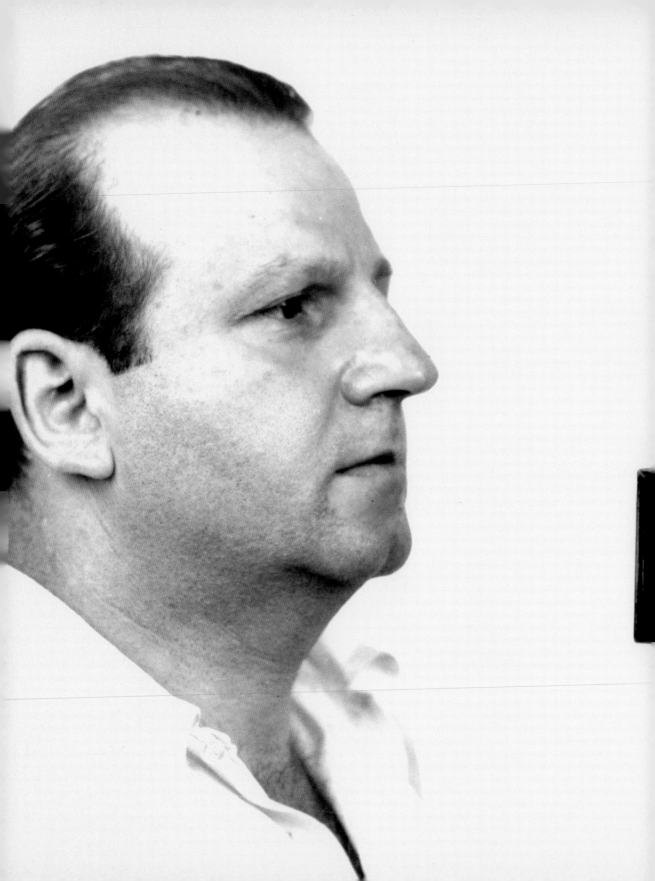

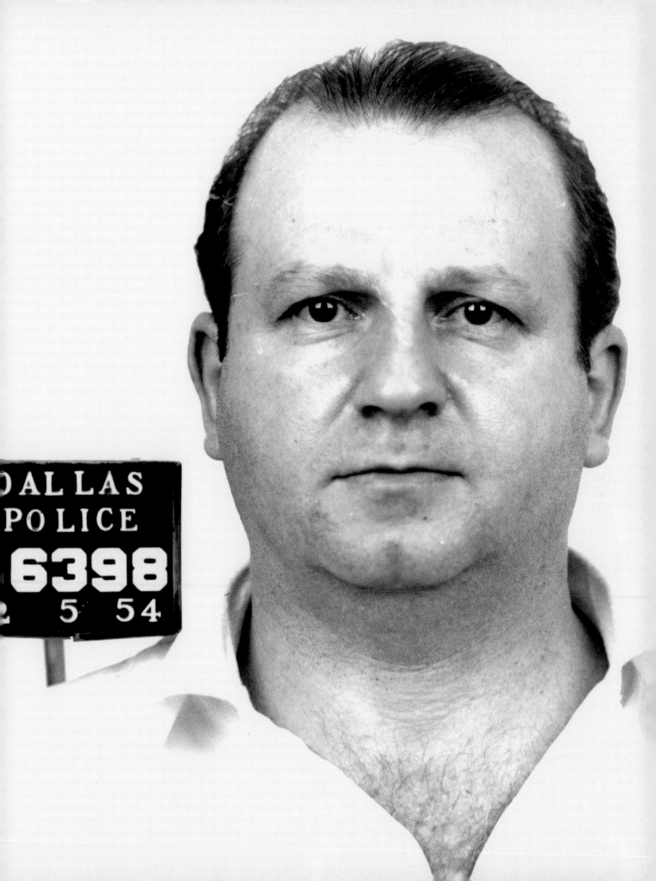

DALLAS
POLICE
6398
2 5 54

Sirhan Sirhan On June 5, 1968, while celebrating an electoral victory during his campaign for nomination as the Democrat candidate for the presidency, Senator Robert F. Kennedy was fatally wounded by two shots from a revolver fired at point-blank range.

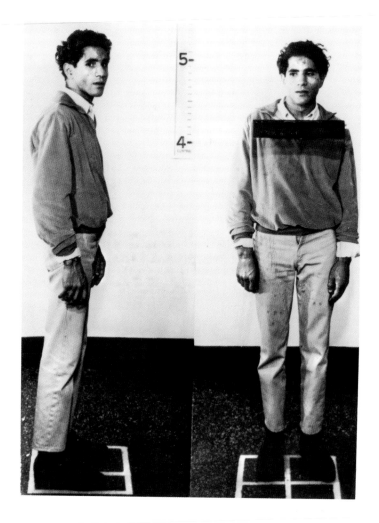

A Palestinian refugee born in 1944 in Jerusalem, Sirhan Bishara Sirhan, known simply as Sirhan Sirhan, declared that he had killed Robert Kennedy because of his support for Israel during the Six-Day War in June 1967. Found guilty of first-degree murder, he was sentenced to death by gas chamber on May 21, 1969. Following the abolition of the death penalty in California in 1972, his sentence was commuted to life imprisonment. By the end of 2006 he had made 13 requests for a conditional discharge, all of which had been rejected.

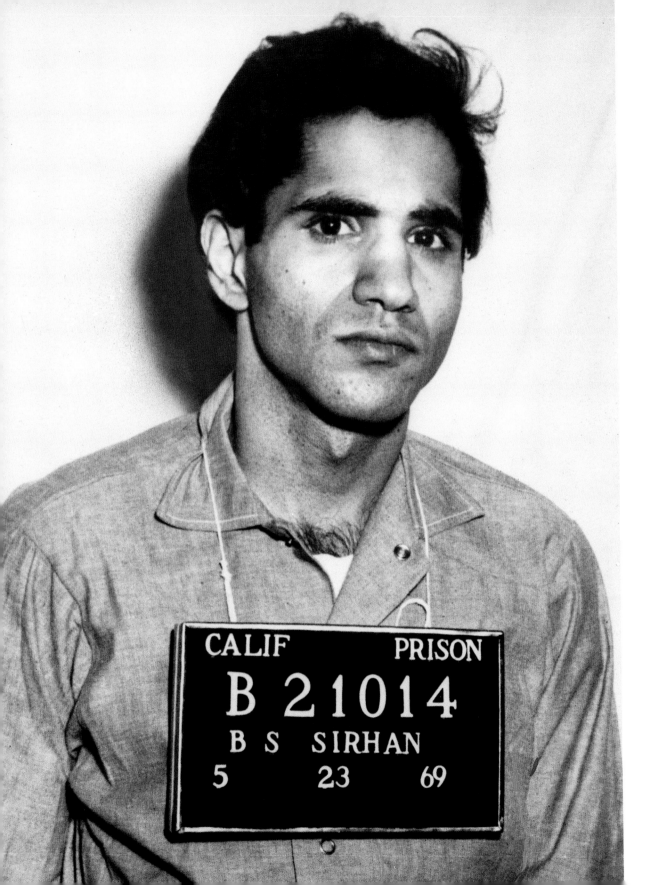

In 1969, a group of students from the university campuses of Michigan formed **the Weathermen**, or the Weather Underground Organization, a radical movement opposed to the Vietnam War, which advocated the violent overthrow of the American government.

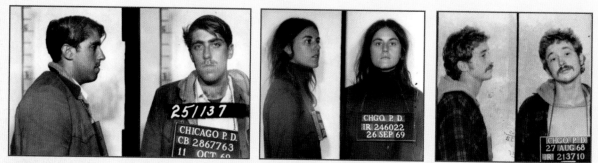

Mark Rudd

Bernardine Dohrn

Bill Ayers

The name "Weathermen" is a reference to a line in the Bob Dylan song "Subterranean Homesick Blues"—"You don't need a weatherman to know which way the wind blows." For four days in October 1969 in Chicago, the Weathermen held their first demonstrations, which were an attempt to cause chaos and heighten public awareness of the war being waged by the Americans in Vietnam. Six demonstrators were killed and 68 were arrested. Following these "Days of Rage," the Weathermen

went underground. From 1970 on, they carried out numerous bomb attacks on public buildings, notably the Capitol, the Pentagon, and the State Department. No one was killed in these attacks except three bomb planters. The movement disappeared when the Vietnam War ended, and most of its members eventually gave themselves in. Owing to numerous procedural abuses committed by the FBI during their hunt for the Weathermen, the leading members' sentences were limited to periods of probation and fines.

Today **Mark Rudd** is a mathematics teacher in a high school in Albuquerque, New Mexico. **Bernadine Dohrn**, a cofounder of the organization, is a lawyer and member of the American Bar Association who teaches college law and runs a legal aid center for children in difficulty. **Bill Ayers** is a professor at the University of Chicago and a campaigner for educational reform. He and Bernardine Dohrn are married and have three children, born during their time underground.

The Patty Hearst Affair On February 4, 1974, Patricia Campbell Hearst, a student of art history at the University of California at Berkeley, was kidnapped by the Symbionese Liberation Army (SLA), a small extreme left-wing group. She is the daughter of press magnate Randolph Apperson Hearst and the granddaughter of William Randolph Hearst, whose life was the basis for Orson Welles's movie *Citizen Kane*.

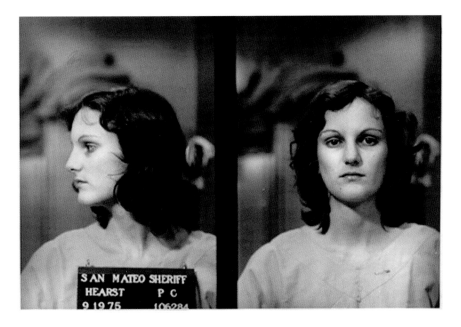

In exchange for **Patty Hearst**, Donald DeFreeze, the leader of the SLA, who had escaped from prison in 1973, demanded the release of two members of the group who were being held for murder. When this was categorically refused by the legal authorities, he then demanded that food be distributed to the poor people on the Pacific Coast. Randolph Appleton Hearst made several million dollars available, and charities handed food out to thousands of destitute people who assembled in front of Los Angeles supermarkets. On the 59th day of the kidnapping, April 3, 1974, Patty Hearst announced that she had been won over to her captors' cause. Under the nom de guerre "Tania," she became a member of the commando group. On April 15, 1974, a video surveillance camera at a bank in San Francisco showed her brandishing a gun during a hold-up. The image made the front pages of the newspapers. On April 25, 1975, Patty Hearst took part in another bank robbery in California. This time a customer was killed. On September 18, 1975, after more than a year on the run, she was arrested in San Francisco. She was charged with armed robbery and sentenced to seven years in prison. She was released 22 months later thanks to the intervention of President Jimmy Carter and pardoned 20 years later by President Bill Clinton. Patty Hearst remains one of the most famous cases of the Stockholm Syndrome, in which a victim begins to identify and sympathize with his or her captors.

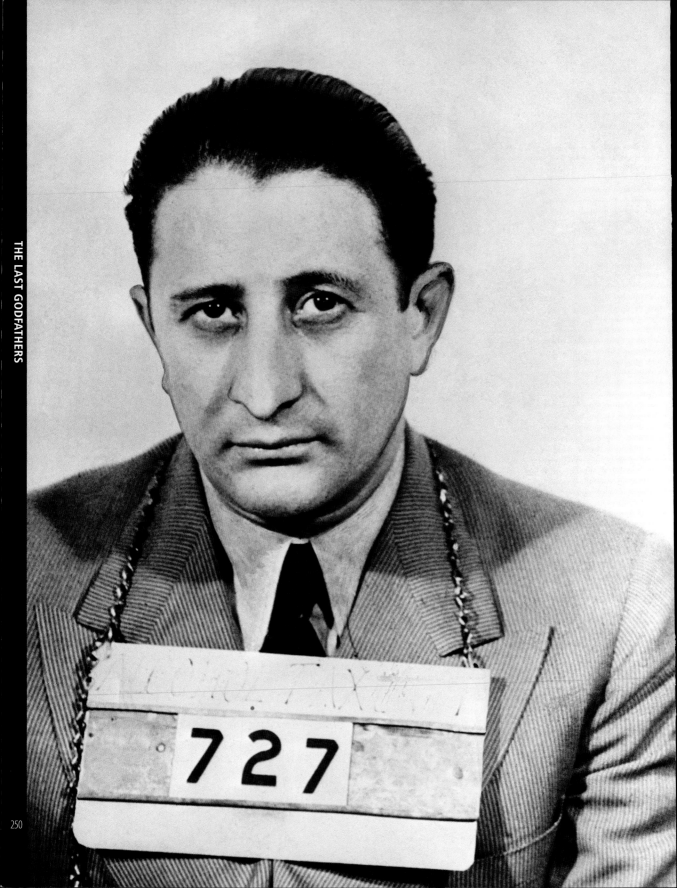

Carlo Gambino He was born August 24, 1902, in Sicily and after the death of his capo Albert Anastasia (see page 97) in 1957, Gambino became the number one godfather, *capo di tutti capi*—THE boss of the five New York families. From 1970 on he was regarded by the FBI as the most powerful racketeer in the United States and pursued for various offenses and for illegal entry into the United States in 1921. His recurrent health problems saved him from having to face trial. He died at 74 of a heart attack in October 1976.

Carmine Galante Born in 1910 in Harlem, Galante was sentenced in 1930 to 12 years in prison for attempted murder during a hold-up. Released in 1939, he carried out numerous "contracts" for Vito Genovese (see page 113) in the 1940s. In 1962 he was given a 20-year sentence for drug trafficking, and when released on parole in 1974 he became the boss of one of the five families in New York. On July 12, 1979, he was murdered in a Brooklyn restaurant. He was 69 years old.

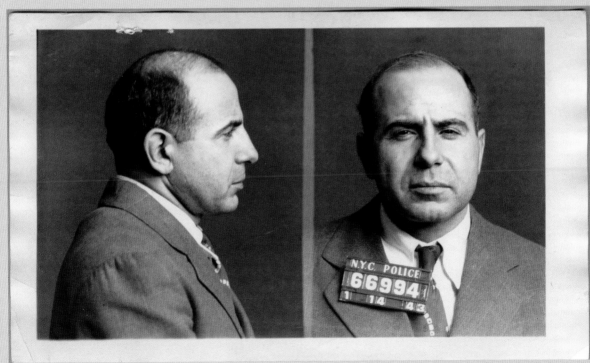

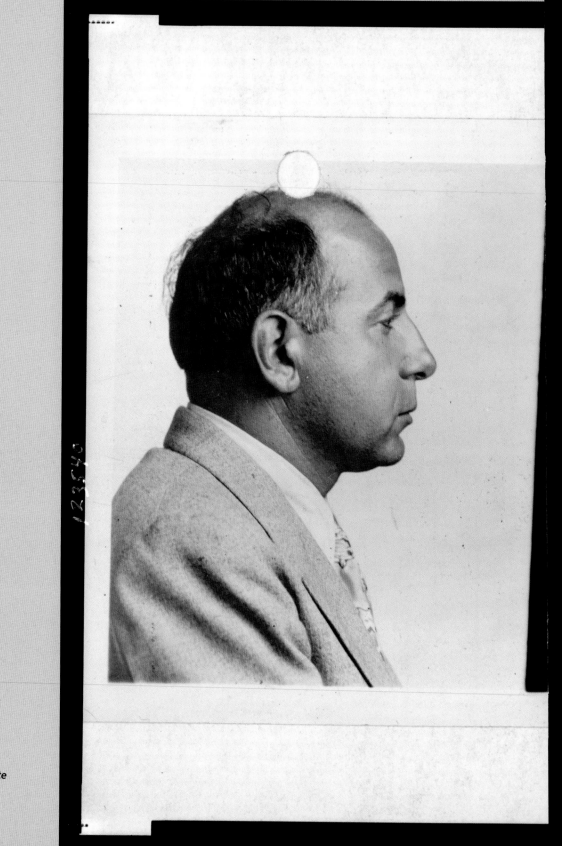

Carmine Galante

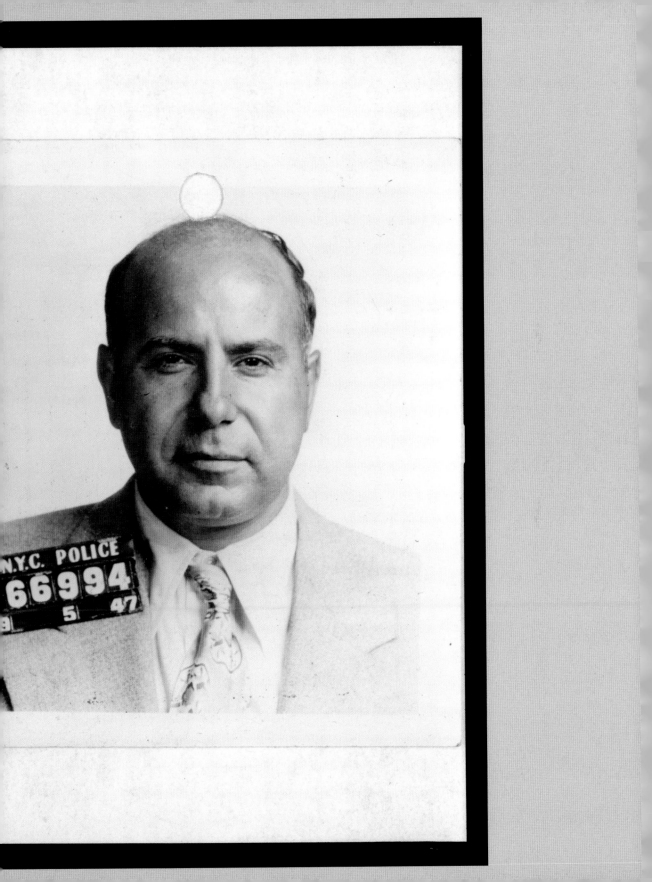

John Gotti Born John Joseph Gotti, Jr. on October 27, 1940, in the Bronx, New York, Gotti was nicknamed "the Dapper Don" and "the Teflon Don." He was put on file by the FBI and declared Public Enemy #1.

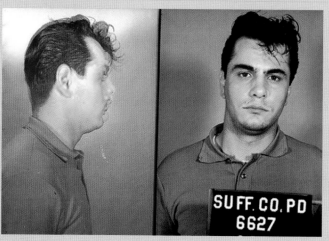

Gotti in 1965, arrested for car theft

Between 1968 and 1972, Gotti was sentenced several times for theft, receiving, and trafficking, and in 1973 he was charged with second-degree murder. After organizing the murder of godfather Paul Castellano, he took control of the Gambino family in 1985. In December 1990 his closest associate and consigliere, Salvatore Gravano, known as "Sammy the Bull," agreed to testify against Gotti in exchange for immunity and entry into the witness protection program. On April 2, 1992, John Gotti was found guilty of 13 murders, extortion, and obstruction of justice, and sentenced to life imprisonment. He died of cancer at age 61 in the Springfield, Missouri federal prison on June 10, 2002.

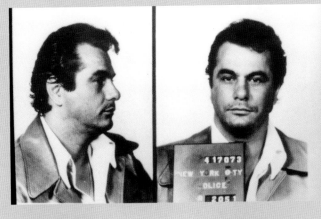

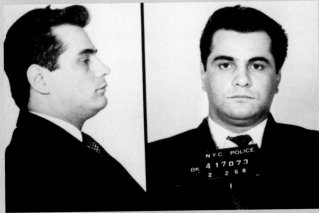

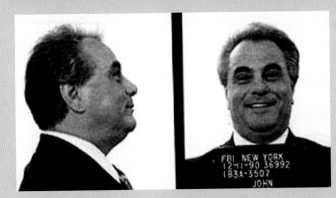

Vincent "the Chin" Gigante Born March 29, 1928, in New York, Gigante was a former professional boxer. In 1957, while working as a hired killer for Vito Genovese, he attempted to murder Frank Costello.

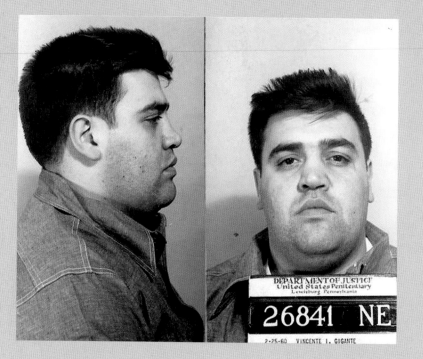

DEPARTMENT OF JUSTICE
United States Penitentiary
Lewisburg, Pennsylvania

26841 NE

2-25-60 VINCENTE I. GIGANTE

Gigante was trapped when Luciano (see page 88) and Costello (see page 111) organized a plot against Genovese (see page 113), and in 1959 he was sentenced to seven years in prison for heroin trafficking. At the beginning of the 1980s, he took control of the Genovese family and became one of the most powerful Mafia bosses in New York and a rival of John Gotti. In 1990 he was charged with murder and racketeering and released on bail. For many years his lawyers managed to have his trials postponed by producing expert psychiatric evidence that presented him as schizophrenic, insane, and psychotic. To simulate madness, Gigante often wandered around in the middle of Greenwich Village in a torn bathrobe, talking incoherently (the press nicknamed him "the Oddfather"). He was eventually tried in 1997 and sentenced to 12 years in prison. He died while in detention in December 2005 at the age of 77.

Salvatore "Totò" Riina was born in Corleone, Sicily, on November 16, 1930. He began his criminal career early: by the age of 19 he had been arrested for murder; he was found guilty and sentenced to 12 years in prison. He was released in 1956 and became a soldier in the gang of Luciano Liggio, along with his childhood friends, Bernardo Provenzano and Calogero Bagarella.

With the arrest of Luciano Liggio in 1974, Totò Riina became the *capo di tutti capi* (boss of all bosses). Under his command, the Clan dei Corleonesi took over drug trafficking and control of public works projects in Palermo.

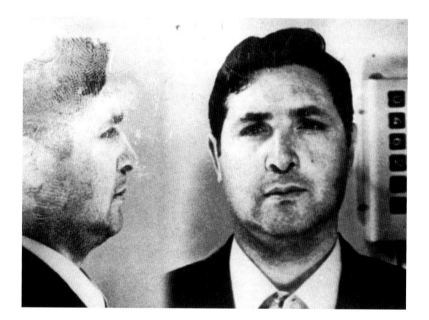

On April 16, 1974, he married Antonietta Bagarella, Calogero Bagarella's sister. The couple had four children.

Riina extended the reach of his own power by eliminating, one after another, members of various rival families. His paid killers murdered members of the Bontade, Inzerillo, Buscetta, and Badalamenti families. The Mafia boss was willing to take on representatives of the national government as well, and ordered high-level assassinations of men such as the prosecuting attorney Pietro Scaglione, the chief of the serious crimes squad Boris Giuliano, and judge Cesare Terranova. The high-level murders continued with politicians Piersanti Mattarella and Pio La Torre, Carabinieri generale Carlo Alberto Dalla Chiesa, and judge Rocco Chinnici, even the top investigating judges Giovanni Falcone and Paolo Borsellino. The term "excellent cadavers" became all too common.

Totò Riina, January 16, 1993

Riina's flight from the law (he'd been a wanted man since 1969) ended on January 15, 1993, when he was arrested by a special squad of the ROS (Raggruppamento Operativo Speciale or Special Operations Group) commanded by the famed Capitano Ultimo, Sergio De Caprio.

Sentenced to numerous consecutive life sentences, he is still imprisoned under the harshest terms of Italian justice, in accordance with Article 41-bis for those convicted of mafia crimes.

O. J. Simpson On June 12, 1994, Nicole Brown Simpson and Ronald Goldman (whom some speculated to be her companion) were found murdered just outside her home in Los Angeles. Evidence found at the scene of the crime pointed to Nicole Brown's ex-husband, O. J. Simpson, as the principal suspect.

On June 17, after a notorious car chase on the California freeways that was broadcast live on television, Simpson was arrested by the Los Angeles police. A false mustache, a passport, $8,000, and a magnum-357 were found in the car. Simpson was charged with double murder. On October 3, 1995, after eight months of criminal trial, the jury reached consensus was described as the "verdict of the century:" Simpson was found not guilty. The announcement beat all previous television viewing records. In February 1997, at the end of the civil trial that followed, O. J. Simpson was found responsible for the death of Ronald Goldman and guilty of assault and battery on Nicole Brown Simpson. He was sentenced to pay $33.5 million in damages. To escape this financial penalty he moved from California to Florida, a state where he was protected from any seizure of property.

Thirteen years later, O. J. Simpson, age 61, was arrested for an armed robbery that happened on September 13, 2007, in Las Vegas. Charged with kidnapping, armed theft, and assault, Simpson was sentenced in 2008 to a minimum of nine years in state prison after the Las Vegas jury deliberated for 13 hours at the end of a 13-day trial—pale in comparison with the "trial of the century."

The Death of Versace Miami Beach, Florida: 8:45 a.m., July 15, 1997. As he did every morning, Gianni Versace walked over to the nearby News Café to pick up a number of magazines and was about to go back inside his South Beach villa, Casa Casuarina, when two pistol shots rang out. He was hit in the back of the neck and in the face. While news reports echoed feverishly around the world, the FBI unleashed a vast manhunt.

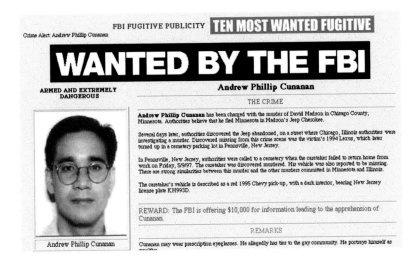

At 8:46 that evening, the name and photographs of the prime suspect were released. He was **Andrew Cunanan**, age 27, an American of Filipino descent, a male prostitute, and believed to be responsible for four other murders. The FBI alert included the notice: "Warning, the suspect is armed and dangerous."

July 17: all of the suspect's movements of the past few months are reconstructed.

July 21: a hotline is activated for anyone with information on Andrew Cunanan. In a few hours, more than 300 reports pour in.

July 23: eight days after the murder a caretaker, Fernando Carreira, checks on a house-boat whose owner is away. He hears a shot and tells his son to call the police. What follows is a siege of the houseboat, with the Miami police, Dade County police, members of the SWAT team, and the FBI all on high alert for two hours. Only after five hours, however, do they break into the houseboat. There they find Cunanan's lifeless body. The murderer had committed suicide with a bullet to his temple.

The Black Dahlia

Elizabeth Short was born July 29, 1924, in Massachusetts. In 1943, while still a minor, she was arrested by the Santa Barbara police for illegal consumption of alcohol. With her dark hair, and often dressed in dark clothes, she arrived in Hollywood at the age of 19, hoping to make a career as an actress. On January 15, 1947, her naked, mutilated body, cut in two at the waist, was found on waste ground in Los Angeles. The press was fascinated by this crime, and Betty Short became known as the "Black Dahlia." Hollywood witnessed the most famous murder case to remain unsolved. In 1987 James Ellroy, who had been scarred by the unsolved killing of his own mother in 1956, adapted this news story into a bestseller entitled *The Black Dahlia,* which was the first part of his "Los Angeles Quartet," written between 1987 and 1992.

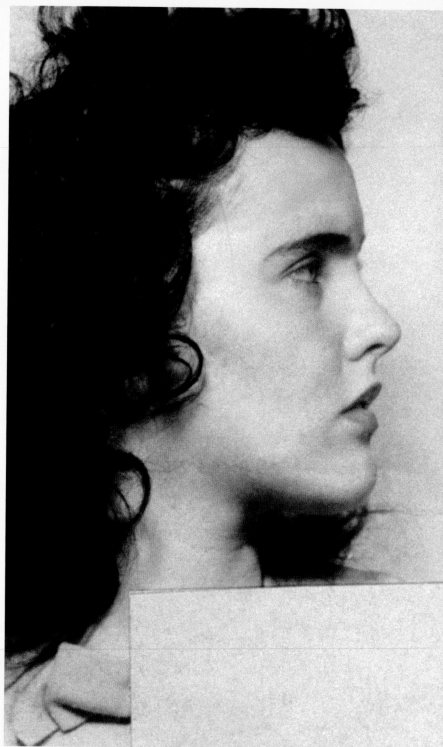

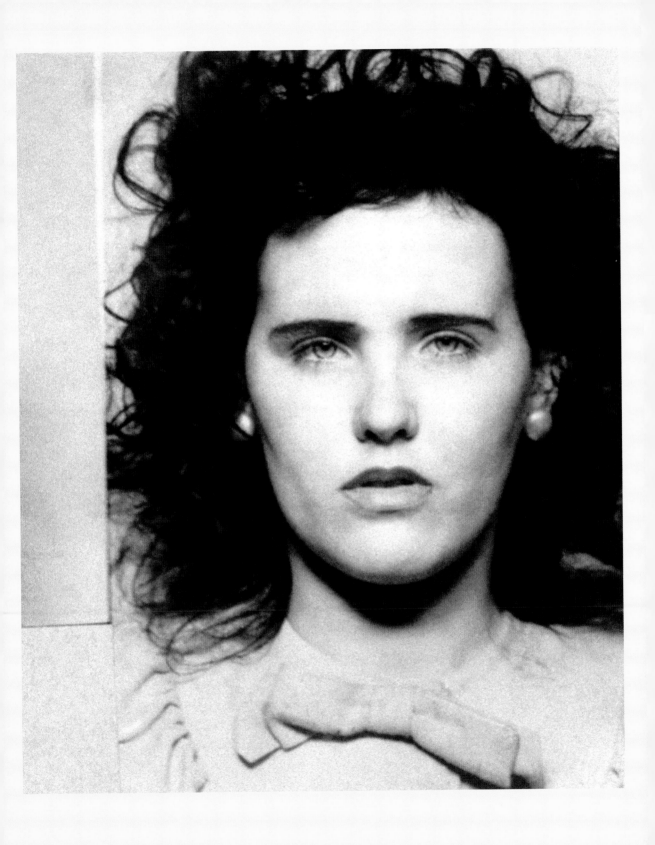

"Red Light Bandit" Caryl Chessman Born on May 27, 1921, in St. Joseph, Michigan, Chessman was arrested on January 23, 1948, accused of being "the Red Light Bandit" who was responsible for numerous thefts and rapes in parking lots of Los Angeles. He was given his nickname because he approached his victims in isolated spots, flashing a red torchlight similar to those used by the police.

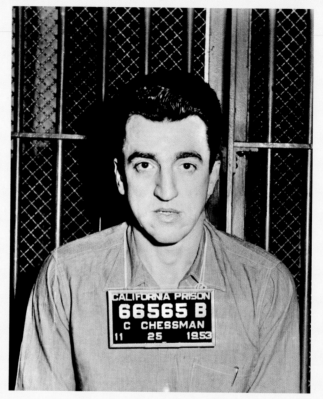

Chessman had already been convicted in 1941 and was on conditional discharge when he was rearrested. During his interrogation he admitted his crimes. He then went back on his statement, claiming that his confessions had been obtained by violence. At his trial he provided his own defense and had to answer 17 charges, ranging from theft to kidnapping. Although he had killed no one, Chessman was liable for the death penalty, because of the "Lindbergh Law" of 1933, which ruled that kidnapping with theft or violence incurred capital punishment. The fact that Chessman had dragged one of his victims out of her car to rape her meant that this crime was classed as a kidnapping. The jury would not allow for any mitigating circumstances, and Caryl Chessman was sentenced to death. Between 1948 and 1960, he filed dozens of appeals with various different appeals courts. Eight times he was granted a suspension of his execution. During his time in prison, he wrote four books, including *Cell 2455, Death Row: A Condemned Man's Own Story* (Cambridge, Massachusetts: Da Capo Press, 2006 reissue), which sold 500,000 copies in the United States. On May 2, 1960, after 12 years on death row, Caryl Chessman was executed in the gas chamber at San Quentin jail in California.

In Cold Blood On November 15, 1959, in Holcomb, Texas, two ex-convicts, Perry Smith and Richard Hickock, murdered a farmer and his family.

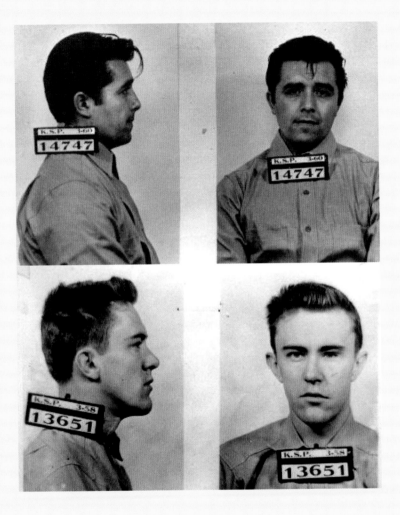

Perry Smith

Richard Hickock

The two men killed the four victims (the parents and their two children) with a shotgun, even though they had nothing to gain from it but a little over 40 dollars. On December 30, 1959, **Perry Smith** (top) and **Richard Hickock** (bottom) were arrested in Las Vegas. They were sentenced to death at their trial in 1960, and on April 14, 1965, they were executed by hanging in Lansing, Texas. For six years, the American novelist Truman Capote told the whole story of the inquiry in the *New Yorker.* On many occasions he met the investigators and questioned the murderers in their cells. In 1966, one year after attending the execution of Smith and Hickock, he published *In Cold Blood,* a bestseller that sold more than 8 million copies. There have been two film adaptations of the book: Richard Brooks's *In Cold Blood* (1967), and Bennett Miller's *Capote* (2006), starring Philip Seymour Hoffman.

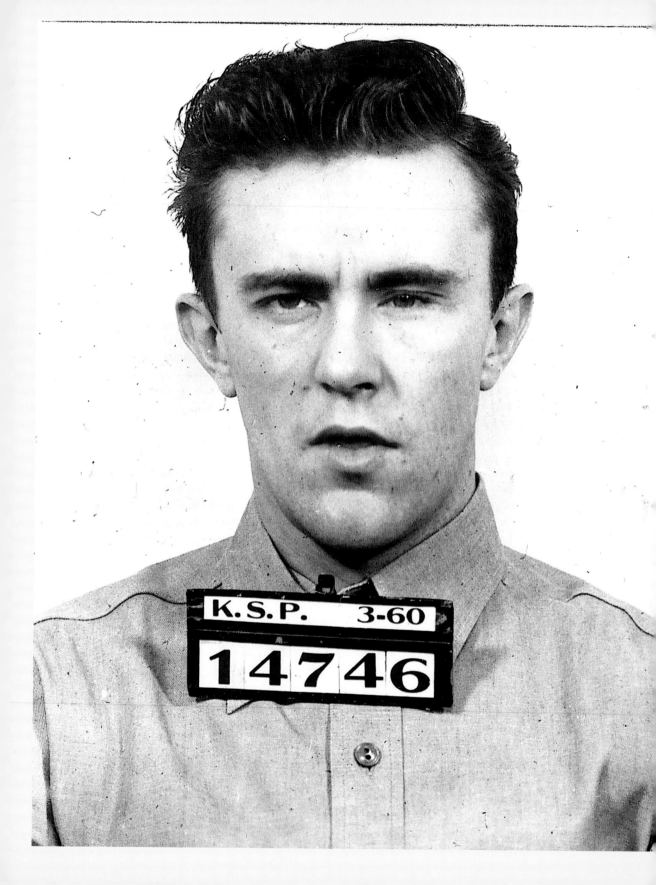

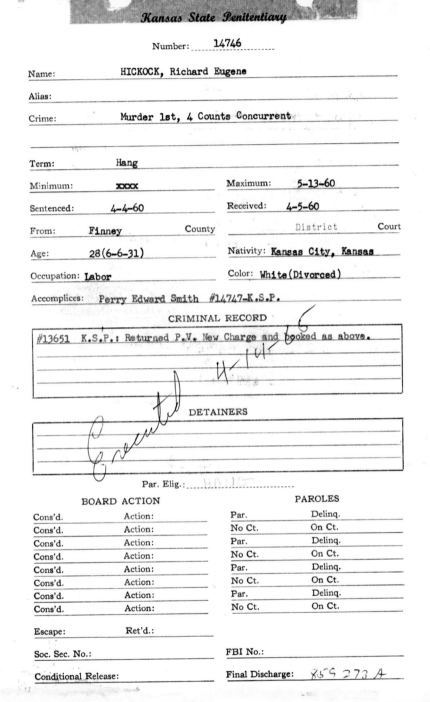

Kansas State Penitentiary

Number: __14746__

Name: HICKOCK, Richard Eugene

Alias:

Crime: Murder 1st, 4 Counts Concurrent

Term: Hang

Minimum: xxxx Maximum: 5-13-60

Sentenced: 4-4-60 Received: 4-5-60

From: Finney County District Court

Age: 28(6-6-31) Nativity: Kansas City, Kansas

Occupation: Labor Color: White(Divorced)

Accomplices: Perry Edward Smith #14747-K.S.P.

CRIMINAL RECORD

#13651 K.S.P.: Returned P.V. New Charge and booked as above.

DETAINERS

Par. Elig.:

BOARD ACTION		PAROLES	
Cons'd.	Action:	Par.	Delinq.
Cons'd.	Action:	No Ct.	On Ct.
Cons'd.	Action:	Par.	Delinq.
Cons'd.	Action:	No Ct.	On Ct.
Cons'd.	Action:	Par.	Delinq.
Cons'd.	Action:	No Ct.	On Ct.
Cons'd.	Action:	Par.	Delinq.
Cons'd.	Action:	No Ct.	On Ct.

Escape: Ret'd.:

Soc. Sec. No.: FBI No.:

Conditional Release: Final Discharge: 855 273 A

Richard Hickock, #14746

Escape from Alcatraz

In the night on June 11, 1962, prisoners Frank Morris and John and Clarence Anglin escaped from Alcatraz.

In the 1950s, **Frank Lee Morris** was imprisoned in Atlanta, where the penitentiary's administration described him as being of "superior intelligence." On January 20, 1960, after several escape attempts, he was transferred to Alcatraz, known as "The Rock," as convict #AZ1441. There he met the brothers **John and Clarence Anglin**, who were convicted for armed robberies and had also been transferred from Atlanta after attempting an escape. In 1961 the three men began to form a plan of escape from Alcatraz. They stole tools from the prison workshops and used waterproof raincoats taken from other prisoners to create a makeshift raft and lifebelts. They made rudimentary dummies from papier-mâché, covering the heads with human hair. On several occasions they outsmarted surveillance systems and searches. In May 1962, they finally managed to create openings through the ventilation shafts in their cells. During the night of June 11, 1962, the three men climbed into the ventilation shafts, reached the roof, got past a watchtower, and slithered down a 50-foot water pipe. They crossed the barbed wire, got to the shore of the island, assembled their raft, and disappeared into the night. On the following morning, June 12, 1962, when the prison wardens of Alcatraz entered the three men's cells, they found the dummies instead of the convicts. The FBI then organized a vast manhunt but never found the bodies and declared the three Alcatraz escapees missing, presumed dead by drowning in San Francisco Bay. Their story was dramatized in a 1979 movie, *Escape From Alcatraz,* directed by Don Seigel, in which Clint Eastwood starred as Frank Morris.

WANTED BY THE FBI

ESCAPED FEDERAL PRISONER
FRANK LEE MORRIS

Photographs taken 1960 FBI No. 2,157,606

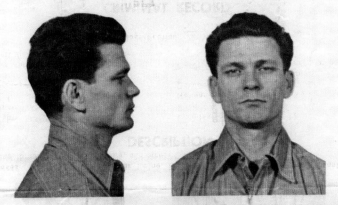

Aliases: Carl Cecil Clark, Frank Laine, Frank Lane, Frank William Lyons, Frankie Lyons, Stanley O'Neal Singletary, and others

DESCRIPTION

Age: 35, born September 1, 1926, Washington, D. C.
Height: 5' 7½"
Weight: 135 pounds
Build: Medium
Hair: Brown
Eyes: Hazel

Complexion: Ruddy
Race: White
Nationality: American
Occupations: Car salesman, draftsman, painter

Scars and Marks: Numerous tattoos including devil's head upper right arm, star base of left thumb, "13" base of left index finger

Fingerprint Classification: 22 M 9 U IOO 12
L 1 U 000

CRIMINAL RECORD

Morris has been convicted of burglary, larceny of an automobile, grand larceny, possession of narcotics, bank burglary, armed robbery and escape.

CAUTION

MORRIS HAS BEEN REPORTED TO BE ARMED IN THE PAST AND HAS A PREVIOUS RECORD OF ATTEMPTED ESCAPE. CONSIDER EXTREMELY DANGEROUS.

A Federal warrant was issued on June 13, 1962, at San Francisco, California, charging Morris with escaping from the Federal Penitentiary at Alcatraz in violation of Title 18, U. S. Code, Section 751.

IF YOU HAVE INFORMATION CONCERNING THIS PERSON, PLEASE NOTIFY ME OR CONTACT YOUR LOCAL FBI OFFICE. TELEPHONE NUMBER IS LISTED BELOW.

DIRECTOR
FEDERAL BUREAU OF INVESTIGATION
UNITED STATES DEPARTMENT OF JUSTICE
WASHINGTON 25, D. C.
TELEPHONE, NATIONAL 8-7117

Wanted Flyer No. 307
June 14, 1962

CALL SAN
FRANCISCO
KL 2-2155

Frank Lee Morris

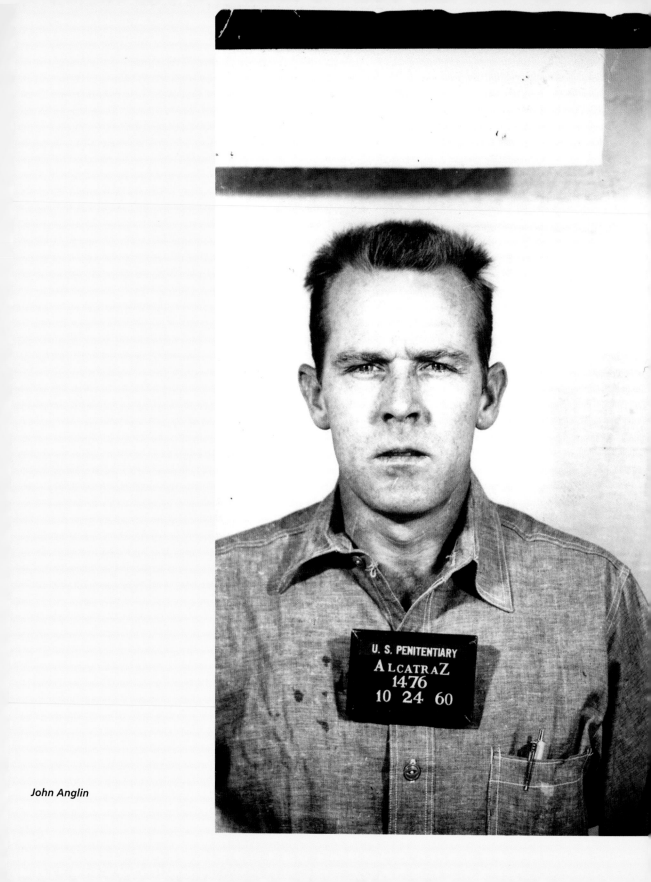

John Anglin

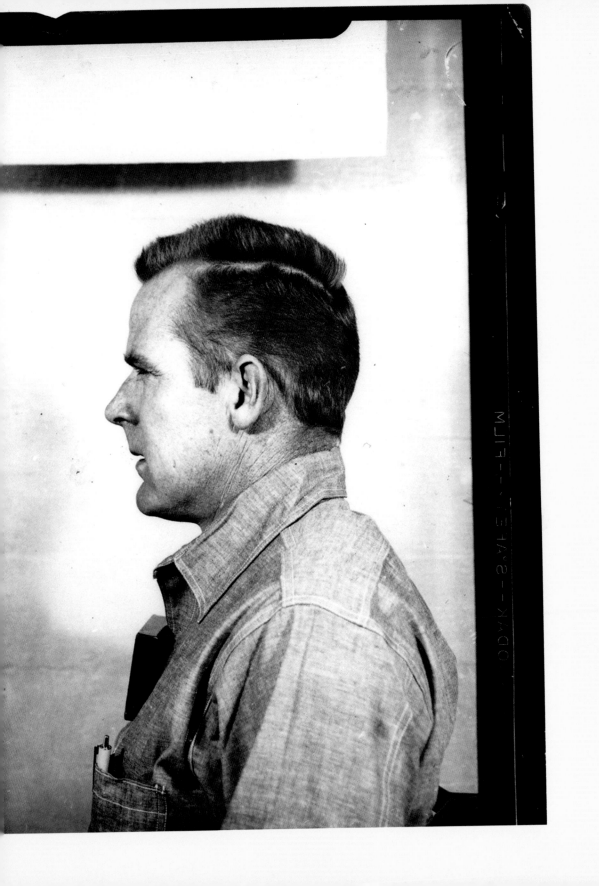

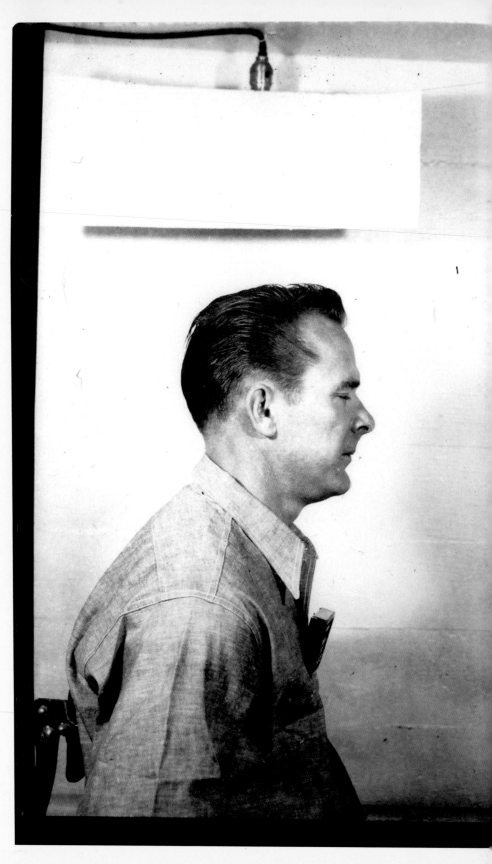

Clarence Anglin

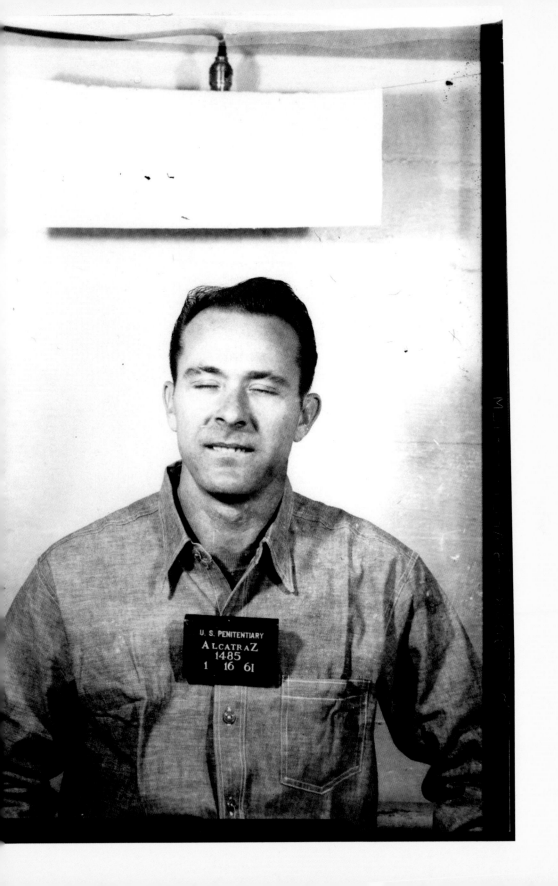

Robert Stroud Born January 28, 1890, in Seattle, Stroud was nicknamed "the Birdman of Alcatraz." In 1909, Robert Stroud was arrested for murder. Found guilty of second-degree murder and sentenced to 12 years in prison, he was held at the federal penitentiary at McNeil Island in Washington State. On September 5, 1912, his sentence was increased by six months for wounding a fellow convict with a knife. In 1916, four years after his transfer to the federal prison at Leavenworth, Kansas, he stabbed a warden to death. He was found guilty of first-degree murder and sentenced to death by hanging. This was then commuted to life imprisonment with compulsory segregation and no possibility of a conditional discharge. During his time in Leavenworth he took an interest in ornithology and raised 300 canaries in two adjacent cells. He wrote two books, which gained him a certain degree of recognition from the general public and the world of science. The prison administration discovered, however, that some of his research materials had been used to make a still and produce alcohol. In December 1942, he was transferred to Alcatraz. In 1959 he was sent to the prisoners' medical center in Springfield, Missouri, where he died on November 21, 1963, at the age of 73. Robert Stroud had spent 54 years in prison, 42 of them in solitary confinement, with no contact with other prisoners. His story was made famous by the 1962 movie *Birdman of Alcatraz,* starring Burt Lancaster.

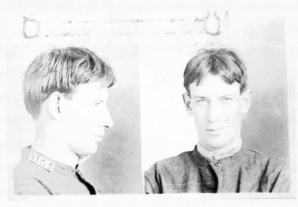

August 30, 1909

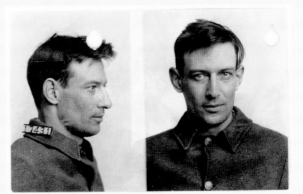

September 5, 1912

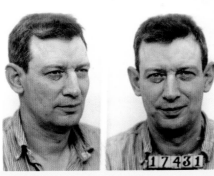

February 28, 1922

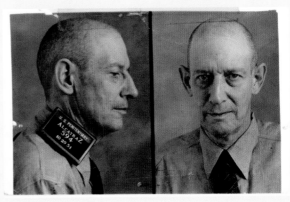

October 29, 1951

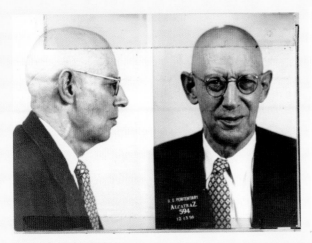

December 13, 1956

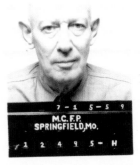

July 15, 1959

Following spreads: The Birdman of Alcatraz at 22, 32, and 69 years old respectively

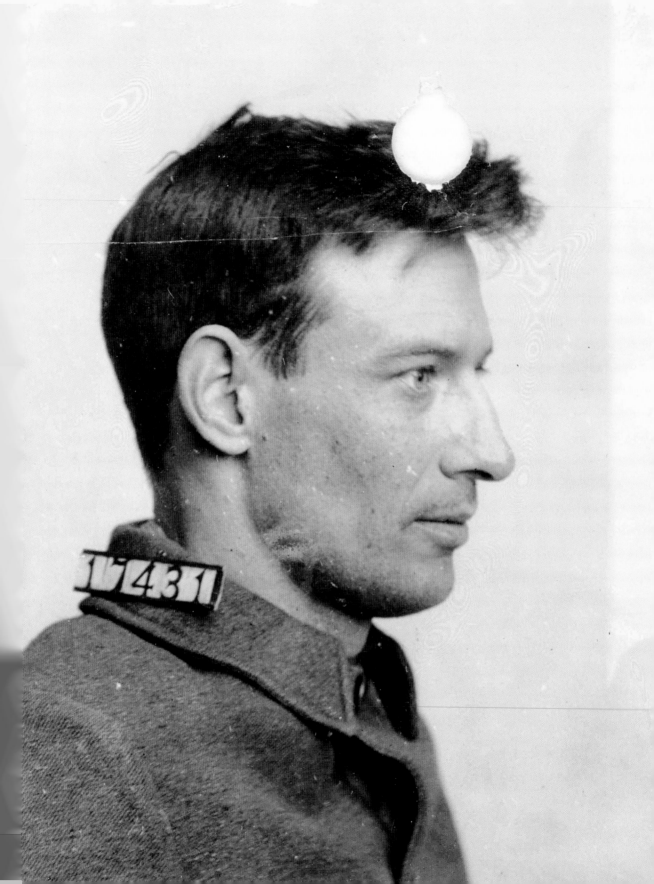

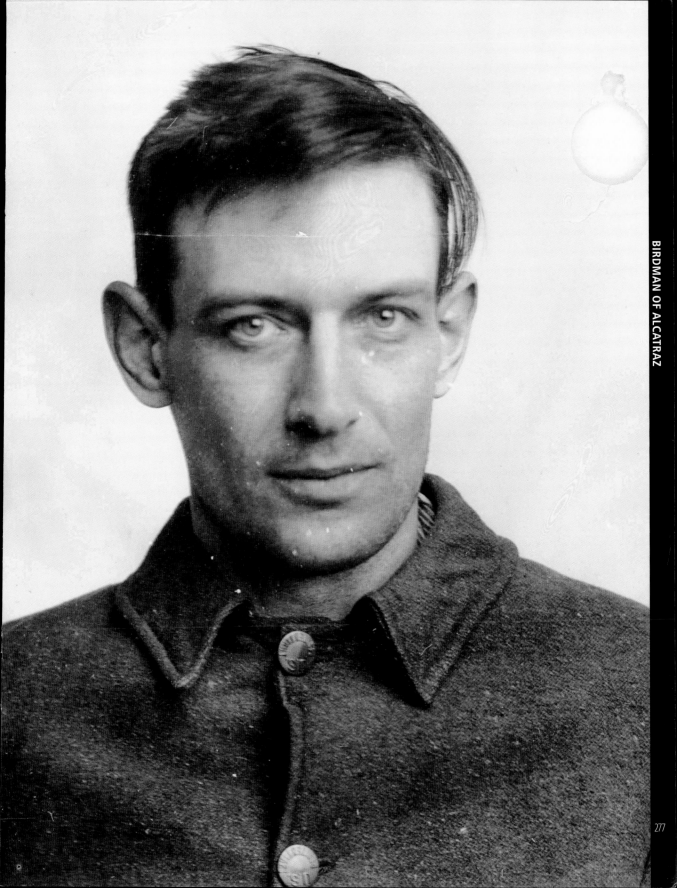

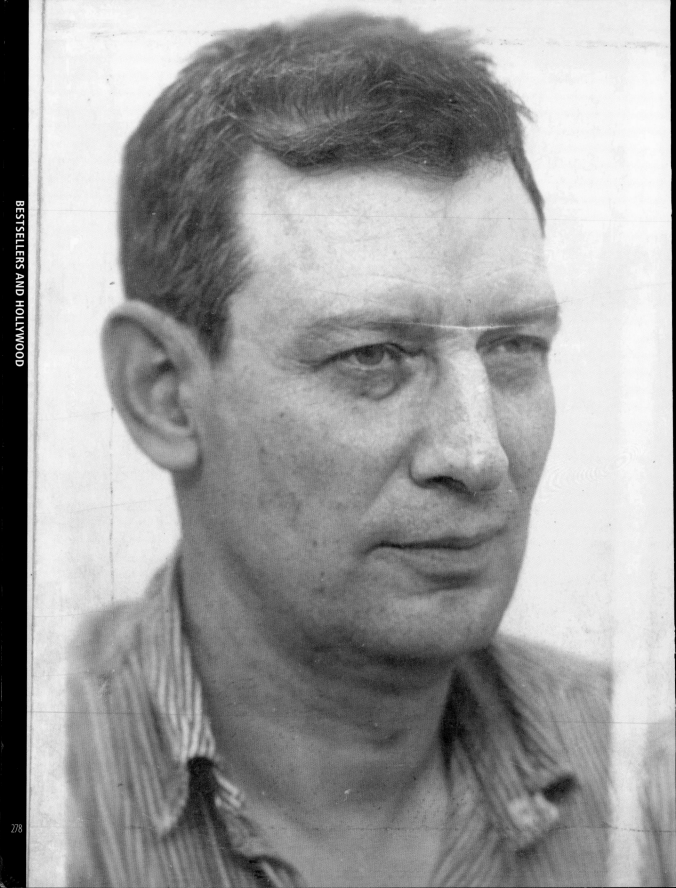

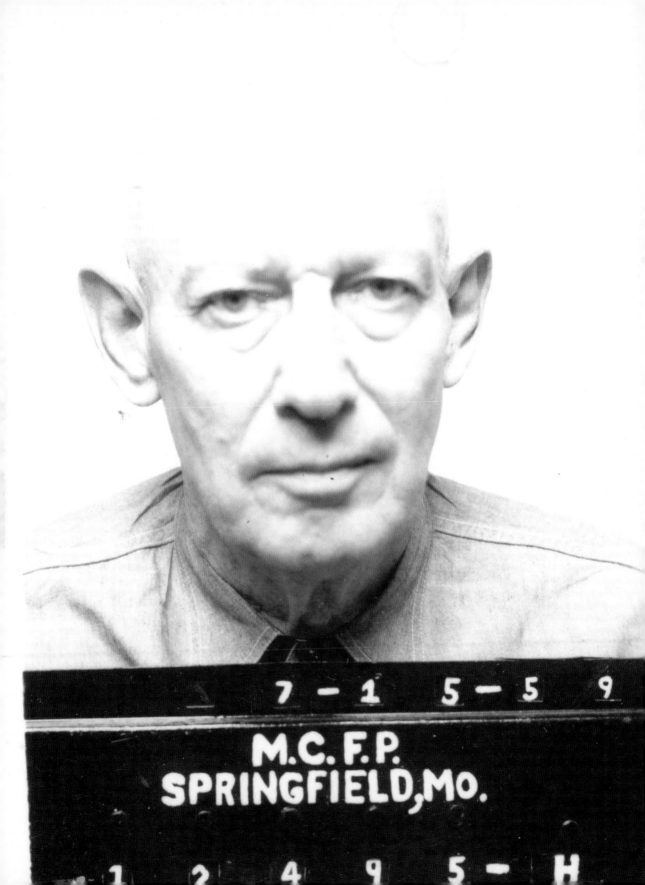

7 - 1 5 - 5 9

M.C. F.P.
SPRINGFIELD, MO.

1 2 4 9 5 - H

Index

Acknowledgments

IN EUROPE:

Nathalie Bec, Brigitte Govignon,
and Isabelle Raynaud at **Éditions de La Martinière**
Stéphane Simon, Christine Bleunven, Bertrand Boutot, and
Franck Baron in behalf of **Téléparis**
Pauline Dauvin, Chrystèle Fremaux-Moustardier, and Kevin
Deysson in behalf of **13ème Rue, NBC Universal Global
Networks France**
Matthieu Charon and **LA FNAC**
Maurice Coriat
Francine Ravel

Sylvie, Léa, and Thelma Pellicer
Jérôme Coullet
Dan Herzberg
Fabrice Agro and Fabien Farrachi at Difuz
Virginie Apiou
Renaud Cazrnes
Grégory Auda
Bruno Duverger

Isabelle Astruc, Marie Lajus, Claude Charlot, Malik Ben
Miloud, Commandant Olivier Daflon, Division Commissary
Vianney Dièvre, and Patricia Bodeman at **Préfecture de
Police de Paris**
Commandant Marie-Louise Boulanger at **Direction
centrale de la Police judiciaire**
Pierre-Frédéric Garret and Capitaine Hervé Conan at
SHPN
Sylvain Manville at **Archives nationales/Ministère de
l'Intérieur**
Agnès de Zolt at **Archives départementales de Lyon**
Géraldine Gall **Archives départementales des
Bouches-du-Rhône**
Damien Richard, Delphine Hervé, and Émilie Charrier at
Archives nationales
Céline Heytens, Xavier Avenage at **Musée de la
Résistance à Champigny-sur-Marne**
Véronique Fau-Vincenti at **Musée de l'Histoire vivante
à Montreuil**

Didier Travier at **Médiathèque Louis-Aragon, Le Mans**
Valérie Kleinknecht at **Mémorial de la Shoah, Paris**
Olivier Cochet at **Police cantonale de Bern**, Switzerland
Jacques Barrelet at **Archives d'État de Genève**,
Switzerland
Isabelle Sampiéri at **Cegesoma**, Brussels

IN THE UNITED STATES:

John Anderson at **Texas State Library and Archives
Commission**
Joan Bacharach and Amanda Williford at **Golden Gate
National Recreation Area**
Chrystal Carpenter Burke at **Arizona Historical Society**
Vicki Casteel at **Indiana State Archives**
Cheryl Cobb at **Missouri State Highway Patrol**
Patrick Connelly at **NARA's Northeast Region**
Lisa De Boer at **Brooklyn Public Library**
Jeff Dosik at **Ellis Island National Park**
Linda Foglia and Erik Kriss at **NY DOCS**
Lyn Frazer at **Montgomery County Archives**
Leonora A. Gidlund and **NYC Department of Records**
Michael Harling
Michael Lorenzini at **NYC Municipal Archives**
Michael Massmann at **Redux Pictures**
Meredith McLemore at **Alabama Department of
Archives and History**
Eithne O'Neill
John Reinhardt at **Illinois State Archives**
Timothy Rives at **NARA's Central Plains Region**
Joe Sanchez at **NARA's Pacific Region**
Nancy Sherbert at **Kansas State Historical Society**
John Slate at **City of Dallas Municipal Archives**
Mindy Spitzer Johnston at **Harvard Law School Library**
Cynthia Van Ness at **Buffalo and Erie County Historical
Society**
Caroline Waddell at **USHMM**
Bridget White at **Minnesota Historical Society**

Photo Credits

AFP PHOTO: Adolf Eichmann (pp. 182–83); Ronnie Biggs (pp. 234–37); Bastien Thirry (p. 238); John Gotti (p. 255, top); O.J. Simpson (p. 260)

Agenzia Fotogramma, Milano: Pietro Pacciani (©Torrini/Giacominofoto, p. 232); Totó Riina (©Studiocamera, p. 259)

AP-SIPA Press: James Earl Ray (p. 220); Jane Fonda (p. 228); David Bowie (p. 231); Elizabeth Short (pp. 262–63); Caryl Chessman (p. 264)

Archives départementales du Mans, France: Léa Papin (pp. 121–22); Christine Papin (p. 123)

Archives d'État Genève, Switzerland: Louis Lucheni (pp. 24–25)

Archives nationales, France: Giuseppe Platano (p. 52)

Archivio Farabola, Milano: Leonarda Cianciulli (p. 124)

Bibliothèque nationale de France: Lutrillier, Bénaud, Lacroix, and Vité (p. 12)

Cegesoma: Carbone and Spirito (pp. 80–81); Georges Hainnaux (p. 130); Jean Filliol (p. 132)

Centro Documentazione Mondadori Segrate: Cesare Lombroso (p. 16); Totó Riina (A. Alecchi, p. 258)

Collection J + C Mairet: Mata Hari (p. 67)

_____/ancienne coll. André Breton: Germaine Berton (pp. 76–77)

Corbis: Stalin (pp. 36–37); "Legs" Diamond (pp. 102–103); Alvin Karpis (p. 155, top); Richard Bruno Hauptman (pp. 156–57); Dr. Sam Sheppard (pp. 210–11); Malcolm X (pp. 222–23); Jack Ruby (p. 243); Sirhan Sirhan (p. 247); Carlo Gambino (p. 250)

Courtesy of Buffalo and Erie County Historical Society: Leon Czolgosz (p. 27)

Courtesy of The Brooklyn Public Library/Brooklyn Collection: "Lucky" Luciano (p. 88); Albert Anastasia (p. 97); Dutch Schultz (p. 99); Jacob Shapiro lineup (p. 110, top); Vito Genovese (p. 113, center)

Courtesy of the Chicago Historical Society: Mark Rudd, Bernardine Dohrn, and Bill Ayers (p. 248)

Courtesy of the Dallas Municipal Archives, City of Dallas: Clyde Barrow (pp. 138–39); Henry Methvin (p. 140, bottom); Lee Harvey Oswald (pp. 239–41); Jack Ruby (pp. 242, 244–45)

Courtesy of the FBI: Elvis Presley (p. 229, bottom)

Courtesy of the Indiana State Archives: John Dillinger (p. 141–42); Harry Pierpont and Charles Mackley (p. 145); Russell Clark (p. 146); Homer Van Meter (p. 146, bottom); Harry Copeland (p. 147)

Courtesy of the Kansas State Historical Society: Perry Smith and Richard Hickock (pp. 265–67)

Courtesy of the Library of Congress: Emma Goldman (p. 28); Luigi Galleani (p. 33); Leon Trotsky (p. 35); Charles Ponzi (p. 82); Al Capone (pp. 83–86); "Lucky" Luciano lineup (pp. 90–91); Meyer Lansky (pp. 94–95); Joe Adonis (p. 96); Dutch Schultz wanted poster (p. 98); Hope Dare, "Dixie" Davis, and George Wienberg (p. 104); Louis "Lepke" Buchalter (pp. 107–109); Abe Reles (p. 110, bottom); Vito Genovese (p. 113, bottom); Waxey Gordon (p. 117); The German Saboteurs—George Dasch and Peter Burger—(pp. 156–59); the Hollywood Ten—Ring Lardner, Jr., and Dalton Trumbo—(p. 198); Alger Hiss (p. 199); Carmine Galante (pp. 252–53)

Courtesy of the Miami Police Department: Lenny Bruce (p. 224)

Courtesy of the Minnesota Historical Society: John Dillinger Wanted circular (p. 141); Evelyn Frechette (p. 142); "Baby Face" Nelson Wanted poster (p. 147); Karpis and Barker wanted poster (p. 152); Fred Barker (p. 153, bottom)

Courtesy of The Montgomery County Archives: Civil Rights movement—Rosa Parks, Martin Luther King, Jr., and Ralph Abernathy—(pp. 212–17); Freedom Riders—Ralph Abernathy, George Bundy Smith, Wyatt Tee Walker, and William Sloane Coffin—(pp. 218–19)

Courtesy of the National Park Service, Statue of Liberty National Monument and Ellis Island: Emma Goldman (p. 29)

Courtesy of the NYC Municipal Archives: "Lucky" Luciano (pp. 92–93); Meyer Lansky (p. 89); Charles Workman (pp. 100–101); Jacob Shapiro (p. 104); Frank Costello (p. 109); Bugsy Siegel (pp. 112–13); Carmine Galante (p. 251); John Gotti (pp. 254 and 255, center & bottom)

Courtesy of the Special Collections Department Harvard Law School Library: Sacco and Vanzetti (p. 30–32)

Courtesy of the Texas State Library and Archives Commission: Clyde and Melvin Barrow Wanted poster (p. 137)